the cinema of THE DARDENNE BROTHERS

DIRECTORS' CUTS

Other titles in the Directors' Cuts series:

the cinema of EMIR KUSTURICA: *notes from the underground*
GORAN GOCIC

the cinema of KEN LOACH: *art in the service of the people*
JACOB LEIGH

the cinema of WIM WENDERS: *the celluloid highway*
ALEXANDER GRAF

the cinema of KATHRYN BIGELOW: *hollywood transgressor*
edited by DEBORAH JERMYN & SEAN REDMOND

the cinema of ROBERT LEPAGE: *the poetics of memory*
ALEKSANDAR DUNDJEROVIC

the cinema of GEORGE A. ROMERO: *knight of the living dead*
TONY WILLIAMS

the cinema of ANDRZEJ WAJDA: *the art of irony and defiance*
edited by JOHN ORR & ELZBIETA OSTROWSKA

the cinema of KRZYSZTOF KIESLOWSKI: *variations on destiny and chance*
MAREK HALTOF

the cinema of DAVID LYNCH: *american dreams, nightmare visions*
edited by ERICA SHEEN & ANNETTE DAVISON

the cinema of NANNI MORETTI: *dreams and diaries*
EWA MAZIERSKA & LAURA RASCAROLI

the cinema of MIKE LEIGH: *a sense of the real*
GARRY WATSON

the cinema of JOHN CARPENTER: *the technique of terror*
edited by IAN CONRICH & DAVID WOODS

the cinema of ROMAN POLANSKI: *dark spaces of the world*
edited by JOHN ORR & ELZBIETA OSTROWSKA

the cinema of TODD HAYNES: *all that heaven allows*
edited by JAMES MORRISON

the cinema of STEVEN SPIELBERG: *empire of light*
NIGEL MORRIS

the cinema of ANG LEE: *the other side of the screen*
WHITNEY CROTHERS DILLEY

the cinema of TERRENCE MALICK: *poetic visions of america (second edition)*
edited by HANNAH PATTERSON

the cinema of WERNER HERZOG: *aesthetic ecstasy and truth*
BRAD PRAGER

the cinema of LARS VON TRIER: *authenticity and artifice*
CAROLINE BAINBRIDGE

the cinema of NEIL JORDAN: *dark carnival*
CAROLE ZUCKER

the cinema of JAN SVANKMAJER: *dark alchemy*
edited by PETER HAMES

the cinema of DAVID CRONENBERG: *from baron of blood to cultural hero*
ERNEST MATHIJS

the cinema of JOHN SAYLES: *a lone star*
MARK BOULD

the cinema of SALLY POTTER: *a politics of love*
SOPHIE MAYER

the cinema of MICHAEL HANEKE: *europe utopia*
edited by BEN McCANN & DAVID SORFA

the cinema of THE DARDENNE BROTHERS
responsible realism

Philip Mosley

 WALLFLOWER PRESS LONDON & NEW YORK

A Wallflower Press Book
Published by
Columbia University Press
Publishers Since 1893
New York • Chichester, West Sussex
cup.columbia.edu

A complete CIP record is available from the Library of Congress

ISBN 978-0-231-16328-6 (cloth : alk. paper)
ISBN 978-0-231-16329-3 (pbk. : alk. paper)
ISBN 978-0-231-85021-6 (e-book)

Series design by Rob Bowden Design

Cover image of the Dardenne brothers courtesy of The Kobal Collection
All stills copyright © Christine Plenus; courtesy of Les Films du Fleuve

CONTENTS

Acknowledgements vii

1 Responsible Realists 1

2 Cinematic Reference Points 26

3 The Video Documentaries, 1974–83 39
 *In the Beginning Was the Resistance; The Nightingale's Song; When Léon M.'s Boat
 First Sailed down the River Meuse; For the War to End, the Walls Had to Crumble;
 R… No Longer Answers; Lessons from a University on the Fly; Look at Jonathan.
 Jean Louvet, His Work.*

4 Foraying into Fiction, 1986–92 63
 Falsch; They're Running … Everyone's Running; You're on My Mind

5 Breakthrough: *The Promise*, 1996 76

6 First Palme d'Or: *Rosetta*, 1999 86

7 Pushing the Envelope: *The Son*, 2002 97

8 Second Palme d'Or: *The Child*, 2005 107

9 A Minor Shift: *The Silence of Lorna*, 2008 116

 Afterword: *The Kid with a Bike*, 2011 127

Filmography 134
Bibliography 141
Index 148

ACKNOWLEDGEMENTS

I wish to thank the following persons in Belgium for their help and support in enabling me to write this book: Jean-Pierre and Luc Dardenne, Tania Antonioli, Helen Pardo, Paul Geens, Dominique Nasta, Marianne Thys, Serge Meurant and Jean-Paul Dorchain.

I am indebted to the following friends and colleagues, who read drafts of my first three chapters and made many insightful comments and valuable suggestions: Paul Tickell, Brian Winston, Felix Thompson and David E. James.

Thanks are due to the Institute for the Arts and Humanities at Penn State University (Marica Tacconi, Director) for awarding me a faculty grant in 2009 to work on this book; to the Matthews Faculty Research Endowment at Penn State Worthington Scranton for supporting my project with a research grant in 2007; to Academic Affairs at Penn State Worthington Scranton (Michael Mahalik, Director) for supporting one of two research trips to Liège in 2008 from campus development funds.

My trips to Liège were enhanced by the comfortable and distinctive accommodations provided by Marlène Gosset and Marie Hannequart. Thanks also to Jack Silverberg and Joy Hockman for their gracious hospitality in the form of a 'Dardennes mini-festival' house party in the USA.

Thanks also to Shu-ching Mosley, who helped in many ways, and to Yoram Allon and Jodie Taylor at Wallflower Press for their encouragement and support.

For John Fletcher

Responsible Realists

With two Palme d'Or awards at the international film festival in Cannes, France – one for *Rosetta* (1999), another for *L'Enfant* (*The Child*, 2005) – the Belgian brothers Jean-Pierre and Luc Dardenne have joined an elite group (Emir Kusturica, Francis Ford Coppola, Shohei Imamura, Bille August) of two-time winners of the most prestigious prize in world cinema. Their other four major fiction films – *La Promesse* (*The Promise*, 1996), *Le Fils* (*The Son*, 2002), *Le Silence de Lorna* (*The Silence of Lorna*, 2008), and *Le Gamin au vélo* (*The Kid with a Bike*, 2011) – have also garnered many prizes at Cannes and elsewhere.[1] This growing oeuvre has established their reputation as leading cinematic auteurs whose mode is a gritty social realism that we associate with practitioners of the 'new French realism' such as Laurent Cantet, whom the brothers admire, and particularly to its regional exponents such as Erick Zonca and Bruno Dumont in northern France or Benoît Mariage and Lucas Belvaux in the southern Belgian region of Wallonia where the Dardennes were born, raised and continue to live and work.[2] We also associate this mode with, for instance, some of the work of Ken Loach, Mike Leigh and Stephen Frears in Britain.[3] The films of the Dardennes share with these contemporaries and others elsewhere a preoccupation with the lives of working-class individuals struggling to survive with a measure of dignity in a new world order that for them is mainly one of poverty, unemployment, social disintegration and environmental ruin. On closer examination the Dardennes' films represent these things and more. From their early video documentary work (1974–83) through their first forays into narrative fiction film (1986–92) to their six key films since 1996 the brothers' vision has been of a will to empower their protagonists and so help to liberate them from economic circumstances, personal relationships and mental states that oppress, restrict and destabilise them in one way or another.

For the subtitle of this volume I chose 'responsible realism', as keywords to the Dardennes' cinema. While the brothers are undoubtedly exemplary realist filmmakers, their relation to cinematic realism is as nuanced and complex as the notion itself. As

for responsibility, I believe that the Dardennes' entire filmmaking career so far has shown their acute awareness of a need for both individual and collective responsibility in human relations. I agree broadly with a dominant critical view that ethical concerns lie at the heart of their work, but I prefer not to see these concerns as detached from a fading sense of politics. In the documentaries, which are firmly grounded in particular social and political histories, these concerns emerge in their sensitivity to the documentary act, that is, to their involvement in constructing and mediating the testimonial discourse that implicates the subjects of their films. Especially from *The Promise* onward they dramatise these concerns in uncompromising portrayals of individual lives that play out against a visibly bleak socio-economic backdrop.

In all but one of the documentaries and in their first fiction film *Falsch* (1986), the Dardennes explore a dynamic relation between history and memory, between public and private narratives. They question how individuals deal with personal experiences that invariably burden them as much as define and inspire them. In their third fiction film *Je pense à vous* (*You're on My Mind*, 1992) – preceded by *Il court, il court le monde* (*They're Running … Everyone's Running*, 1988), a short film set in the present – the brothers begin to turn their attention away from the relation of the past to the present via diverse commemorative acts to dramas of the more recent past and of the present day. The story of a family threatened by the effects of industrial collapse, *You're on My Mind* is set in 1980. *The Promise* and subsequent films are set in the present. Shaped by the evolution of a post-industrial society already seen in its formative stages in *You're on My Mind*, the later dramas focus on crises of conscience and action that indirectly form an individual response to socio-economic conditions. We may thus see the developing cinema of the Dardennes as an ethical body of work within a politically informed social realist mode, one that engages with questions of honesty to ourselves and others, and of how we assume and exercise a sense of human responsibility.

Film Practice

> A good director tries to eliminate [the] distance between audience and action, to destroy the screen as a picture frame, and to drag the audience *through* it into the reality of the scene. (Roemer 1966: 265)

Making all their films together as Jean-Pierre and Luc Dardenne and not seeking solo careers independently of each other puts us in mind of the uncommon and fascinating phenomenon of brotherly (or sibling) directorial pairs: Auguste and Louis Lumière, Vittorio and Paolo Taviani, Ethan and Joel Coen, Stephen and Timothy Quay, Andy and Larry (now Lana) Wachowski, Peter and Bobby Farrelly. Unlike, for instance, the Tavianis, who alternate leadership on the set, the Dardennes have a highly symbiotic relationship in all phases of the filmmaking process: casting, location, rehearsal, shooting, postproduction, promotion and publicity. In Jean-Pierre's words, 'we are the same: one person, four eyes' (see Brooks 2006). During shooting, however, one stays on set with the actors and technicians, while the other watches the video monitor for an overall sense of rhythm. In choosing this method they obey a single rule: whoever is

behind the monitor must not speak to actors or crew members. Once they complete a take, they discuss it in front of the monitor, then with their cinematographer.

Luc writes the screenplays but does so in continuous dialogue with Jean-Pierre, who often takes a greater responsibility for the more technical aspects of their projects. As Luc puts it, 'I hold the pen, but it writes with two hands' (2005: 24). He adds that when he writes his diary entries in the first person singular, he is effectively also using the first person plural. In interviews the brothers have been known to finish each other's sentences, but they display a refreshing tendency not to sound too earnest about their mutual understanding and close working relationship.

In creating their films the Dardennes' major reference points are as much in litera-ture and philosophy as in cinema or the visual arts in general. Their cinema of respon-sible realism, one that acknowledges the humanity of others and sustains a dream of the future, draws them to the French philosopher Emmanuel Levinas; to neo-Marxist and liberal humanist thinkers such as Hannah Arendt, Theodor Adorno and espe-cially Ernst Bloch; and to lesser known figures such as Catherine Chalier, author of a treatise on tears subtitled 'Fragility of God, Fragility of the Soul' (2003). Among their wide-ranging literary touchstones are the Bible – which teaches how to stay with the literal, says Luc (2005: 82) – Shakespeare, Dostoyevsky,[4] Camus, Faulkner and Toni Morrison. Luc admits a need for literature and music to inspire his screenwriting activity. As a prelude to writing a script he enters an intensive reading phase and listens particularly to Beethoven's piano sonatas and concertos. He likens the rhythm of a film to that which he hears in Schumann. Yet the moment he enters the screenwriting phase, all ideas must be subsumed by a quest for concrete images and dialogue that will embody them in audiovisual terms. This rationale recalls André Bazin's faith in the power of images and, as Ivone Margulies (2003) points out, in the French theo-rist's fascination with the incidental and contingent elements of the visual field. The Dardennes' work exemplifies realist cinema of this kind, in which the material world offers up images and moments of everyday life that both drive and exceed the narrative in whose service they have been photographed.

Their film practice hinges on steadfastly refusing to be lured by the formulaic, the glamourous or the visually excessive, which they find to be endemic to most commer-cial cinema, a 'cinema without style', says Luc (2005: 26), whose 'technical comfort' (2005: 61) they decline. They seek to remain as independent as possible of that domi-nant cinema given the financial and administrative exigencies of production, distribu-tion and exhibition of fiction films. While they accept that filmmaking in Belgium necessarily involves them in the mechanics of a *dirigiste* system, that is, one predicated on state support and promotion of a quasi-national film industry, they are careful to relate themselves tangentially to that system. They resist identifying with the conven-tions of a national film culture and its assumptions of taste and acceptable product, while readily acknowledging the practical impossibility of doing as they wish outside that culture.

In the late 1970s when the Dardennes were establishing their presence as video documentarians, few film companies existed in Wallonia. The brothers soon realised a need to establish their own company in order to maintain their independence and

artistic control. Dérives, which they founded in 1975, has the status of a non-profit collective committed to documentary filmmaking; in 1994 they founded Les Films du Fleuve, a for-profit company committed to the making of fiction films. Given the limited infrastructure of Belgian film production, in which an artisanal mode continues to prevail in the absence of a national film industry, the brothers have always been aware of the need for partnerships with other private and with public bodies. In 2000 they decided to appoint an executive producer, Olivier Bronckart, so that they could concentrate on the filmmaking side, and in 2002 they entered into partnership with the French producer Denis Freyd and his company Archipel 35. Other regular private partners include the European cultural television channel Arte and the French channel Canal Plus, which have both shown a sustained willingness to invest in feature films. From the earliest days they have regularly sought grants in aid from public partners, notably the European Union which supports film initiatives via schemes like the Council of Europe's production fund Eurimages, as well as RTBF (Belgian French-language public television), the Belgian Ministry of the French Community and the regional government of Wallonia, all of which share a commitment to the promotion of audiovisual culture. The Belgian and French advance on box-office receipt system (*avance sur recettes*) has also proven to be an important part of their fundraising; without it *The Promise* would not have been such a breakthrough success. More recently they have also taken advantage of a federal tax shelter in Belgium for the production of films. And if we look, for instance, at the sources of financial support for *The Silence of Lorna* (see Filmography), though still modest compared to many commercial productions, it has grown commensurately with the Dardennes' high reputation to include five major and numerous minor bodies from both private and public sectors.

From the beginnings of Dérives and Les Films du Fleuve the Dardennes have sought to establish a collective artistic identity not only for the production of their own films but also for those of others; by 2008 Les Films du Fleuve had made ten such fiction films. As well as committing to independent production, the brothers believe that an independent distribution network for European films is a worthy undertaking. Thus in 2008–9 they served as presidents of such a network: Europa Distribution.

The Dardennes' relative autonomy as filmmakers does not imply either a dictatorial or a complacent attitude to the business of making films. They are respected for a lack of egotism in their approach to their profession. Indeed, as perfectionists, they are highly self-critical and rarely pleased with what they achieve. Typical of this accountability was their refusal to place the blame for the failure of *You're on My Mind* on anyone but themselves. They acknowledge that while the story was admirably suited to their interests, they failed to find the right way to tell it. And while they always set up as far as possible in advance of shooting and reserve the right to call the final shot, they listen carefully to the questions and suggestions of their close-knit team of actors and technicians. Equally they encourage executive producer Bronckart and production partner Freyd to offer their artistic inputs.

The economy of scale that marks the Dardennes' production of fiction films matches the relative lowness of their budgets. *The Promise*, their first film after creating Les Films du Fleuve, was made for €1.6 million, a figure little short of one million less

than for the commercially coproduced *You're on My Mind* four years earlier. Alongside a growing reputation and rising costs have come steadily increasing budgets: *Rosetta*, €1.9 million; *The Son*, €2.6 million; *The Child*, €3.6 million; *The Silence of Lorna*, €4 million; *The Kid with a Bike*, €5.8 million. Nonetheless it is noteworthy that in 2002 *The Son* cost only slightly more than *You're on My Mind* a decade earlier. Luc tells Pascal Edelmann that 'we normally find €1.2 or €1.3 million in our country, one million in France and the rest ... from Eurimages' (2007: 221).

For relatively low-budget productions the duration of their principal photography is quite long reflecting the Dardennes' perfectionism and attention to detail. Shooting time in days remains fairly consistent: *The Promise*, 40 days; *Rosetta*, 56; *The Son*, 64; *The Child*, 61; *The Silence of Lorna*, 60; *The Kid with a Bike*, 55. It rose a little for *The Son* only because of technical problems, so for the other films after *The Promise* its variation has remained within a basic seven-day range.

The Dardennes take a long time over a film – three years as a rule – typically sending themselves up as 'cows' who need to ruminate a lot. They prepare meticulously to shoot a film by devoting much time to scriptwriting, discussion, location scouting and casting. They spend three to four months on location scouting equipped with a video camera to seek out the right visual and aural settings. The only time they have delegated location scouting was for *The Silence of Lorna* and then only because they needed additional time to travel in the Balkans to cast the leading role. Though they work out a script carefully before shooting, everything including the ending depends on the *mise-en-scène* to which changes may be made on the spur of the moment. They use no storyboards and are extremely wary of conventional strategies such as the explanatory establishing shot, the shot/reverse shot and the use of music. Rare instances of music are brief and diegetic, while nondiegetic music occurs only in a single instance at the end of *The Silence of Lorna* and in a short repeated passage in *The Kid with a Bike*. They use direct sound and do not overdub. Dialogue is sparse; they drive their films more by sound and image than by word. Since everything is so well worked out beforehand, they engage in limited editing that is, according to their editor Marie-Hélène Dozo, interviewed by Jacqueline Aubenas, dictated by the rhythm of the narrative, by the characters and by the *mise-en-scène* (2008: 180). They admit that editing is always a difficult stage for them, while staying open to necessary changes in both production and postproduction.

Choosing equally carefully whom they work with, the Dardennes gather around them on each occasion more or less the same small team of actors and technicians. Outsiders are unwelcome to enter the process at any stage, as the brothers prefer privacy during filmmaking to protect an air of mutual confidence and understanding that they strive to engender among their collaborators. They take a long time over casting decisions until they are sure of their choices for parts. They do not base these choices on an actor's professional visibility or technical competence but rather on being convinced that a certain body or face may incarnate a particular character. This fit is so tight that actors' and characters' names occasionally remain the same: Assita Ouedraogo/ Assita in *The Promise*, Olivier Gourmet/Olivier in *The Son*. They prefer to work with a mixture of seasoned actors and young nonprofessionals usually drawn from their own

region (the Albanian actress Arta Dobroshi in the title role of *The Silence of Lorna* is an exception). There is in any case a dearth of teenage professionals in Belgium. They appreciate the willingness of these young actors to throw themselves into a role with a lack of physical self-consciousness. Most of their actors had never appeared in film before, including the highly experienced Gourmet whom they plucked from theatre in Liège. No film by the Dardennes had been planned around an individual actor until *The Son*, in which they developed the character of Olivier around Gourmet. Yet his performance does not call attention to his identity as a professional actor, which is one of the highest compliments it may be paid.

The brothers rehearse their actors exhaustively both in preproduction and during principal photography. These rehearsals include one month on costume tryouts alone. They do not rehearse dialogue, nor do they permit their actors to improvise. On the set they try to create a human tension to match the tension demanded dramatically of a shot or a scene. Aiming to create a certain rhythm, they direct their actors almost exclusively to perform physical actions and they expect the actors to respond exactly. In *The Son*, for instance, when Olivier and his apprentice Francis (Morgan Marinne) run into one another at a hot dog stand, the brothers asked each actor to consume fourteen hot dogs before they put the shot in the can. As Luc states, 'for the camera, the actors are revealers, not constructors' (2005: 106). In this way they recall Robert Bresson, who endlessly rehearsed his nonprofessional actors until their actions became automatic. The action that was not 'thought' was thus the right one to capture on film.[5] The brothers insist on their actors being willing to embody their characters and to relinquish any wish to take up a technical distance from their role. Gourmet remarks that 'the characteristic of the Dardennes' characters is that they *are*' (in Aubenas 2008: 145). Jean-Pierre sums up their rejection of wilful acting: 'we kept saying to [Gourmet in *The Son*], "do less, be neutral"' (in Andrew 2006).

In asking their actors to reveal rather than construct a part, the brothers aim to discover hidden elements of performance over and above original intentions. In *The Son*, for instance, some of the best and most natural acting by Gourmet and Marinne came late on a day of shooting when they were tired and had lost some of their self-discipline. Gourmet was often exhausted by rehearsal alone, remarking wryly that his face is best at 4pm (see Danvers).

Gourmet (Roger) and Jérémie Renier (Igor) remember a difficult atmosphere persisting throughout the shooting of *The Promise*. The brothers were under enormous pressure to succeed once they had redrawn their methods and had decided to work independently of the mainstream film industry. They knew they were staking their future career on *The Promise*, and so the film became a make-or-break venture. The tension on the set was almost unbearable and the weight lifted only after glowing reviews began to appear. Following that experience Gourmet says he understood better both the brothers' need to get everything right and the degree of their perfectionism that is 'occasionally fastidious beyond measure' (in Aubenas 2008: 148). By the time of his central role in *The Son*, Gourmet could speak confidently of being 'on the same wavelength' as the brothers despite their insistence that he take no other acting jobs for two months before the shoot. Staying at home and doing some carpentry, he killed

two birds with one stone by preparing himself conveniently for the role of a woodwork instructor. Gourmet recalls that on this occasion he felt relaxed on the set, even though the brothers remained tense.

The Dardennes insist on filming scenes in chronological order, so that the tension among the characters accumulates steadily until it is released in a cathartic or revealing scene at the end. It is important also to them that their establishment of a narrative rhythm not be disrupted by shooting scenes out of order and having then to rely on the editing stage for a coherent and fluid pattern to emerge. Luc maintains that 'one of the virtues of continuity shooting … is to make appear an ending that has had the entire shooting time to mature' (2005: 188). Their extensive preparation generally eliminates a need for multiple takes; consequently there is little discussion on set. However, they are willing to reshoot as many times as necessary and often at a different pace, so that a shot or scene conveys exactly what they want it to do. And they expect their team to cooperate no matter how arduous the conditions may be. In short, the brothers trust their collaborators but demand as much of them as they do of themselves.

The aforementioned emphasis on filming physical movement reflects the Dardennes' longstanding focus on the expressiveness of the human body, including hair and clothing. They avoid psychological profiling of their characters and never broach this aspect with their actors, preferring to let character develop in the flow of varied physical activity that drives the narrative forward. Likewise, they focus on places and objects that may carry some symbolic value but primarily serve the interest of the narrative. Yet they avoid identifying both interior and exterior settings in order to transcend the limitation of the local and to permit the narrative to establish its own frames of reference.

The Dardennes' filming method relies to a great extent on camera mobility, long takes and tight framing. Regarding the art of framing, Luc cites Bazin on Jean Renoir, who 'understood the true nature of the screen, which is not so much to frame the image but to hide its surroundings… For the most habitual structure of the image in anecdotal and theatrical cinema, a structure inherited at once from theatre and painting, for the plastic and dramatic unity of the "shot", Renoir substitutes the look at once ideal and concrete of his camera (2005: 22)'. Luc extends this premise: 'to go as far as to hide the image itself, to lose the frame in the subject matter, so that the image becomes a subject searching for the frame' (ibid.). Beginning with *The Promise* this method of camera and character in tandem grows more marked in *Rosetta* and *The Son*. In *The Child*, however, we begin to see more instances of the camera pulling back and revealing a greater spatial relationship between characters, a tendency that goes further in *The Silence of Lorna*, which seems to pick up visually from the final two-shot in *The Child* of Bruno (Jérémie Renier) and Sonia (Déborah François) embracing in the prison visiting hall. Moreover, in *The Silence of Lorna* the camera is more stable and the shot compositions are consequently more distanced and observational. This is due partly to the brothers having reduced their camera mobility by adopting 35mm film and partly to a gesture on their part toward the conventional genre film, but above all it is due to their desire for a different texture within the characteristic overall look of their films.

> The serious realism of modern times cannot represent man otherwise than as embedded in a total reality, political, social, and economic, which is concrete and constantly evolving. (Auerbach 1968: 463)

My purpose is not to discuss at length the well rehearsed and ongoing debate on realism in film but rather to illuminate the Dardennes' own distinctive realist style. However, it is worth noting that recent studies of genre, of intertextual and performative strategies, and of varieties of spectatorial experience have recalled into question the whole idea of realism in cinema. Meanwhile, scholars continue to examine realism as both a philosophical concept and an artistic method that goes back to ancient Greece and the nineteenth century respectively. As has been argued in many different ways and especially by thinkers on the left, a progressive realism in art must seek an aesthetic form that responds to the social reality of a particular time or place. The social conditions that give rise to a realist cinema will vary and change; its forms of representation will also change as well. The resulting realisms exist in dynamic and often curious relation to one another. Realism as an artistic method, writes Roy Armes, 'remains only one of the possible means of expression … and in no way constitutes a guarantee of truth' (1986: 17).

Within this broad context I suggest that the Dardennes construct a realism of their own via a personal choice of formal and technical strategies deriving from different types of film practice. This style and their choice of working methods combine to create a cinema that refuses the formulaic and spectacular attributes of Hollywood, Bollywood, or wherever a dominant narrative coding (or 'Institutional Mode of Representation' in Noël Burch's 1973 term) prevails. In doing so their cinema may already be seeding what Fredric Jameson identifies conditionally as the 'function of a new realism' whose disruptive aesthetic reinvents for our postmodern times the modernist emphasis 'on violent renewal of perception in a world in which experience has solidified into a mass of habits and automatisms', a world in thrall to the 'commodity system and the reifying structure of late capitalism' (2007: 212, 213). He further reminds us of a need to distinguish between the idea and practice of realism: its cognitive status as an attitude towards the reality of the world and its methodical status as one of many forms of art. In describing the present reality of the world as 'the emergence in full-blown and definitive form of that ultimate transformation of late monopoly capitalism variously known as the *société de consommation* or as post-industrial society' (2007: 208), he also describes the brothers' filmic world.

I argue for the Dardennes' realist cinema as reimagining a political consciousness suited to these times. One appropriate entry point to their work is to consider how their film practice corresponds in several respects to a tradition of neo-Marxist aesthetics developed from the 1930s onward, notably by Georg Lukács, Bertolt Brecht and Walter Benjamin. All grappled in various ways with the longstanding problem of the artistic value of the artwork in relation to its conditions of production. Far from being archaic from a present perspective, this theoretical tradition is relevant to an

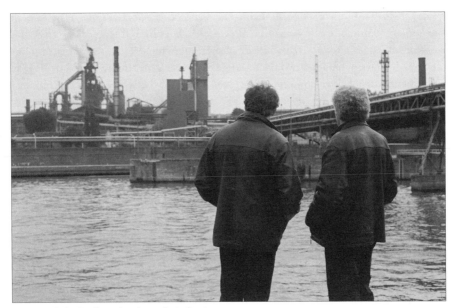

Home turf: the Dardenne brothers take in Seraing.

understanding of the brothers' films, and to invoke it here is to recuperate a side of the debate on realism that predates the influential structuralist and post-structuralist reconfigurations of the term.

Lukács argued for realism as a dynamic form representing the drama of class struggle in its historical movement. In the hands of imaginative and discriminating artists a realist mode transcends the naturalist mode characterised by empirical observation, a pessimistic and deterministic world view, and a murky psychologism. Thus he dismissed the literary movement associated with naturalism despite its 'scientific' concern with the life of the lower classes. From their own contemporary perspective the Dardennes would share his view of a probing, progressive realism as well as his resistance to doctrinal art. We should remember that Lukács also circumspectly dismissed the narrowly mimetic socialist realism sanctioned by Soviet ideology. However, by privileging the form of nineteenth-century bourgeois fiction in his realist model and rejecting the formal experiments of modernism, Lukács's theory remains of limited value in understanding the progressiveness of twentieth-century cultural forms.[6]

In a 1938 article published posthumously (1967) Brecht took issue with Lukács on this limitation, arguing rather for the revolutionary value of popular culture and of modern performative art including the cinema but represented principally in his position by advances in theatrical staging and method. Brecht perceived popular art and realism as 'natural allies' and believed it is necessary for the progressive artist to speak the language of the people.[7] The Dardennes would likely share his view, if it had not proven naively optimistic given the constraints on producing political art within the commoditised culture of late capitalism. Jean-Luc Godard's radical cinema of the late 1960s and 1970s is a prime example of this difficulty. Equally, the brothers would likely recognise his wish to 'cleanse' realism of its essentialist, conventional and nonhis-

torical elements. But while his distancing effect and other self-conscious techniques of disrupting the mimetic text were influential on the Dardennes' documentary work and on *Falsch*, they have reversed this affinity in their subsequent social realist fiction films wherein Brechtian methods would interfere with the direct representation of daily life. Luc affirms 'today's contemporary paradox': to aestheticise reality, art must be de-aestheticised (2005: 70). He might easily have been reflecting on Godard's salutary experience.

Despite being overly optimistic, Benjamin went beyond Brecht by understanding the potential of cinema to exceed theatre as a revolutionary art. In his celebrated 1936 essay 'On the Work of Art in the Age of Mechanical Reproduction', he offers a set of remarkably close analogies to the Dardennes' film practice. Dismissing the idea of viewer identification with an onscreen actor as being trapped within character psychology, Benjamin claims this misplaced identification 'is really … with the camera. Consequently the audience takes the position of the camera; its approach is that of testing' (1979: 230). He argues that in the sight of the camera lens 'the aura that envelops the actor vanishes' and its loss is compensated by the 'artificial build-up of … the cult of the movie star' (1979: 231, 233), a commodity value that the Dardennes also stringently resist. And they would concur with Benjamin's belief that 'by close-ups of the things around us, by focusing on hidden details of familiar objects, by exploring commonplace milieus under the ingenious guidance of the camera, the film, on the one hand, extends our comprehension of the necessities which rule our lives; on the other hand, it manages to assure us of an immense and unexpected field of action' (1979: 238). It is unsurprising that Benjamin, citing Rudolf Arnheim and V. I. Pudovkin, considers – as do the Dardennes – the close relation of props and accessories to the playing of the actor as central to the representative capacity of film. And Benjamin, like the brothers, was fascinated by the significance of ordinary and especially small objects, an idea he took – as Arendt points out in introducing his essays – from Goethe's belief in the existence of archetypal phenomena 'in which … word and thing, idea and experience, would coincide' (1979: 12).[8] By contrast with the painter as a magician, Benjamin likens the cameraman to a surgeon 'penetrating deeply' and boldly into the web of reality (1979: 235). This analogy resembles Luc's description, very apt for a steeltown boy, of the camera 'as a blowtorch … to heat the bodies and objects. To be very close in order to reach a state of incandescence, an intensity that burns, puts one beside oneself, in a state of having access to what would be pure human vibration' (2005: 136).

Informed consistently by an ethico-political consciousness, the Dardennes' major films deal distinctively with subject matter recognisable to most of us – the lives of people living on the socio-economic margin – and represented in a dynamic realist style drawing on a variety of documentary and fictional methods and techniques. This style implies a political vision of the characteristic features of post-industrial life in advanced Western societies. But this vision is no longer of a typical class situation within a historical epoch, as Lukács proposed, though one partial exception in the Dardennes' work may be *The Silence of Lorna*. Insofar as the eponymous character is an eastern European forced to migrate to a western European country in search of work,

we may choose to see the film as typifying the situation of a new 'class' formed by the transnational logic of the late capitalist phase.

Within a generally accepted framework of social realist cinema – however we understand or wish to inflect a category that permits a wide variety of content and form – the Dardennes make what Claire Monk (1999; 2000), writing about British films of the last two decades, calls 'underclass' films. Some of the films Monk identifies are generic (e.g. gangsters, youth subcultures), others concern issues of hyper-masculinity, and many are heavily commoditised to their detriment as politically significant realist texts. All portray marginalised and often brutalised members of what she calls – in opposition to a neoconservative appropriation of the term 'underclass' – a *post*-working-class micro society in the powerful grip of a dominant world order. This late capitalist system now operates on a global scale but shows increasing signs of dysfunction and potential implosion.[9] However, we must pause to ask whether this underclass is either totally new or working class or even a 'class' at all, and we may wonder rather if it is a postmodern return of Marx's dangerous and class-unconscious *lumpenproletariat* (Bruno) with the addition of many unemployed former (Roger) or would-be (Rosetta) members of the traditional wage-labour system. I will return to this question in concluding this chapter.

Given their fusion of social realism and glamourised individualism, Monk states her reservations about films like *Trainspotting* (Danny Boyle, 1996) and *The Full Monty* (Peter Cattaneo, 1997) as pretending to be authentic representations of underclass experience. The Dardennes' films also show the lives of disempowered individuals belonging to this subordinate social class, but their own contemporary style eschews fashionable imagery, fetishised sex or violence and a suspect triumphalism based on the entrepreneurial, consumerist values of a purportedly classless society.

Monk's analysis elsewhere of the role of crime in 1990s British underclass films reveals a context of depressed working-class communities with high unemployment where petty crime, especially theft and drug-dealing, becomes a local survival strategy. This is also true of Igor and Bruno, the respective protagonists of *The Promise* and *The Child*, of the junkie Claudy (Jérémie Renier) in *The Silence of Lorna*, and to an extent of the impressionable youngsters Steve (Jérémie Segard) in *The Child* and Cyril (Thomas Doret) in *The Kid with a Bike*. All resemble the artful dodgers of films like *Shopping* (Paul Anderson, 1994) or *Smalltime* (Shane Meadows, 1997), though these films are more flamboyant, self-conscious and ironic than those of the Dardennes. Monk adds that these British films show many minor crooks coming eventually within the broader reach of organised crime. *The Child* and *The Silence of Lorna* also vividly represent what Monk calls 'increasingly blurred … boundaries between underworld and underclass' (1999: 175).[10] Again we must pause to ask whether this interface is a new phenomenon or an unfortunate postsocialist return of what Luc's university teacher, the Belgian Marxist political economist Ernest Mandel, calls the 'pauperised and lumpenised pre-proletarians, wanderers and waylayers, their qualities and defects quite different from those of the bourgeois or the wage-earner' (1984: 1–2). This menacing mass haunted nineteenth-century European capitals like Paris and London, and Mandel reminds us that the great realist Balzac 'related the rise of professional

criminals to the rise of capitalism and the consequent emergence of unemployment' (1984: 5). This has a disturbingly familiar ring today.

One consequence of the collapse of traditional leftist discourses and grand ideological narratives has been in how realist cinema of the last three decades has represented ordinary people. While Hollywood's dream factory has invariably struggled to represent working-class characters convincingly, even the British cinema, for instance, one with a strong tradition of social realism, has increasingly tended since the 1980s, as Monk argues, to emphasise the spectacular and the personal in portraying working-class or underclass life. Whether we wish still to speak of a working-class population or of their more variegated successors in the 'multitude' that populates the empire of globalised capital described by Michael Hardt and Antonio Negri (2004), we may see in realist films of this period what John Hill calls a 'narrowing down of social space' in which 'the working class is increasingly identified in domestic and familial terms' (2000: 251). Though broader affiliations remain visible if waning in all the Dardennes' fiction films – skilled or unskilled post-industrial working class, rehabilitative and retraining groups, ethnic and immigrant communities – the brothers train their sights on dramas of interpersonal relationships that are microcosmic versions of the agonies at large in the lower social strata. Hence a crisis of memory for all the Jewish family members in *Falsch*; a conflict between a steelworker and his wife in *You're on My Mind*; skewed father/son relationships in *The Promise*, *The Son* and *The Kid with a Bike*; a painful mother/daughter relationship in *Rosetta*; a travestied family unit in *The Child*; and a problematic arranged marriage in *The Silence of Lorna*.

Monk and other critics have pointed to the *hybrid* nature of this new cinema (and television drama) in Britain, which explores intersections between realist aesthetics and the expectations of cinematic melodrama.[11] In films that practise this method a prevalent realism derived from but not restricted to observational naturalism does not preclude the introduction of melodramatic elements albeit in indirect, subdued form. However, if tested against the established conventions and codes of screen melodrama (bourgeois ethos, female centredness, sentimentality, visual excess, and so on), then most of these films remain firmly within a realist vision that has simply accommodated some melodramatic elements in the interest of plot and character development.

Film scholars have broadened the definition of melodrama to such a degree that it now incorporates many elements that seem far removed from the basic notion of a Manichaean drama inciting sympathy and pity or repulsion and contempt for its protagonists, of a spectacle in which good triumphs over evil and desire over circumstance, and of an excessive *mise-en-scène* mirroring the emotional overflow of the narrative. For instance, Jane Gaines (1996) cites as an example Sergei Eisenstein's *Stachka* (*Strike*, 1924) and argues from Marx's theory of contradiction in *Das Kapital* to suggest that melodrama can be a politically progressive form in the way it dramatises dichotomies and contradictions in social and economic life. She adds that feminist critiques of melodrama can identify its appeal to the powerless and the disinherited, that is, exactly to the kind of characters we find in the Dardennes' films.

Within this progressive notion of hybrid realism, Jacqueline Aubenas, for instance, writing about *The Promise* and *The Child*, sees the Dardennes venturing into melo-

dramatic territory 'with all the emotion, surges, and narrative overload implied by the genre ... but by shifting it, by writing it as if it were documentary' (2008: 113). While agreeing that the brothers' films carry an intense emotional charge often associated with melodrama, I would argue that they avoid either identifying excessively with the emotions of their characters or adopting symbolic resolutions in the form of forced endings. By concentrating on their protagonists' everyday physical experiences they embed a social analysis implicitly within their dramas of individual lives. We may tend to read the frequent emotional surfeits in the course of the narrative as 'pure' melodramatic elements when in fact they are understandable if unreasonable responses to situations of extreme duress. There is no insincerity, sentimentality, or straining for effect in such emotional overflows.[12] For example, if we consider the expression of anger, then Maggie, in Loach's *Ladybird, Ladybird* (1993), may be compared to Rosetta. Expressing their admiration for the British director's *Raining Stones* (1993), it seems clear that despite the flow of tears and the symbolic resolution of a wedding, the brothers do not share the opinion of some critics that melodramatic contrivances mar the realism of Loach's work. Jean-Pierre says that 'things seem to happen naturally, as if they were taken from life', while Luc identifies 'several great moments. One is when the man's best friend goes home broke. His daughter comes back with some money, and we understand she has been dealing drugs. He sits in his armchair and cries: he has lost his status, his morale. It's terrible for him as the head of the family. Loach shows human beings with a very strong sense of dignity, and how the working class has been destroyed from within, by poverty and unemployment' (in Johnston 2003).

One major difference between the Dardennes and Loach is that they do not share his preference for a Brechtian distancing of the camera from his characters. Another difference is their studied resistance to narrative exposition whereby they also avoid his tendency (for instance, in *Carla's Song*, 1996) to didactic tone and programmatic construction. And while the Dardennes do not pretend to have either Loach's or Leigh's knack for comedy, Luc similarly admires Leigh's *All or Nothing* (2002): 'the bodies of the actors, heavy, so heavy, so true in their downfalls, their struggles, their wounds, their words that they cannot manage to speak to each other, or to us' (2005: 141).

The Dardennes' own realist form is by no means only comparable to their contemporary counterparts in Britain and elsewhere. As European auteurs, their films owe much in content and form to an auteurist cinematic tradition that includes French poetic realism of the 1930s and especially Italian Neo-Realism of the late 1940s and early 1950s. The poetic realists, like the Dardennes, prefer gritty but more fatalistic portraits of working-class milieux, while formally they anticipate film noir and are more mannered in style than the Dardennes. The brothers are closer to the Neo-Realist tradition in blending a highly observational mode with a distinctive rhetoric of the image to produce an idealist cinema of moral concerns, one whose core values are positive and hopeful, and one that transcends passive representation of social substrata in perpetual struggle against a vicious circle of oppression and frustration. The Dardennes may have long since adandoned overtly leftist filmmaking, but they have covertly relocated their former ideological stance to an ethically modulated humanistic vision

similar to that found in Neo-Realism. Relocating their world view is a key question in understanding their work, one that I also return to in concluding this chapter.[13]

By choosing to film the surface of the world in unadorned detail, but not superficially, the Dardennes invite the spectator to enter a physically and morally charged space. It is via the visceral experience of the spectator that profound human meanings may emerge rather than by an attempt on the part of the directors to graft such meanings onto the film from a comfortable distance. They acknowledge, however, that this can happen only if a film is good enough to succeed in this way. Writing about *Rosetta*, Luc states that 'the film happens elsewhere. We don't know where, but elsewhere. In some place where we descend into the origin of the human being' (2005: 80).

Despite the impecunious, calamitous, and unstable lives of the Dardennes' protagonists, the brothers are by no means miserabilist filmmakers dutifully observing an unjust and coarsened social fabric stained by bankrupt values and coming apart at the seams. They may be social realists from Wallonia but merely to show that 'it's grim down South' is far from their artistic aspiration. They are no longer documentarians, after all. They oppose a dominant ethic of pity that by focusing on the suffering human body creates a victim fetish and invites a melodramatic turn. Their characters may live on the edge and from hand to mouth, but they do not sink into apathy or passivity. This opposition, Luc notes, is 'an act of cinematic resistance' (2005: 37).

The brothers eschew conventional narrative closure and do not flinch from closing in visually and figuratively on their beleaguered characters. Yet they allow the possibility of some kind of redemption, reconciliation, or implicit resolution, even as this possibility is not fully realised within the diegesis of the film. They offer glimmers of hope that their troubled protagonists will emerge from the life crises that beset them and rediscover a sense of responsibility to themselves and to others. But the brothers cannot impose this sense on the narrative via a convenient symbolic resolution. Hence the subjunctive mood of their films: what may be is more important than simply what is. And this mood elevates their films from the descriptive bounds of observational naturalism to the deeper level of a dynamic realism attuned to a vision of hope and of change for the better.

Philosophy and Politics

The brothers want to make films that people sit up and take notice of.
(Olivier Gourmet, in Danvers)

My choice of 'responsible' as a keyword avoids the overly religious connotation of 'redemption' in describing a latent transformation in the lives of the Dardennes' main characters at the end of each major film. At the same time 'responsible' points both to the idea of moral obligation and to that of responding or opening up to another person, one who hitherto may have been perceived as a means to an end, an obstacle, or even an enemy. It is therefore doubly suited to a discussion of some of the ethical questions informing the Dardennes' oeuvre. These questions, especially from *The Promise* onward, have become increasingly prominent in criticism of their films.

A concern with the ethical dimension of their films corresponds to a recent philo-sophical turn in film studies,[14] one that has broadened from its primary interest in the ontology of the image to include matters of moral philosophy.[15] Before looking more closely at these ethical issues, I will consider how we may relate some other philo-sophical ideas to the cinema of the Dardennes.

Daniel Frampton (2006) coins the term 'filmosophy' in the title of a book in which he argues that cinema creates its own 'film-world' as a cousin of reality. Believing that tired debates on the nature of realism have hindered a fresh approach to cinema, he proposes the concept of a thinking 'filmind' that expresses itself as film form in action. He perceives film as an organic intelligence producing its own image of the world and identifies several areas of 'film-thinking' in *The Promise*, *Rosetta*, *The Son* and *The Child*. For those susceptible to these ingenious metaphysics, Frampton's notion of an independent filmic consciousness offers an alternative way of understanding how the Dardennes reject many conventional elements of fiction filmmaking and in so doing create an original realist cinema of their own.

Along similar lines and taking a lead from phenomenology, especially Merleau-Ponty's idea that bodily experience is the true key to knowledge of the world, Vivian Sobchack (1992; 2004) develops the concept of cinematic intersubjectivity whereby film viewer and film text play reversible roles. She suggests that film has a body and that the camera eye represents this body's experience of perceiving the world rather than facilitating a passive contemplation of mimetic images. This view corre-sponds to the Dardennes' effort to film the material world in an active, physical way. Luc describes his cameraman Benoît Dervaux and assistant cameraman Amaury Duquenne as constituting a single 'body-camera' (2005: 175), an idea that also recalls from a different standpoint the structural-psychoanalytical apparatus theory of Christian Metz and Jean-Louis Baudry. Furthermore, Paul Arthur suggests that this physical method engenders a 'corporeal cinema', a Bressonian meta-genre that includes the Dardennes. Emerging during the 1990s and prompted by an awareness of the body in feminism and queer theory, corporeal cinema 'is rooted now in the fertile terrain of realism, in a broad range of formal methods that are applicable to low-budget productions and to films made in developing countries' (2006: 48). In turn, some critics perceive the Dardennes' influence on a vein of recent American independent cinema, three examples of which are Lance Hammer's *Bullet* (2008), about Southern black trailer park life; Courtney Hunt's *Frozen River* (2008), about two poor people, one white and one Native American, and which recalls *The Promise* in its theme of transporting illegal immigrants across borders; and Debra Granik's *Winter's Bone* (2010), about poor whites caught up in methamphetamines in rural Arkansas.

The psychophysical relationship of the individual to his surroundings is an area of investigation initiated by Benjamin in his meditation on Baudelaire and *flânerie* in nineteenth-century Paris. Among contemporary critics, R. D. Crano (2009) anal-yses 'furtive urbanism' in the Dardennes' film narratives by applying Gilles Deleuze and Félix Guattari's idea (from *A Thousand Plateaus*, 2004) of an open and smooth as opposed to a closed and striated spatio-temporal continuum in order to explain

the peculiar way in which the brothers' characters live, move and have their being. This continuum manifests itself in activity that disrupts the established urban order: unbridled, uncontrolled vehicular or pedestrian movements within the urban space along with an occupation of unofficial, unsanctioned, abandoned or marginal locations. Tying this to Deleuze and Guattari's notion of deterritorialisation and invoking Bresson as a model, Crano finds evidence in the Dardennes' films of 'haptic vision' – affective, shifting, indistinct – rather than the clear, cool optical perception of the ordered, established, official urban space (2009: 10–13). The nod to Bresson suggests what Crano calls 'a cinema(tography) of subtraction' capable of producing, as do the Dardennes, an 'affirmationist art' (the term is Alain Badiou's), whereby an event is created from that which lies at the edge of conventional perception and might otherwise be ignored.

Another thinker whose work is useful in considering these modes of urban activity and perception is Marshall Berman (1988), who examines the largely deleterious social effects of roads and their traffic in the modern city from the Paris of Baudelaire's day to contemporary scenes of speed, congestion, intimidation and subdivided land. In turn, he identifies the city dweller whose movements must adapt to this threatening space by way of what Baudelaire called 'leaps and bounds' and 'sudden movements' (1988: 159). In this way these individuals not only protect themselves from harm but turn the situation to their advantage. We might call it a streetwise mobility or a form of urban resistance that is represented powerfully in *Rosetta* and *The Child*. Rosetta and Bruno carry out their personal projects against the grain of the system and regardless of the highway-dominated environment in which they have to operate in order to survive. For Bruno it is more of a choice than for Rosetta. Until his downfall Bruno works the streets smartly – panhandling, embezzling, making deals here and there – on foot, on buses, and on a rented motor scooter. Rosetta feels more constrained by the same space, moving in defensive mode as she hurriedly crosses busy streets, though she too creates her own expedient footpath through woods, a route that both hides her humble domicile from others as she alights from a bus and permits her privately to exchange her city centre jobseeker's shoes for the rubber boots she uses to fish and forage around her caravan-site home.

These broadly phenomenological ideas intersect with ethical issues that the Dardennes raise in their films. Jane Stadtler (2008) invokes Merleau-Ponty's idea that if human perception is embodied, then ethical insight also stems from a vital physical experience of the world. Stadler suggests that ethical awareness in film emerges from the viewer's need to identify with characters by somehow entering their world. The question becomes one of how to enter and to what degree in order to arrive at an ideal or at least optimal point, since over-detaching or over-identifying would lessen or even negate the potential of the ethical transaction.[16] In this respect, Stadtler analyses Gary Oldman's *Nil by Mouth* (1997) as an example of extreme social realism that articulates this ethical mode in the filming of an 'endangered gaze' (the term is Sobchack's). Oldman's style in this film has much in common with that of the Dardennes: unstable, mobile, hand-held camerawork, and limited glimpses of a broader canvas; it differs, however, in its more hysterical employment of zoom shots and focus pulls.

A key figure in any discussion of ethics in the Dardennes' films is Levinas, who pioneered French phenomenology in the 1930s after studying with Husserl and Heidegger. Luc has acknowledged the influence of Levinas on his own thinking about the subject matter of their films, and several scholars have subsequently seized upon this line of enquiry. For Levinas, ethics as the first philosophy counters the primacy of ontology in the Western tradition. Thus the subject is always in an obsessive relation to, in hostage to the other. It is noteworthy that Levinas prefers the word *prochain* ('neighbour' or literally 'the one next to you') to the more impersonal *autrui* ('others'). This radical and undeniable alterity must be acknowledged but cannot be 'said' ontologically, since the notion of the self will always get in its way. The necessary acknowledgement of our responsibility occurs in a face to face encounter with (or, more accurately, in Levinas's language, exposure to) the other.[17] Out of this exposure comes clear knowledge of the impossibility of murder. Yet the face to face is not a perceptible, empirically verifiable experience even if it involves physically facing another person. Rather, it is a kind of epiphany, a revelation that eliminates by its nature any threat of violence to the other.

Responsibility to the other implies a new subjectivity, a transformed identity, one that challenges the supremacy of individual freedom and the imperatives of the self. The Dardennes' major films dramatise this change in their protagonists, but it is a change that implicates the viewer too. Marc-Emmanuel Mélon argues that the brothers invent a Levinasian visual grammar by reversing one of the philosopher's maxims to propose that 'optics is ethics', since 'the optic, that of the camera as much as of the character's gaze, is at the origin of all film and can lead the viewer to have an ethical experience' (2008: 263). Consequently their films, in the view of Jacques Dubois (2008), attempt an extremely difficult integration of the empirical and the transcendental, of the visible and the unseen.

The question of murder, fundamental to Levinasian ethics, arises in every one of the Dardennes' films from *The Promise* onward. Whether the murder, or at least manslaughter, is of oneself (*Rosetta*) or of another (*The Promise, The Son, The Silence of Lorna*), whether it has happened or may yet do so, whether it has been narrowly avoided (*The Kid with a Bike*), whether it is literal or symbolic (*The Child*), it remains a key element in the narrative structure of each film.[18] The possibility or fact of murder precipitates a critical encounter between characters (Igor/Hamidou/Assita; Rosetta/Riquet; Olivier/Francis; Bruno/Sonia; Lorna/Claudy) that may be described as a cinematic equivalent of that which for Levinas can only be at best an approach to the face to face exposure to the other. Though these encounters are typically climactic, they may also occur amid the unfolding of the narrative and may represent various turning points for the characters. Examples of such points are Igor's promise to the dying immigrant Hamidou in *The Promise* and Lorna's unexpected intimacy with the doomed junkie Claudy.

Perhaps the most thoroughgoing application of Levinasian thought to the Dardennes' films has come from Sarah Cooper (2007), whose idea of 'mortal ethics' suggests that the brothers challenge the very being of cinema. Understanding the brothers' penchant for filming physical action in close proximity to the characters as

a form of ethical thinking, she contends that their way out of thinking and speaking – in other words, out of a philosophical trap – is the body whose proximity to the viewer represents a desirable 'ethical point' that discourages the viewer's identification with characters but encourages a mutual recognition of responsibility. The brothers' choices of *mise-en-scène* and camerawork 'speak' ethics without limiting our vision to the conventions of cinematic perception. Cooper indicates how the Dardennes represent the face to face encounter obliquely by physical contortion, as it must be to retain its philosophical validity: Igor and Assita in awkward proximity at the end of *The Promise*; at the end of *Rosetta*, she on the ground looking toward her friend Riquet (Fabrizio Rongione), whom we see only by his outstretched hand; the necks and backs throughout *The Son* as well as the unnerving intimacy of the ultimate struggle between Olivier and Francis in the woods. However, these angular visions grow scarcer in *The Child* and *The Silence of Lorna* where composed frontal or profile shots are more evident.

I remain nonetheless wary of overstating the Levinasian connection especially at the expense of the Dardennes' evolved political consciousness. As I suggest at the end of the documentary chapter, the philosophy of Bloch is in many ways as good a prism through which to view the brothers' ethical refractions as is the thought of Levinas, especially given that Bloch's heterodox Marxist sympathies render his utopian humanism always a political matter. Luc's philosophical references in his diary anyway are eclectic: Hegel, Sartre, Wittgenstein, Aristotle and Kierkegaard are present too. And we should remember that the Dardennes are filmmakers not philosophers, so they accept the possibility of art, whereas Levinas, unlike Bloch, was as sceptical of its role and value as he was of politics. At least the brothers apply the ideas of Levinas to art theory. For instance, regarding the philosopher's idea of the impossibility of killing another human being, Luc argues that art may be a key to the maintenance of this taboo. He is also honest enough to wonder if art has ever saved anyone, while guarding the possibility that it may perhaps do so (2005: 42, 54).

One problem with Levinas is that he was not an astute political thinker. Howard Caygill (2002) describes the political for Levinas as a troubling gap between ontology and ethics. Horrified by fascism and the Holocaust in the 1930s and 1940s, his philosophical ideas grew out of his distaste for the political, which he associated with the evil of war and considered only in relation to the past or the future. His critique of political ontology includes Marxism, while his ethics of alterity goes well beyond Jacobin principle or proletarian solidarity. He believed in mankind ideally as a community of equals but one that was suffering from unequal ethical relations. Yet these relations are those of alterity, which always has a political component whenever the other belongs to a subordinated or disadvantaged group. I would suggest, then, that the influence of Levinasian ethics on the Dardennes extends beyond questions of individual behaviour to constitute a reworking of the political into new contexts of socio-economic otherness.[19]

Leftist thinkers have criticised Levinas for his adherence to an ethics of obligation. Terry Eagleton (2009), for instance, argues that ethics is political rather than personal, that responsibility is not absolute or infinite and must take stock of justice, prudence and realism. Since the social context remains crucial to the ethical relation, this view

rejects the universal moral rule of Kantianism. For Eagleton, the ethics of Levinas is 'inhuman', as it constitutes a meta-ethics that is always at a double remove from human action. Such a transcendent view of the face to face encounter remains vulnerable to criticism of its remoteness,[20] of its being trapped within the duty bound tenets of a neo-Kantian deontology whose beautiful and abstract universality ignores the realities of daily life, social interaction and the physical environment.[21] Eagleton argues that a true politico-ethics must retain its social and historical contexts and cannot, as in Levinas, depend on an unbounded individual experience. He believes that an alternative ethical tradition running from Aristotle through Aquinas to Hegel and Marx is perhaps more pertinent to the dilemmas of the present day. This search for an ethical socialism already underway in the thinking of disaffected pre-World War Two humanist Marxists intensified after the war in the harsh light of Soviet despotism and a correspondingly amoral dialectic. By 1971 even Lukács had concluded the socialist necessity of 'the alternative view of the individual' (cited by Loewenstein 1980: 154). I suggest, then, that we should look as much, if not more, to this tradition than to that of Levinas for evidence of the ethico-political impetus in the cinema of the Dardennes.

While on the subject of heterodox Marxists, we may also see the Dardennes' films as indirectly expressing the ideas of Henri Lefebvre and the Situationists after him: on everyday life and city spaces; on the relations between work and money; and on the loss of a fundamental social bond in the phenomenon of alienated labour.[22] One of Lefebvre's ideas most applicable to the Dardennes' films is that of the dialectical production of space. Mobile populations create representative social spaces by their interaction with peers, state authorities and the physical environment. Though unacknowledged by Crano, this idea would seem to have influenced his concept of 'furtive urbanism' via Deleuze and Guattari. For Lefebvre, in the spirit of early Marx, everyday life always has the potential for individual and collective transformation. We may discern from this principle the tenacious attitude and energetic ingenuity of Igor, Roger, Rosetta, Bruno and Lorna.

From a more recent perspective, the ideas of Etienne Balibar on the European community (2004) and Hardt and Negri on global commonality (2004) identify a need to change established political and economic structures in order to heal social divisions in Western society resulting from the collapse of traditional socialism and the dominance of the late capitalist order. To this end Hardt and Negri's revitalised politics of the multitude envisions a growing cooperation of singular and plural identities. Given that work (or want of it) is a focal point of the Dardennes' films, we may understand the relevance to them of Hardt and Negri's claim that 'all categories of labour are tending toward the condition of mobility and cultural mixture' (2004: 133).

I suggest that underlying the Dardennes' major films is a similar sense that radical socio-economic changes have to occur if the lives of people exemplified by their protagonists are to improve and become fulfilling. The salvation of Igor, Rosetta, Olivier, Francis, Bruno, Lorna and Cyril may lie not only in their moral awakening but also in transforming the conditions that largely determine the choices they and others close to them make in their daily lives. This returns us to Eagleton's revaluation of ethics and

to Hegel for whom, Peter Singer explains, the idea of individual freedom goes beyond the classical liberal definition toward an understanding of '*why* individuals make the choices they do'; Hegel 'saw these choices as often determined by external forces which effectively control us' (2005: 367). At the same time we should remember that Marx countered this determinism by advocating a resistant combination of individual and collective action.

Some orthodox Marxists criticise *The Silence of Lorna* and other films by the Dardennes as being unconvincing, contrived and unsympathetic to their working-class characters. Invoking Marx's belief (stated in *The German Ideology*) that life determines consciousness and not vice versa, David Walsh views the brothers' work as the product of 'discouraged radicals' (2006) who fail to point a finger at the leftist political institutions that have 'abandoned the Belgian working class to the tender mercies of globalised capital' (2008a). Though he praises the worth of the brothers' films in stimulating 'debate and thought', Walsh reproves their avoidance of the 'extenuating circumstances' of their characters and their retreat into 'middle-class sermonising, preaching virtue to the downtrodden' (2008b). However, others of a similar persuasion defend the brothers' cinematic strategy; Jim Wolfreys (2008), for example, writes 'some will see the lack of a broader canvas of class solidarity as a weakness in films like *The Silence of Lorna*, but what kind of weakness is this? The lack of political solutions means that there are no consolations on offer here beyond simple human defiance in the face of the trauma inflicted on individuals by the system.'

David James has lamented the fact that the question of class appeared to be absent from film studies. It has yet to reappear in any substantial way, while various other approaches – psychological, philosophical, multicultural and identitarian – have come to the forefront of film theory. James was particularly concerned that identity politics 'ignored' class background and 'systematically inhibited' (1996: 3) any residual class consciousness or loyalty. Meanwhile, much post-Marxist theory has moved even further from a materialist base. We therefore still lack an appropriate ideological context for situating the Dardennes' films. But here is where we may return usefully to the notion of an underclass within the broader debate on the fate of class relations in contemporary society.

Political scientists and sociologists have subjected class to intense critical scrutiny especially following the collapse of communist societies in Europe. While many would accept that Marx's theory of class no longer applies categorically to the present day, and some may argue that class is either irrelevant, dead, or merely a discursive practice, much evidence remains to suggest that reports of its death have been greatly exaggerated. David Lee and Bryan Turner, for instance, contend that the 'myths of class-lessness' promulgated mainly by neoliberals and postmodernists 'persistently ignore the findings of rigorously conducted research' (1996: 9). This view corresponds to the reality of an underclass represented in the Dardennes' films, of a category referring to the unemployed (Rosetta, Bruno), to a broader disadvantaged group within the unskilled or semi-skilled labour market consisting of non-native undocumented workers (Hamidou, Lorna) but also post-working-class natives (Igor, Francis, Roger) apprenticed or officially unemployed but engaged in 'occupational marginality', and

to those (Cyril in the care of social services, also refugees, asylum seekers and dysfunctional individuals like Rosetta's mother) who are as dependent as the unemployed on the munificence of the state. Olivier, as a skilled tradesman, presents an exception, though he too lives and works close to the social margin. All in some way are victims of the global economic order (the underclass understood *structurally*), while even those choosing their lot (the underclass understood *culturally* or *behaviourally*), such as Bruno, appear to do so in reaction to the constraints of their socio-economic situation.

Marxist critics have also questioned the integrity of the Dardennes' films in their emphasis on life changes precipitated by an acknowledgement of individual failure to respond to the other. For instance, Walsh (2006) perceives the brothers as having 'allowed events to wear down their ideological defenses', and so he finds their films artistically unsatisfying and their idea of a sudden personal regeneration 'simply wrongheaded'. However, I would argue that the Dardennes' singular achievement as social realist filmmakers lies in having understood that while leftist ideology may still be capable of explaining the need for such change, it can no longer provide a blueprint for action. They carefully avoid the pitfalls of a doctrinaire cinema while maintaining an active if oblique political consciousness that continues to bear the traces of their socialist formation. As Jean-Pierre says, 'in the end, the way we depict our characters has something, and at the same time, nothing to do with sociopolitical positions' (in West and West 2003). Moreover, the brothers claim that 'by approaching the margins we can see better what's in the centre' (in Bunbury 2008).

The world the Dardennes depict has changed in many ways from the early 1970s when they launched their career, but the period since then has witnessed a steady replacement of the traditional working class by a resurgent mass of indigent individuals: the poor, the unemployed, immigrants, refugees and various social misfits. No less than in the dispossession of the peasantry and the formation of an urban proletariat during the Industrial Revolution, the reemergence of this underclass has resulted, as its structural theorists argue, from the shifting strategies of international capital and its corresponding political reinforcement. Shaken to the core by the ever increasing demands of capital, the world of the Dardennes' protagonists resembles in many ways that of the nineteenth century in which, as Eric Hobsbawm reminds us, one of the most devastating consequences of pauperisation was that it was both economic and social, bringing about 'the destruction of old ways of life without the substitution of anything the labouring poor could regard as a satisfactory equivalent' (1969: 94).[23] The underclass today remains subject to and exploited by the dictates of a global capitalist system and the state apparatuses that support it. Luc perceives the brutal individual competitiveness of this system as having caused a 'social euthanasia' whereby disadvantaged and marginalised people have been stripped of a meaningful identity (2005: 107).

Despite the Dardennes' resistance to the limiting representation of local landscapes (a lesson harshly learned in *You're on My Mind*), they acknowledge the reality of what Luc calls, in a filmed interview with Frédéric Bonnaud, a landscape of 'empty devastation' formed by boarded-up buildings, factory walls and industrial detritus of various

kinds. But they also see these 'dead zones' as indicative of the contemporary situation, of a certain postmodern condition. Jean-Pierre says that despite this void in which young people especially seem 'lost' and lacking a connection to older generations, these zones within the urban centre, unlike suburban areas, are 'still crossed by a solidarity' that bears the trace of a different past. Jean-Pierre adds that he and his brother remember their home town of Seraing as 'a city of fire ... a working-class fortress', a place of which it was said 'when Seraing sneezes, Belgium is sick'. And despite the changes wrought by deindustrialisation, people still live, move, and have their being there, a reality that recalls Lefebvre and the idea of actively formed urban space.

In his analysis of the Dardennes' oeuvre, Martin O'Shaughnessy (2008) suggests that their major films represent an 'ethics in the ruin of politics'. Here, as in his book on the 'new face of political cinema' in France (2007), he argues that the brothers' films engage with contemporary forms of oppression that have become largely invisible and thus resistant to leftist ideology and to working-class solidarity. Consequently, the struggles of individuals, which can no longer find a clear political corollary, become those in which the fulcrum of change shifts towards an awakening into personal responsibility. This is all well and good, but I suspect its Levinasian allure understates the brothers' consciousness of continuing political oppression, which they embed subtly in the fabric of their films. As Emmanuel d'Autreppe (2008) maintains, their films construct the politics of history, memory and social conscience in another form: that strictly of what the camera shows. I would argue that the Dardennes' films do not suggest a ruined politics so much as the need for a political cinema today to adopt a set of aesthetic strategies that will satisfactorily represent the immense social and cultural transformations wrought by the workings of global capital. And there is a corresponding need for an ethical consciousness to inform and accompany these new political representations.

This assertion does not diminish the drama of ethical crisis as central to the Dardennes' major films. It is reasonable anyway to view the brothers' oeuvre as that of former radicals disillusioned like many others by the failure of leftist politics since the 1980s and more concerned now with the paths of individual lives than with grand revolutionary narratives. However, I believe it would be a mistake to see them as having rejected altogether the political value of cinema. Though they insist they have never been Marxist-Leninists – 'we didn't share the illusions of a proletarian dictatorship' ('Luc et Jean-Pierre Dardenne' 1996–97: 33) – and that their cinema is no longer even sympathetic to classic leftist ideology, we may consider its discourse as remaining broadly and implicitly post-Marxist in the context of contemporary life. 'We try to change things', Luc continues, 'but without mystifying, without believing that cinema will change the world' (1996–97: 56).

Their vision is more than one of moral shortcomings. In the sights and sounds of all their dramas from *You're on My Mind* to *The Kid with a Bike* lies a sense of the devastating social and psychological effects of a postmodern world in which few reassuring certainties remain. This brave new world frames their depiction of ethical dilemmas within personal relationships. The alienation of their characters, to recall a key concept in Marxist theory, is as marked as that experienced formerly by the members of the

traditional working class. As was apparent to the Frankfurt School philosophers, for whom it was one of the few valid remnants of Marxist theory, alienation may now have a very different form – involving vast shifts in socio-economic structure, language, culture and technology – but its disruption of humanity remains profound.

Faced with the challenges of making narrative fiction films about individual lives, the Dardennes have succeeded admirably in marrying the personal and the political in an innovative way. They deftly avoid two limiting extremes of social realist film: the lure of the melodramatic and the imposition of the doctrinaire. Yet somewhere between these poles lies a film style informed by their ethico-political humanism, a style enabling us to understand the plight of their characters and a hope for better to come. Though we are dissuaded from identifying with characters by the detachment of the camera from either our or their point of view, an unsentimental depiction of these characters' emotional and physical lives invites and even obliges us to confront the concrete coordinates of their hardscrabble world.

Notes

1 *The Kid with a Bike* was released after completion of the main parts of this book; but for a concise discussion of the film, see the afterword to this volume.

2 The term *nordiste* ('northernist') describes the cinematic representation of an experience of loss and uncertainty shared by urban and rural populations in parts of northern France and southern Belgium. For discussion of some of these films in relation to the Dardennes, see chapter two.

3 We should note that within a broad realist mode these directors also display an interest in stylisation, theatricality and melodrama.

4 Jean-Pierre, a youthful follower of the Standard Liège football team, discovered Dostoyevsky following an interview with the club's star player Roger Claessen, who had confessed his love of the Russian author. This prompted Jean-Pierre to read Dostoyevsky in order to emulate his sporting hero (see Dargis 2005).

5 See Dardenne (2005: 106); also Bresson (1977: 12).

6 George Bisztray (1978) compares models of realism in Lukács and Maxim Gorky. The early Gorky – before social Darwinism and commitment to the party line took him over – is an interesting figure in relation to the Dardennes. Coming from a background of rural poverty and with a romantic-anarchistic vision, he formulated a model of humanistic, ethical realism in which he stressed the dignity, especially, of manual work (cf. *The Son*) and the heroism of a willingness to work (cf. *Rosetta*). His most famous play, *The Lower Depths* (1902), grimly but sympathetically depicts underclass life on the impoverished edge of Russian society.

7 See Adorno, et al. (2007: 79–85).

8 The idea of the significant insignificant is also taken up by Roland Barthes (1982) as part of his analysis of literary realism.

9 Monk's cinematic analysis corresponds broadly to that of British sociologists (e.g. Peter Townsend) who perceive an underclass in the process of construction leading to an institutionalised situation of those on the bottom rung of the social ladder. This sympathetic view

stands against a cultural theory of the underclass espoused by neoliberal and conservative sociologists such as Charles Murray. This view stresses the non-accountability and dysfunctional value system of underclass members. Out of the same school of thought comes, for instance, the doctor-essayist Theodore Dalrymple (2001), who attacks liberal concepts such as 'relative deprivation' and 'the dispossessed' used by sociologists and criminologists to explain away the self-centred, irresponsible value system of the underclass. This debate applies *mutatis mutandis* to Belgian society; the Dardennes clearly sympathise with a liberal view.

10 Mike Bartlett offers an explicit comparison between the Dardennes and the underclass films of Alan Clarke (e.g. *Scum*, 1979, and *Made in Britain*, 1983) in which Clarke refuses to indulge the viewer and offers a vision that is as critical of the traditional left as it is of the right. Bartlett sees this quality to a lesser extent more recently in the films of Shane Meadows (e.g. *A Room for Romeo Brass*, 1999).

11 See, for example, Samantha Lay (2002). Michael Ryan and Douglas Kellner (1988) made an earlier attempt to open up the discussion of realism in a similar way in respect of American cinema. In contrast to mimetic or spectacular cinema they write of a 'discursive transcoding' of reality, one that freely uses figuration and 'rhetorical operations' to constitute a more provocative 'representational strategy' that may include elements of genres such as melodrama or film noir.

12 In discussing ethics and narrative, the Nigerian author Chris Abani (2009) draws close to the Dardennes' own view by expressing his hope 'to create an art that can catalogue the phenomenon of our nature, all of it, without sentimentality, but rather by leaning into transformation, so as to offer up what Diane Arbus would call the veritable, inevitable or the possible, so that we can all have that terrible but necessary confrontation with all of ourselves. Whatever we feel about specific situations, we must at all costs avoid the sentimental.'

13 For Morando Morandini, lying at the heart of Neo-Realist ideology is 'the positive and generous, if a little generic, desire for a profound renewal of people and society. Hence some have suggested that its base values are humanistic and that it is therefore inaccurate to talk of a Marxist or revolutionary hegemony behind the films. After all, the renewal of people and things is far from socialist transformation, and fraternity is not the same as class solidarity' (1997: 357).

14 Two contrasting approaches have led the ontological study of film. One, coming out of Anglo-American psychology and analytic philosophy, marks the work of scholars such as Noël Carroll, Thomas Wartenberg and Cynthia Freedman. The other, deriving from continental philosophy – representing one of what Jameson calls 'the recurrent neo-Kantian revivals' (2007: 196) – marks the work of scholars such as Gilles Deleuze, Stanley Cavell, Vivian Sobchack and Daniel Frampton.

15 The study of ethics has been slower than other areas in entering philosophical film criticism. However, a growing body of work exists, one example of which is Joseph Kupfer's application of Aristotelian virtue ethics to film (1999).

16 In any case, the idea of viewer identification with character has become highly problematic especially regarding the analysis of classical Hollywood cinema.

17 Its theological origin lies in both Old and New Testaments: 'Thy face, Lord, will I seek' (*Psalms*, 27: 8) referring to the Israelites' attendance at public worship known as 'seeking the face of God'. And in *I Corinthians* 13: 12 we find the famous verse 'for now we see through a glass, darkly; but then face to face: now I know in part; but then shall I know even as also I am known'.

18 The importance of murder explains the brothers' admiration of Woody Allen's *Crimes and Misdemeanours* (1989), a film about a man who kills his mistress to hide their adulterous affair and benefits from his act. This film has attracted considerable attention from philosophical film critics as a darkly comic representation of a moral dilemma.

19 A critique of the ethical turn has begun to appear from within the neo-Kantian, post-Althusserian ranks. One exponent is Jacques Rancière (2010), who argues for an aesthetic regime – marked by a primacy of expressiveness and a coincidence of the known and unknown – over an ethical or representative one in establishing a 'dissensual' art and politics.

20 See, for example, Jacques Derrida (1978). Yet Eagleton criticises Derrida's own ethics for much the same reasons as Derrida does those of Levinas. Nor does Eagleton spare the political left, believing it has failed to recognise the Aristotelian-Hegelian tradition in which the ethical always means the politico-ethical.

21 Robert Legros (2008) offers a Kantian reading of the Dardennes' films.

22 For another take on the mundane and undramatic in film, see Andrew Klevan (2000), who takes his lead from Stanley Cavell's philosophical scepticism. See also Richard Sennett (1998), who criticises the human effects of 'flexible' late capitalism and the widespread disposability of labour. Sennett has also written extensively on urbanism.

23 E. P. Thompson too reminds us that 'in some of the lost causes of the Industrial Revolution we may discover insights into social evils which we have yet to cure' (1964: 13).

Cinematic Reference Points

Our life is our first source of inspiration. (Jean-Pierre Dardenne, in Edelmann [2007: 218])

The Dardennes and Walloon Culture

The Dardenne brothers come from the province of Liège, an important section of a Walloon region that was once the Belgian industrial heartland. Heavy industry dominated much of this region and has had deep and lasting effects upon working life, social relations and the environment. If we accept that the region helped form the Dardennes, we may better appreciate their working partnership and understand the content of their films.

The old regional industrial belt – likened by Ernest Mandel to a line of the Paris Metro and spreading along the dual axes of the Meuse and Sambre rivers – runs almost continuously from around Mons in the west to Verviers in the east and is home to around two-thirds of the Walloon population. The development of the principal industries of coal, steel, textiles, chemicals, ceramics and glass defined the national and international identity of this belt, since Belgium was the second nation after Great Britain to undergo an industrial revolution. That it happened in Wallonia was due to a timely coincidence of abundant natural resources and decisive British entrepreneurial investment in which John Cockerill in 1817 was the key figure. This long industrial history resulted in prosperity for the manufacturing sector as well as a proud tradition of working-class solidarity and militancy. The tradition remained strong until the inexorable decline of the industrial base, most notably in coal and steel, which from the 1970s to the present day has left in its wake a region scarred by large-scale social, economic and environmental problems. What remains of industry today has been hugely downsized. By 2005, for instance, unemployment accounted for almost twenty per cent of the regional population.

Things were very different in the region when Jean-Pierre Dardenne was born on 21 April 1951 in Engis and Luc Dardenne on 10 March 1954 in Awirs. Known for its lime and chemical plants, and once dubbed one of the most polluted places in Europe by no less a figure than Jean-Paul Sartre, Engis is a small town on the northern bank of the River Meuse, adjacent to Seraing, which lies on the southern bank. Formerly home to the giant steel company Cockerill-Sambre, Seraing lies twenty kilometres west of Liège, a fiercely free-spirited city that is the urban centre of eastern Wallonia. The brothers understandably named their production company Les Films du Fleuve (river), since the Meuse has marked their life and work as much as the factories, housing estates, streets and railways that line its banks throughout the area.

The Dardennes have made almost all their documentary and fiction films in the region, of which they are as much the products as are the subjects of most of their films; *faute de mieux* it continues to nourish their artistic imaginations. For Luc, their regional location within a small nation offers them a 'necessary isolation' and enables them to avoid many of the pressures of the international film world. For instance, he finds Krzysztof Kieslowski's French-made *Blue* (1993) disappointing, preferring his Polish films, wondering if he is out of his element elsewhere, and concluding that it is 'difficult for a filmmaker to emigrate' (2005: 27).

The brothers' final documentary is *Regarde Jonathan. Jean Louvet, son oeuvre* (*Look at Jonathan. Jean Louvet, His Work*, 1983). The film, which examines the effect of regional identity and history on leftist author Louvet, begs the question of the Dardennes' own relationship to Walloon society and culture as Belgian federalism continues to reshape the region in the post-industrial era. Following a series of consti-tutional reforms starting in the late 1980s, an increasing devolution of power from the capital Brussels to Wallonia has resulted in a largely autonomous regional government that must address chronic social and economic woes.

Even during the industrial might of the region, the notion of Walloon culture, as distinct from that of mainly francophone Brussels and as diametrically opposed to that of Dutch-speaking Flanders, remained unclear apart from a foundational flourish in the late nineteenth century associated with the rise of Walloon political radicalism. One reason for this weak cultural identity lay in the overweening influ-ence of the French language that Wallonia shares with its national neighbour to the south. Another reason was that French culture in Belgium was concentrated in Brus-sels, now also a self-governing region though geographically in Flanders. Despite a common language and an official French Community of Belgium, the citizens of Wallonia and Brussels lead very different lives and the two regions share little social or cultural identity.

For a long time most Belgians saw Walloon culture as no more than a folkloric phenomenon based on various regional dialects and social rituals. Even a cultural move-ment as innovative as the surrealist group in Hainaut province (1932–45) appeared less a manifestation of Walloon culture than a localised part of an international avant-garde. As industry and agriculture declined in Wallonia, regional economic power and influence in Belgium shifted steadily to Flanders, and the demoralising effects of this loss further weakened an already insecure cultural identity. This situation, which

Louvet describes as one of 'nothingness' and 'stagnation', reached a critical point in the 1970s, as the full implications of the decline became apparent.

Regional intellectuals and artists fought back in the late 1970s. Conscious of a growing need to detach from the unitary Belgian state and from the hegemonic culture of metropolitan Brussels, they sought to forge a stronger identity. An outstanding event was the declaration on 15 September 1983 of a Walloon Manifesto. One of the signatories was Louvet, another was the filmmaker Jean-Jacques Andrien. Louvet explained the idea: 'the social and political struggle has to happen, in Wallonia, by the setting up of a cultural leadership whose task will be to convey an image of Wallonia, an identity of its own, branching out into the entire social fabric' (1991: 52).

At the same time, with greater regional self-determination in the offing, various writers and artists began to seek 'the keys of a new Walloon imaginary' (1991: 53). They generated texts and performances focusing on Walloon society and history including the region's constituent subcultures. An example of this is the Italian immigrant community spawned by a generation that settled in Belgium in the years after World War Two mainly to provide much needed labour in the regional coal industry. In cinema the misfortune of this community faced with growing unemployment was the subject of Paul Meyer's Neo-Realist fiction *Déjà s'envole la fleur maigre* (*From the Branches Drops the Withered Blossom*, 1960), its title taken from a poem by Italian Nobel laureate Salvatore Quasimodo.

We may trace socially conscious Walloon cinema of this kind back to a celebrated documentary, *Misère au Borinage* (*Borinage*, Henri Storck and Joris Ivens, 1933), which portrayed destitute striking coal miners and their families in the area around Mons known as the Borinage at the western end of the industrial corridor. Neither filmmaker came from the region – Storck was a bilingual Fleming, Ivens was Dutch – but their film set an example of politicised cinema for Meyer and others, who emerged with strong regional voices first with the tide of 1960s leftism and later in the disenchanted confusion of the postmodern age.

Among these voices the work of Andrien, Luc de Heusch and Thierry Michel notably connects with that of the Dardennes. Andrien's *Le Grand Paysage d'Alexis Droeven* (*The Wide Horizons of Alexis Droeven*, 1981), set in an area of bitter French/ Dutch language disputes at that time, represents lyrically the devastating collapse of the once prosperous Walloon agricultural sector, while *Australia* (1989) is an international romance unfolding against the fading of the woolen industry in Verviers in eastern Wallonia in the 1950s and 1960s.

De Heusch, who died in 2012, is an important figure in Belgian cultural history. A member of the international artistic group COBRA, he was best known for his art and anthropological films, having co-founded the International Committee of Ethnographic and Sociological Film with Jean Rouch. His only full-length fiction film *Jeudi on chantera comme dimanche* (*Songs on Thursday as Well as on Sunday*, 1967) was produced by his father-in-law Storck and co-written by Hugo Claus, the most renowned Belgian author of the last half-century. Closer to British realist cinema of the 1960s than to much French cinema of that time, the film shatters the consumerist and socially mobile illusions of the decade in its love story of a working-class Liège couple

caught up in a troubled economic situation. Though not from the region (he was born in Brussels), de Heusch deftly foregrounded a Walloon social crisis underway. The film was ahead of its time and may be seen as a forerunner of the Dardennes' work, though it is closer in style to *You're on My Mind* than to the brothers' major films.

Michel, like the Dardennes, began with documentary investigations of regional crisis: *Portrait d'un autoportrait* (*Portrait of a Self-Portrait*, 1973) about a village under the sway of a sugar company; *Pays noir, pays rouge* (*Black Land, Red Land*, 1975) about the coal mining area around Charleroi; and the semi-fictional *Chronique des saisons d'acier* (*Report on the Steel Seasons*, 1980) about the declining steel industry and its social consequences. His interest in portraying this reality in fiction film, again like the Dardennes and slightly ahead of them, culminated in *Hiver 60* (*Winter 60*, 1982), which corresponds to the brothers' own films of 1979–80 on the history of the general strike of 1960–61. Michel has since turned his attention to postcolonial and other non-European subjects.

Since the 1970s other Belgian documentarians and fiction filmmakers, regional natives or not, have addressed the past and present reality of working-class life in Wallonia and the agonies of its heavy industry. They include Manu Simon, Manu Bonmariage, Monique Quintart, Wieslaw Hudon, Jean-Pierre Grombeer, Maurice Rabinowicz, Anne-Marie Etienne, Bénédicte Liénard and Loredana Bianconi.[1] Jean-Claude Riga and Nicole Widart, both associated with Liège local community access television station Canal Emploi,[2] co-directed *Paysage imaginaire* (*Imaginary Land-scape*, 1983), a video documentary on the last major steelworkers' strike in the Liège conurbation, which had just taken place. Made around the time of the Dardennes' equally demythologising *Look at Jonathan*, with which it has a number of similarities in content and form, the film also anticipates *You're on My Mind*, the brothers' retrospective fiction based on the same events. Riga followed with *Ronde de nuit* (*Ring of Night*, 1984), a more detached and rhapsodic depiction of the steelworker's routine.

Following the Dardennes' international breakthrough in 1996, a number of Belgian and French directors have made fiction films comparable to those of the brothers and which have come to represent a distinctive 'northernist' (*nordiste*) cinema marked by its social realist style. Among these directors are Benoît Mariage, Bouli Lanners, Joachim Lafosse and Lucas Belvaux from Belgium; Bruno Dumont, Erick Zonca and Thomas Vincent from France.[3] Their films have drawn critical praise for their idiosyncratic qualities and several have enjoyed a measure of commercial success. The Belgian examples have benefited from an increased public investment in cinema of their region, an initiative that would have been less confidently undertaken without the Dardennes' exemplary reputation. This initiative saw the establishment in 2001 of Wallimage, an investment fund for co-production of films in Wallonia supported by the regional government. Based in Mons, with an annual budget of €5.5 million following the later addition of support from the Brussels region, Wallimage functions as a coordinating hub of the regional audiovisual industry.

We may consider several of these 'northernist' films in relation to the Dardennes' own style and themes. Mariage's *Les Convoyeurs attendent* (*The Carriers Are Waiting*,

1999), stars Benoît Poelvoorde as Roger, *père de famille*, in an echo of *The Promise*.[4] Yet unlike the Dardennes, the director clearly identifies the setting in and around Charleroi. In portraying a small working-class family struggling to better itself materially, the film presents a situation commonly found in the brothers' work, but the resemblances more or less end there. Filmed in limpid black and white, *The Carriers Are Waiting* yields a poetic realism in which the forms of the decaying urban landscape produce a supplementary aesthetic effect, as in certain British realist films such as *Kes* (Ken Loach, 1969) or *The Optimists of Nine Elms* (Anthony Simmons, 1973). Mariage also gestures directly to Albert Lamorisse's *Le Ballon rouge* (*The Red Balloon*, 1955) and to Meyer's *From the Branches Drops the Withered Blossom*, especially in shots of slag heaps towering over old mining towns. By romanticising his realist subject and also making it darkly humourous, the director moves away from *le style Dardenne* and anticipates that of Lanners' *Eldorado* (2008).

Lanners' film, in which he also acts, is a strange and often beautiful road movie that nonetheless adheres to the Dardennes' world in portraying two underclass characters each facing a life crisis and struggling against the odds laid by urban and rural decay. One is Elie, a young junkie who calls to mind Claudy in *The Silence of Lorna*. In an oblique homage on the part of Lanners, the pair's odyssey ends squarely in Dardennes' territory amid the post-industrial landscape of Liège and Seraing. Otherwise the film eschews the brothers' unadorned realism in favour of a hyper/magic realist style recalling the films of Belgian master auteur André Delvaux and showing ordinary people and places in an extraordinary, painterly light.

Lafosse's *Propriété privée* (*Private Property*, 2006) is a bleak open-ended drama of aimless lives with unemployment as an indirect factor. The film makes no concessions to glamour, romance or sentimentality despite the presence of Isabelle Huppert in a leading role. The director's use of a handheld camera, long takes and a grainy image as well as an absence of music further places the film under the sign of the Dardennes. It differs, however, in its wholly rural setting, whereby it represents stagnating life in the Walloon countryside in the manner more of Andrien or Lanners.

Belvaux's *La Raison du plus faible* (*The Law of the Weakest*, 2006) opens with shots of a factory interior and a disused steelworks recalling not only *Rosetta* and *You're on My Mind* but also Aki Kaurismäki's *Tulitikkutehtaan tyttö* (*The Match Factory Girl*, 1990), a favourite film of the Dardennes. Set in Liège, the first part of the film is very much in the Dardennes' mould by revealing the plight of domestically troubled and hopelessly unemployed industrial workers – formerly the 'aristocracy of the working-class' – clinging to a past of tradition and pride. The director slowly turns his film into a conventional heist movie with farcical elements, a revenge tragedy played as a genre film. The band of thieves robs the company that by letting them go had robbed them of their own steadily earned living. In an act of awakened responsibility and of honour among thieves typical of the Dardennes' redeemed protagonists, the professional criminal Marc (played with panache by Belvaux) redistributes their ill-gotten gains to the poor and needy. The film ends in a decidedly non-Dardenne manner with a Hollywood-style rooftop shootout and an aerial tracking shot of the city.

Dumont sets *La Vie de Jésus* (*The Life of Jesus*, 1997) in a small French town and its rural surroundings. Though its graphic sex and violence contrast with the Dardennes' films, it shares with them a blunt view of a jobless community fraught with social and economic problems. It also has a major racial theme, something that the Dardennes have broached only in *The Promise*. Dumont also suggests a latent transformation in the end; the conscience of its main character Freddy appears to have been stirred by a tragedy he has precipitated – as is also the case of François, played by Dardennes' regular Renier, in *Private Property*.

Zonca shot *La Vie rêvée des anges* (*The Dreamlife of Angels*, 1998) in the Lille-Roubaix conurbation, larger but not unlike Liège-Seraing in its atmosphere of bright lights and social gatherings masking an overall drabness. Two working-class girls, Isa and Marie, form a friendship and, rather like Rosetta or Lorna but without their seriousness and determination, struggle to survive on the social margin by way of menial temporary or factory work.

Consistently rooting their own work in the life of their native region, the Dardennes have emerged as the leading exponents of this 'northernist' realism. They are proud of this achievement but firmly resist any attempt to label them as regionalist filmmakers. Even though all their fiction films but one (*Falsch*) have been shot in the Liège-Seraing area, they have been careful to distance themselves from regional politics and its constricting premises. As a result, their dramas of individual lives on the edge of society are not restricted or subsumed by either the spectacle of specific locality or by the totalising tendency of ideological discourse whether it be in the name of leftist politics in general or of Walloon regionalism in particular. Having fallen into this double trap in making *You're on My Mind*, Luc explains that they have since been wary of filming scenery, of showing 'industrial landscapes that smother voices and bodies' (2005: 170). 'In places, faces, bodies, and clothing', he writes, 'we seek a mixture, an indetermination suited to our era' (2005: 55).

Luc admits to being Walloon at heart but believes that to turn sentimental attachment into political belief leads to dangerous forms of nationalism. In any case the brothers see themselves as making films about individuals in universal situations: economic hardship, social disintegration, personal isolation and moral responsibility. They have found no need to go beyond their own area to discover people and conditions that pertain to the chosen themes of their films. In an article entitled 'Lutte' (struggle), referring to individual bodies of the working class as opposed to its collectivity, Luc argues that since the 1950s such individuals have only appeared occasionally in cinema. Now, he continues, 'in the harsh light of economic crisis they are reappearing' in a changed form, no longer bearing the weight of myth, of the identity of factory workers, or of protesters in the streets. Instead, 'they are there on the sidewalks, as many women as men, alone, on the margins. They call themselves the homeless, the young unemployed, the underground, the moonlighters, the refugees from Eastern Europe, from Africa, and from Asia. By filming these excluded bodies, by recording the revolt that keeps them on their feet, by taking them as narrative protagonists, a branch of contemporary cinema tries to speak again to reality' (1995: 90).

With characteristic modesty the Dardennes do not claim to be cinephiles in the sense of having absorbed film culture through youthful exposure to and study of film. Their strict, pious father forbade them as boys to watch either cinema or television, which he considered to be largely the devil's work, though he was quite happy to recount the plots of Jacques Tati's films to them, Tati apparently being of the divine party whether knowingly or not. While in this Miltonic vein, let us note that the brothers often refer to the town of Seraing they knew as youngsters as 'Paradise Lost' and to their films as a constant if inconclusive quest for a 'Paradise Regained'. As a result of their cinematic deprivation they came late to an appreciation of the seventh art. Luc admits that overall he has seen relatively few films but 'fortunately there's the Cinematheque' (in central Brussels) and its screening room. 'Without it', he continues, 'I would never have seen, never have got any impression of Murnau, of Rossellini, of Mizoguchi' (2005: 44).

Beginning their career as documentarians in the mid-1970s, the Dardennes adopted film as an accessible and expedient agitprop tool from their theatrical work with the French militant author Armand Gatti rather than from a fully formed cinematic education. They claim to have known little about the possibilities of cinema and particularly of documentary until their association with Gatti. Several of Gatti's own dramatic films, notably *L'Enclos* (*The Enclosure*, 1960), left a mark on them. Despite this indirect introduction to film, we may situate the brothers within a history of committed documentary cinema going back to Dziga Vertov in the 1920s. Though they speak little of their influences, their documentary practice draws primarily on a French tradition dominated by what Brian Winston describes as 'the impressionistic film essay rather than the sociological public education text in the Grierson mode', a form that nonetheless 'shared that dominance with engaged political work to a greater degree than was true of Britain and America' (1995: 183). As a modern form of economical means and flexible technology, the francophone documentary was developed as *cinéma vérité* in the 1960s by Rouch and Edgar Morin and taken up by filmmakers such as Chris Marker and Marcel Ophüls as well as Godard in some of his later work. *Cinéma vérité*, for Erik Barnouw (1974), is documentary as 'catalyst'; its purposeful and artful provocation of enquiry into a subject fittingly describes the brothers' approach. It is an approach far removed from the less formal style and more detached strategy of direct cinema, its anglophone equivalent.

In locating the Dardennes as social documentarians, the groundbreaking work of the National Film Board of Canada provides a crossover connection between the francophone and anglophone traditions as well as anticipating some of the brothers' own methods. Introduced in 1967, the Board's socially engaged Challenge for Change project encouraged active participation in video work by citizens. Taking their lead from Rouch's practice, project filmmakers developed a protocol of pre-screenings and test screenings for the subjects of their films, 'so that these subjects could both have some influence on the final work and be prepared for what trials exposure might bring' (Winston 1995: 200). The project produced notably the video *VTR St. Jacques* (1969), in which 'residents of St. Jacques, a depressed section of Montreal, were invited to

tell their problems to VTR recorders – manned by volunteers from St. Jacques itself' (Barnouw 1974: 260). Whether or not the Dardennes knew of this film at the time, it offers a clear model for the kind of communal activist approach they employed in their own first documentary project, a systematic recording of local working-class stories, and for their own protocol in subsequent and more reflexive enquiries into the relation of individual testimony to broader issues of politics, history and memory.

One documentarian in the European tradition whose work the brothers particularly admire is the Dutch director Johan Van Der Keuken. It goes further: Van Der Keuken has clearly had as formative an influence on the brothers' fiction films as on their documentaries. In November 1981 Luc participated in a week-long seminar on Van Der Keuken at the INSAS film school in Brussels and contributed an opening essay to a publication of the proceedings. Anticipating many of the brothers' own views on filmmaking, Van Der Keuken spoke of the participatory value of the over-the-shoulder shot, of a destruction of presupposed reality, and of the setting-up of 'a dialogue with the matter at hand' wherein 'we feel a respiration, a rhythm, an internal logic' (1983: 11). For his part, Luc observes in the director's work a 'reversibility of the seer and the seen'; the presence of 'layers of reality that do not appear, that resist being put into images'; an interest in faces 'on which is imprinted the suffering of the uprooted, the excluded, the mutilated, the dispossessed'; and a 'humanism that emanates from [his] films [and] certainly has to do with those shots of faces' whose expression is of resistance to their plight (2005: 4–7).

The brothers' eclectic and catholic taste leads them to reject the oft-drawn distinction between popular and art cinema. For instance, they consider *Rosetta* – a difficult and demanding experience for a viewer, if ever there was one – to be a popular film precisely because its story is simple and may address anyone. It is revealing that classical Hollywood cinema, which would seem to contrast starkly with the brothers' own vision of film, is a key reference point for them, as it was for the French New Wave auteurs of the 1950s and 1960s. Luc mentions that in imagining Bruno and Sonia in *The Child*, he saw Eddie and Jo from Fritz Lang's *You Only Live Once* (1937), and he suggests the *mise-en-scène* of Lang's *Hangmen Also Die* (1943) bore on their conception of *The Silence of Lorna*.[5] Having watched several films by Howard Hawks, Luc admires their 'unique' rhythm, 'as if it were not the rhythm dictated by the story that interested Hawks but something more difficult to film, something that would be more like life itself' (2005: 149).

That Luc should mention his viewing of the films of Roberto Rossellini comes as no surprise, as Italian Neo-Realism and its progeny throw as much light on the brothers' sources of inspiration as do the contemporary practitioners of social realism in France, the United Kingdom and elsewhere.[6] In a 'favourite films' poll conducted in 2005 by the French magazine *Télérama*, the Dardennes chose Rossellini's *Germania, Anna Zero* (*Germany Year Zero*, 1947) as their number one choice followed by F. W. Murnau's *Sunrise* (1927) and John Cassavetes' *The Killing of a Chinese Bookie* (1976).

In 1994, as the brothers were transforming themselves into the creators of a different kind of cinema that would result in *The Promise*, they watched Rossellini's film again. Luc describes it as 'our model', noting especially its 'intensity' and 'cutting edge' (2005:

33). Set in a bombed-out Berlin, this prime example of Neo-Realist 'rubble' cinema depicts the city's inhabitants doing anything, legal or not, to survive in the wake of wartime defeat. Bartering and theft feature prominently in these activities. The film's main character, the teenager Edmund, resembles the Dardennes' young protagonists in living on the edge of society in difficult circumstances. With a rebellious attitude masking an inner despair, the blond Edmund physically resembles Igor in *The Promise*, Francis in *The Son* and Bruno in *The Child*. And Edmund similarly succumbs to moral confusion. Swayed by his former schoolteacher's Aryan ideology, he poisons his invalid father to death, but his consequent guilt drives him to suicide. Further comparisons with the Dardennes include Rossellini's use of an entirely nonprofessional cast, of locations shot in available light, of an elliptical narrative structure, and of a probing camera that often frames the action in uneasy close-up. That the Neo-Realists tended to prefer medium and long shots to close-ups, as Bazin recognised, and that they invited greater sympathy with their characters are but two reasons why we should be careful not to over identify the Dardennes' style with this or any other film school or movement. But there remains much they share especially the recurring theme of a search for human dignity and decency in the daily lives of ordinary people.

Luc mentions how *Sunrise* was constantly in their minds while working on *The Child*. While Murnau's silent melodrama might seem a long stretch to the Dardennes, the final moral awakening of its hero, who has betrayed his wife, is not unlike Bruno's own attempt at reconciliation with Sonia, his girlfriend and mother of his child. Luc goes further: *Sunrise* 'must have some strong hooks in our joint "unconscious", for we talk about it each time we set out on a new film' (2005: 147). As for *The Killing of a Chinese Bookie*, Cassavetes adopts a raw, slice of life approach and uses the 'bad' shot that reveals more than a studied one. Further aspects of Cassavetes' film that the Dardennes will have appreciated are the use of a handheld camera as well as the stripped down action and dialogue wherein apparently insignificant elements contribute to the meaning of the film.

Coming from Belgium, a small country with a limited film industry, the Dardennes have also been likened to the members of the *Dogme* 95 movement that emerged from Denmark in the mid-1990s with a vow of cinematic chastity (natural, simple, direct, resolutely unspectacular) and an awareness of the realities of film production in smaller nations. Though Luc states that at the time they made *The Promise* they were unaware of the existence of *Dogme*, we may nonetheless perceive in both cases a form of cinema emerging from limited means and a corresponding understanding of the concept of creativity under constraint (a phrase borrowed from Norwegian philosopher Jon Elster) whether that constraint be chosen or enforced.

As francophone filmmakers the brothers respond enthusiastically to various auteurs of French cinema. They express a strong liking for the work of two distinctive realists: Maurice Pialat and Robert Guédiguian.[7] And while Bresson is an important figure in understanding the development of the Dardennes' cinema from *You're on My Mind* onward, it is more often others who attribute an affinity to him that is true only in certain respects. While accepting certain things in common – such as portraying a world of corruption, prejudice and injustice that can rarely be changed or overcome –

the brothers now strongly dislike being compared to Bresson, as they feel it obstructs a clear view of their own work. It may be that the Dardennes' protagonists are redeemed in some way at the end – as are Bresson's from *Le Journal d'un curé de campagne* (*Diary of a Country Priest*, 1950) through *Le Procès de Jeanne d'Arc* (*The Trial of Joan of Arc*, 1962) – but there is little sense of Christian grace or salvation unlike in the French director's films. In any case, the protagonists of Bresson's later films – such as the eponymous Mouchette (1968) and Lancelot in *Lancelot du lac* (*Lancelot of the Lake*, 1972), or Yvon in *L'Argent* (*Money*, 1983) – find no redemption, and his vision grows bleaker in a way that is alien to the Dardennes for whom there is always a measure of guarded optimism, of possibility, of escape from an untenable situation. Any redemption in the Dardennes' uncompromising world has to come from their protagonists' own consciousness and choice of action; for them, spiritual intercession is not an option.

The Dardennes share with the French master a meticulous approach to filming that borders on the obsessive, a preference for location shooting and the use of nonprofessional actors, and a sensitivity to the significance of natural sound. They also share his distaste for acting technique, which Bresson deemed fit only for the theatre, which was not a true art in his view; in cinema, however, the will of the actor must be bypassed. Other shared distastes include narrative exposition, theatrical scenery and commercialised visual effects. The brothers, like Bresson, prefer unspectacular but intensely meaningful slices of everyday life and choose detailed images of physicality especially in representing the gestures of domestic and workplace routines. In *Money*, for example, we see Yvon, a fuel delivery man, dressed in overalls rather like Igor, the apprentice mechanic in *The Promise*, or Francis, the carpentry apprentice in *The Son*. And like those of Igor, Francis, Rosetta and Bruno in *The Child*, Yvon's face is at once steely and vulnerable, hard and soft.

In *Money* too Bresson shows his interest in young people as protagonists, though Yvon, initially an innocent victim of circumstance, is ultimately defeated by the chain of events that binds him to crime and punishment. At the end, like Bruno, Yvon confesses his wrongdoings but fails thereby to save himself. Unlike his Bressonian predecessor, Fontaine in *Un Condamné à mort s'est échappé* (*A Man Escaped*, 1956), Yvon is now a condemned murderer with little chance of escape.

Michel, the antihero of Bresson's *Pickpocket* (1959), resembles Bruno in *The Child* in following a life of petty crime that he justifies despite its apparent futility. Style reigns over substance for these young men. The chance to redeem themselves presents itself through the willingness of their girlfriends – Sonia for Bruno, Jeanne for Michel – to love and forgive as, in the final scene of each film, they embrace within the prison where the men are being held.

One of the Dardennes' major aesthetic principles, like Bresson's, is eliminative rather than additive, based on a desire to reduce superfluous elements, to pare to the core of the matter. Rather than relying on establishing shots, they follow his predilection for visual synecdoche whereby partial views employing close-ups of bodies and objects initiate a scene before the camera pulls back to reveal it more fully, if rarely in its entirety. In so doing, they often emphasise hands and faces but strictly to serve an unemotional representation. Despite this process the Dardennes never seem

as remote or hermetically perfect as Bresson; their characters are warmer, livelier and more human than the cool inscrutables of Bresson's world.

Other differences remain. Bresson relies heavily on the art of editing, while the brothers are less interested in this stage of postproduction. Though they share an interest in the rhythmical construction of a film, Bresson's comes more from editing than does theirs, which is more dependent on movement within each shot. The kinesis of the Dardennes' characters matches that of their camera, while Bresson's figures move in and out of fixed frames. His static camera at a constant distance from its object (he worked almost exclusively with a 50mm lens) contrasts boldly with that of the brothers, which is restless and constantly varying its position. Partly as a result of this, their images are closer to documentary realism and far from Bresson's stylised look, one that at times approximates the deliberate artificiality of hyperrealist painting. So we may see the Dardennes as admirers rather than disciples of Bresson.

Among contemporary European auteurs, the Dardennes recognise the influence of Polish director Kieslowski and especially of *Dekalog* (*The Decalogue*, 1988) with its predominant urban realism, its moral imperatives and its deliberately 'bad' camera placements that challenge the conventional relationship between spectator and character. Among gritty directors, they also like the work of Kaurismäki especially *The Match Factory Girl*, the finale of the Finn's 'Proletariat Trilogy'. In this laconic, episodic film the sound of saws and machines in the opening scene brings to mind the factory and workshop scenes at the beginning of *Rosetta* and *The Son* respectively. And the exchange of money – as in *The Promise*, *The Child* and *The Silence of Lorna* – betokens a world where everything is for sale, where everything is reduced to transactions of one kind or another. The factory girl Iris, worn down by her daily grind and bereft of love or support at home, resembles Rosetta. Though she has a job, she has no life, nobody to confide in or grow close to. Yet like Rosetta, she refuses to be crushed by those who discount or reject her, though her solution, which reflects Kaurismäki's interest in deconstructed melodrama, plays out in a very different way from that of the Dardennes' character. Kaurismäki's camerawork is different, as are his black humour and pop cultural references, especially musical – the peculiar Finnish taste for retro rock bringing a touch, *à la* Quentin Tarantino, of surf and rockabilly into the film. While the lyrics of the songs Iris hears on radios, in dancehalls and bars mirror her own situation, an ironic postmodern conceit on the part of the director, they are nonetheless part of the diegesis. This is true also of almost all the rarely-heard music in the Dardennes' films, such as in the café scene in *The Promise* when Igor and his father sing a *karaoke* duet and in *The Silence of Lorna* when Lorna dances with her intended Russian mobster spouse.

The Dardennes also have an affinity with classical Japanese cinema especially that of Akira Kurosawa and Kenji Mizoguchi, as we might expect given the brothers' interest in the theme of awakening human responsibility. The brothers consider Kurosawa's *Nora-inu* (*Stray Dog*, 1949) and Mizoguchi's *Akasen chitai* (*Street of Shame*, 1956) to be among a select few 'formative' films.

Stray Dog resembles *Germany Year Zero* in its blend of noirish overtones – modelled on the police procedural – and documentary-style realism in its 'rubble' theme of an

exhausted and disheartened nation in the wake of wartime defeat. A chain of events, beginning with the theft of his standard issue revolver, precipitates a moral crisis for its hero, Murikami. He begins to empathise with his nemesis, the gangster Yusa, the mad one in the multitude of 'stray dogs' living on the streets and doing anything necessary to survive. In this way he resembles the softened attitude of Lorna to the junkie Claudy in *The Silence of Lorna*, or the teacher/father figure Olivier to the boy killer Francis in *The Son*, or Igor to the immigrant widow Assita in *The Promise*. And when Yusa cries his own remorse at the end, he resembles the jailed Bruno in *The Child* in tears at his visit from Sonia. In immediate postwar Japan, ration cards are bargaining chips as valuable as the computerised chips Bruno and Sonia need to keep their mobile phones connected. Another interesting link is with the work of another Belgian from Liège, Georges Simenon, whom Kurosawa greatly admired. In *Stray Dog* he fails to pull off a thriller in the famous author's polished style, but instead he transcends the generic limitations of Simenon's craft to produce a film that helps usher in his great humanist dramas such as *Rashomon* (1951) and *Ikuru* (1952).

As in the Dardennes' films (especially *The Silence of Lorna*) the themes of financial expediency and exchange of money are central to *Street of Shame*. Mizoguchi neither moralises nor sentimentalises its prostitute characters. Though all five women struggle financially in a cycle of payment and debt, they do what they do to survive, as the money is better than working for nothing at home. The system, a combination of government and employer, is always going to exploit them anyway by cheating them, turning them against one another, or threatening them with no work at all.

There are of course other directors and other films that relate in some way to the Dardennes. I have chosen only some of those most helpful in understanding how the brothers construct a distinctive realist style within the broader parameters of international auteurist cinema. Above all, as the brothers attest in the epigraph to this chapter, it is the everyday reality around them that defines their cinema more than anything else.

Notes

1 For instance, Simon, *Encore une...* (*Another One...*, 1975); Bonmariage, *Du beurre dans les tartines* (*Butter on Our Bread*, 1980); Quintart (with Marie-Hélène Massin), *Et si on se passait de patrons?* (*And If We Did Without Bosses?*, 1978); Hudon, *A chacun son Borinage* (*To Each his Borinage*, 1975); Grombeer, *Wallonie* (1971); Rabinowicz, *Une Femme en fuite* (*Woman on the Run*, 1982); Etienne, *Impasse de la vignette* (*One Summer After Another*, 1990). Liénard's *Une Part du ciel* (*A Piece of Sky*, 2002) echoes *Rosetta* in depicting working-class women resisting enclosure in factory and prison. Bianconi, the daughter of an Italian immigrant, has followed Meyer's depiction of the Italian mining community in the Borinage with the semi-fictional *La Mina* (1989) and the feature *Comme un air de retour* (*Tomorrow Will Be Better*, 1994). Given the Albanian slant of *The Silence of Lorna*, we should note her documentary *En Albanie* (*In Albania*, 2009). For further discussion of a socially conscious Walloon cinema emerging until 1980, see Chantal Van Den Heuvel (1982).

2 For the importance of these television stations to the Dardennes' early career, see chapter three.

3 An example of Vincent's work is *Karnaval* (1999), shot in Dunkirk.

4 Poelvoorde is best known for his role as a charismatic hit man in *C'est arrivé près de chez vous* (*Man Bites Dog*, 1992), a mock documentary directed by Remy Belvaux, André Bonzel and Poelvoorde himself.

5 Luc also devotes a diary entry to his admiration of *Rancho Notorious* (1952) (2005: 131).

6 For instance, the brothers express a particular liking for Pier Paolo Pasolini's *Accatone* (1961) and for two films by Nanni Moretti: *Bianca* (1984) and *Il Stanza del figlio* (*The Son's Room*, 2001).

7 For instance, Pialat's *Passe ton bac d'abord* (*Graduate First*, 1979), *A nos amours* (*To Our Loves*, 1983) and his television mini-series *La Maison des bois* (*The House of the Woods*, 1971); Guédiguian's *L'Argent fait le bonheur* (*Money Makes for Happiness*, 1993).

The Video Documentaries, 1974–83

In the Beginning Was the Resistance; The Nightingale's Song; When Léon M's Boat First Sailed down the River Meuse; For the War to End, the Walls Had to Crumble; R... No Longer Answers; Lessons from a University on the Fly; Look at Jonathan

Jean-Pierre and Luc Dardenne grew up in a middle-class family within a larger work-ing-class community. Their father, Lucien, was head of industrial design at Dumont-Wauthier, a huge chemical plant that for a long time was the economic lifeblood of Engis and with which most of the townspeople were associated in one way or another. Despite an often fraught relationship between father and sons, Luc acknowledges that Lucien imbued in them a sense of moral obligation, so that in a way he is present in all their films. And cultural life was by no means excluded from the Dardenne household; their mother Marie-José was a part-time operetta singer.

The two brothers went to school in Seraing, travelling daily on local trains, which they remember in stark contrast to today as being packed with schoolchildren and workers of all kinds. Luc went on to study literature at the University of Liège and took courses in political economy with Ernest Mandel. Jean-Pierre chose to study theatre in Brussels at the Institut des Arts de Diffusion (IAD), a leading francophone arts and mass communication school. Neither brother graduated from these institu-tions, but at IAD in 1969, in the heady days of leftist rebellion, Jean-Pierre fell in with Armand Gatti. This meeting proved decisive in the birth of the brothers' artistic career. A survivor of World War Two concentration camps, Gatti had proceeded, under the influence of Brecht and of his own experiences with Ché Guevara and other guerilla revolutionaries, to explore the potential of militant socialist theatre.

In 1973 Luc lost interest in his university studies, though he later took a degree in philosophy from the University of Louvain-la-Neuve. He joined his brother in Gatti's theatrical troupe and together they participated in a number of his projects, such as *The Durutti Column* and *Adelin's Ark*, which were performed at various locations across Wallonia. Gatti had also made political films since 1960, and it was by association with him that the brothers grew interested in filmmaking, sharing their leader's view that as in the agitprop tradition of Vertov and other Soviet filmmakers of the 1920s there was as much political potential in the production and exhibition of films as in the staging

of live theatrical performances. Gatti taught the brothers how to make video films, and from him they also learned the value of demystifying technique and of working single-mindedly from one's own convictions regardless of available means.

In the early 1970s the new technology of video was perceived to have an extraordinary potential for political use because of the relative inexpensiveness and simplicity of the filmmaking equipment. Using half-inch reel-to-reel tape, the Sony Portapak, introduced in 1968, featured rudimentary in-camera editing and immediate playback. It liberated filmmakers further from dependence on a complex, costly and lengthy industrial process than had lightweight cameras and portable tape recorders in the Anglo-American direct cinema and European *cinéma vérité* documentaries of the 1960s. Video put the means of film production readily and conveniently in the hands of anyone with a desire and a will to do it. For many aspiring filmmakers video offered an ideal preparation or even a substitute for the cinema.

On leaving Gatti's troupe in 1974, the Dardennes worked for several months in a cement factory and on the construction of a nuclear power site in order to raise enough money to buy a Portapak. With this equipment they spent the next few years making politically driven videos. Their first achievement was a series of grant-aided 'interventionist' films, *Au commencement était la résistance* (*In the Beginning Was the Resistance*), investigating the history and conditions of working-class life in and around Liège. Commissioned by the Maison de la Culture in the town of Huy on the Meuse down river from Liège, these videos consisted of unedited testimonies of unionists and strikers at various industrial plants, who were interviewed at home on housing estates in Engis and Seraing. With Jean-Pierre filming and Luc recording the sound, they gathered one hundred testimonies covering the period from 1936 to the General Strike of 1960–61 and its aftermath. According to the militant agenda that spawned them, the finished films were screened to the same people who were their subjects, on the principle that the local community would then share and own a comprehensive documentation of its history and identity. The films could also circulate freely within the community as a stimulus to friendship, solidarity, political consciousness and further action.

It was fortunate for the Dardennes that Belgium was one of the first European nations to embrace the possibilities of a video culture; Vidéoption, a short-lived federation of video groups, existed as early as 1973. Furthermore, industrial Wallonia happened to be a precocious centre of video production. One reason for this was that Liège especially was home to a large community of artists interested in exploring video in a grand cinematic tradition of artists' films. Another reason, more relevant to the Dardennes' own intervention, was a strong social and ethnographic documentary tradition in Belgian cinema boosted in the 1970s by the advent of video. This tradition looked back notably to the work of Henri Storck and Joris Ivens in revealing the extent of poverty among Walloon coal miners in *Borinage*. In this sense, the Dardennes are spiritual heirs both of their own national tradition and of an international radical cinema born in the 1920s and 1930s. Their activity on a local level recalls the projects of the Workers' Film and Photo Leagues that flourished briefly in North America and Europe during the 1930s.

With a Marxist education deeply engrained in them by Gatti, especially the belief that politics and art are closely intertwined, the Dardennes decided to enlarge their documentary vision beyond the mere recording of testimony as functional activism to a more structured interrogation of the relations between politics, history and memory. Their six subsequent films variously utilise the documentary modes identified by Richard Kilborn and John Izod (1997) as *interactive*, by which subject and filmmaker acknowledge each other's presence, and *reflexive*, by which the process of filmmaking is opened in varying degrees to the viewer's gaze. The Dardennes were among the first Belgian documentarians to employ these progressive modes, which were pioneered by Rouch and other exponents of European *cinéma vérité* in the 1960s and had evolved from the more basic *expository* or *observational* modes. All of these modes have been widely theorised.[1] This phase of the brothers' career began with *Le Chant du rossignol. Sept voix, sept visages de résistants. Une ville: Liège et sa banlieue* (*The Nightingale's Song. Seven Voices, Seven Faces of Resisters. One City: Liège and Its Surroundings*, 1978) and ended with *Look at Jonathan* in 1983. These six films searchingly investigate relations between ideology, history and personal experience. They remain dialectical exercises but emphasise the stories of individuals rather than those of a group or class, exploring the effect upon private lives of public transformations: war, revolution and exile; new directions in mass communication; a collapsed industrial base; a broadening fissure in the social fabric; and a replacement of social democratic consensus into an aggressive neoliberalism that grew forcibly in the 1980s and spawned our uncertain postmodern world. Befitting their interactive and reflexive forms, the films also address corresponding issues of aesthetics, mediation and artistic licence.

The Dardennes' post-agitprop documentary output coincides with the first part of what Philippe Dubois (1990) describes as a golden age of Belgian video between 1978 and 1986. Dubois considers the brothers, along with video artist Jacques-Louis Nyst (working out of the Liège Fine Arts Academy) and social documentarian Jean-Claude Riga, to be the outstanding exponents of the genre at that time. One key factor in this wave of creative video in Wallonia was the emergence and consolidation of television stations interested in commissioning, producing and screening video art and documentaries. Proponents of this cultural project in conglomerated broadcast video (*vidéo-animation*) saw in it the potential of a challenging body of work with broader reach and appeal than the rawboned militant video form exemplified by the Dardennes' first efforts. One institutional channel with regional stations was RTBF, the national public French-language broadcaster, whose groundbreaking showcase programme *Vidéographie* (1976–86) was the first of its kind in Europe. From 1978 RTBF entered video production on its own. Another key factor was the formation of a chain of twelve local community access stations (TVL/C) by the Ministry of the French Community with the intention of giving vision and voice to the populace. The densely penetrative cable networks in Belgium since 1966 reinforced this initiative. Several local stations, such as Canal-Emploi in Liège and Antenne-Centre in La Louvière, proved to be important sites of video exhibition. The ministry pronounced a policy of support of video production for television via a system of agreements with filmmakers. This system proved instrumental in initiating the second phase of the

Dardennes' documentary work by offering them greater creative freedom and a clear incentive to make films that would reach a broader and less specialised audience.

Questioned by Frédérick Pelletier (2002) on their relation to commissions for television films, Jean-Pierre replies that they did not consider themselves either as television programme makers, which would have implied a different methodology and mode of address, or as exponents of video as an autonomous medium, which would have placed them among artists of the form. Their relation was thus a basic one of convenient production and exhibition of their films.[2] Luc acknowledges that perhaps they were already searching consciously for their own cinema via a timely opportunity to broadcast their work. The medium of television nonetheless presented very different conditions of reception: each of their discrete filmic texts had to fit within a sequential flow of programming and was viewed domestically on low-definition small-screen receivers by an audience relatively indifferent to the authorial identity and status of its creators. The brothers' relationship to this audience – 'strange and very, very abstract', Luc tells Pelletier – also differed greatly from that of their cinema in that the percentage figures yielded by the Audimat, a television rating device installed in selected households, gave them little sense of how many people saw their films. Luc adds that the paucity of television criticism and of contact with its practitioners – unless one had the stature of a Godard – served to exacerbate this highly impersonal situation.

In any case, the phenomenon of *vidéo-animation* in Belgium had all but run its course by the end of the 1970s and the community television network had duly lost much of its audience. Belgian social documentarians including the Dardennes began consequently to rethink their practices along more sophisticated and less ideologically determined lines. A major stimulus was RTBF's 1977 screening of Godard's episodic *Six fois deux: sur et sous la communication* (*Six Times Two: On and Beneath Communication*, 1976), an innovative and influential video critique of, among other things, political cinema and documentary aesthetics. The establishment in 1980 in Brussels and Wallonia of a network of workshops with ministerial support further encouraged this progressive turn. Though the Dardennes would eventually leave video documentary for the fresh pastures of cinematic fiction, the establishment in 1975 and official sanctioning in 1977 of their filmmaking collective Dérives (the name 'Drifters' taken from Situationist philosophy and from the pervasive influence of the River Meuse) proved influential in generating increased state grant aid and served as an exemplary model for the newly emerging workshops.

Luc has described their video years as a phase of apprenticeship, and we may see elements of an original film style developing in the six documentaries they made before essaying the fiction film. However, much of *In the Beginning Was the Resistance* has not survived, while even *The Nightingale's Song*, which was shot in black and white on half-inch tape, contains sections damaged beyond repair despite a DVD transfer that has fortunately preserved most of the film.

According to Luc, he and Jean-Pierre 'wanted to tell stories worthy of being told because effectively they contain that element we call utopian, but not in the sense of a result, of that which will come to realise utopia, rather in the sense of something that, at a given moment, escaped from that toward which the "normal" course of things

would have tended; people – sometimes in groups, sometimes as individuals – do things, speak words that break the context, the determination of context' ('*Luc et Jean-Pierre Dardenne*' 1996–97: 39). Thus the brothers began to chart their own 'trajectory', a term they took from Gatti while simultaneously detaching themselves from reliance on his views and methods. This trajectory required that their witnesses be totally free to express themselves without obligation to any political position. The brothers understood the danger of constructing individual narratives within a discourse that no longer corresponded either to present experience or to the process of commemorating idealistic and courageous acts. Present and past constantly interact in their revised documentary practice, creating an open dialectic of actuality and memory that is free of ideological demands.

Out of a huge mass of material constituting *In the Beginning Was the Resistance* came three separate documentaries: *The Nightingale's Song*; *Lorsque le bateau de Léon M. descendit la Meuse pour la première fois* (*When Leon M.'s Boat First Sailed Down the River Meuse*, 1979); and *Pour que la guerre s'achève, les murs devaient s'écrouler* [aka *Le Journal*] (*For the War to End, the Walls Had to Crumble [The Paper]*, 1980).

The Nightingale's Song

The title of *The Nightingale's Song*, whose lyrical ring shows Gatti's influence, comes from a poem loosely remembered by the Dardennes in which the nightingale, once it has been disturbed, must change its location in order to continue singing its unchanging song. The witnesses inhabit a new space – that of the profilmic event – in which to 'sing' their memories unbound by the trauma of the past. In a manner that follows the radical departure from conventional documentary witnessing initiated by Marcel Ophüls' *Le Chagrin et la pitié* (*The Sorrow and the Pity*, 1970), six men and one woman tell of their clandestine operations in the Belgian Resistance during World War Two: sabotage, armed struggle, union activity and underground publication.

The Walloon Resistance movement, which started in Charleroi and spread to Liège and other areas, continued until liberation in 1945. The witnesses recall a 'doctrinal' struggle to combat the German occupation and to avoid working for the benefit of the occupiers. Some resisters were syndicalists, some communists and others independent. All agreed, however, on a need to risk 'more violent action than in the period from the 1921 strike to 1940'. There are several references to the Spanish Civil War especially as some of the witnesses – 'tenacious folk', says one – had served the republican cause as members of the International Brigade. Furthermore, two witnesses describe surviving Nazi concentration camps.

The film was first screened in Liège to an audience of seventy in a vaulted cellar that functioned as Les Grignoux, an alternative cultural centre. This organisation remains active and has, for example, been instrumental in the recent construction of a new cinema in the centre of the city. At that first screening was the late Jean-Paul Tréfois, the creator of *Vidéographie* for RTBF, which showed parts of it on the programme.

In each of their documentaries the Dardennes attempt a progressive form that articulates the shifts in their own ideological and aesthetic positions. We may see this

Interactive documentary: *The Nightingale's Song*, 1978

process already under way in the relatively simple *The Nightingale's Song*. Accompanied by powerful piano music, the establishing shot of an industrial landscape localises the film in the Liège area. Subsequent shots of a tape recorder and a television monitor that are reprised at the end give us to understand the brothers' wish to create a documentary that is both interactive and reflexive. They also use expository conventions, such as a female narrator in voice-over introducing various witnesses during over-the-shoulder shots of one of the brothers preparing to conduct an interview. This medium shot serves as a visual model for the subsequent interview sequences, while the voice-over narration and the use of titles help to contextualise the discourse of the witnesses. The brothers also carefully distinguish between narrator and interviewer, thus deflecting their own dominant role in the interpretive process. However, the narration shifts at one point to a male voice-over perhaps in order to offset the authoritative threat of a univocal narration. At the same time, by placing themselves as interviewers in the frame with their subjects, the brothers acknowledge implicitly a shared resistant history born of the communal experience of their native region. The use of ordinary locations for the interviews, such as living rooms and back gardens, bolsters this sense of commonality.

As the Dardennes cut to close-ups of objects on a table, of handheld photos and documents, we begin to see how they choose to embed their enquiry in the material world by using specific objects as powerful emblems of their subjects' enunciations and of the active value of commemoration. The narrator speaks of the potential of these objects to be something other than a 'mausoleum' of past struggles.

Filmed also in places specific to their resistance, the witnesses recall the details of their activity, which included sabotage of industrial production and of transportation lines. These extant places function dynamically in relation to the spoken testimonies by allowing a re-enactive element to enter the commemorative act. One female witness, who was involved in lodging and nursing resisters as well as in transporting weapons, describes a dangerous journey she undertook to Brussels with guns in her suitcase. Unlike in France, there was no *maquis* or central Resistance organisation, so the testimony draws attention to the bravery of associates who offered shelter in safe houses. The city of Liège was divided into sectors for purposes of operational logic. However, to protect the network of helpers, the resisters' orders never stated a name or a full address – all was coded. These helpers included young and old of both sexes. Clandestine newspapers (a theme that became the main subject of the brothers' next documentary but one) encouraged active and passive resistance as well as informing people of what was being done.

Much of the Resistance work involved maintaining a Liège-Charleroi network against deportation. Of the two witnesses – one male, one female – who were sent to concentration camps, the man tells of going to Buchenwald. As he speaks, we see shots of the river and hear industrial sirens that serve to juxtapose wartime memories with familiar sights and sounds. Such shots of the river and its industrial background return after each testimony, as if to draw the successive testimonies together as vital parts of a whole anchored in the reality of the local landscape. The woman recalls her lack of fear, even on her arrest and deportation to Ravensbrück. Her remembrance is less of herself than of another woman whom we see in a photograph and who did not return (a fate shared by the witness's husband and one son) and of that woman's effort to save children from the gas chambers.

Though *The Nightingale's Song* stays broadly within the conventions of the talking-head documentary, it is a thoughtful, moving and artfully constructed film that demonstrates a step forward in the Dardennes' use of video to construct a meaningful text around compositional, editorial and narrative choices.

When Léon M's Boat First Sailed Down the River Meuse

The second film in an unofficial trilogy drawn from their initial workers' movement project, *When Léon M's Boat...* shows the Dardennes blending personal and collective histories in a more sophisticated and poetic manner. Though again made in black and white on half-inch videotape, the more professional look and sound of this film is due largely to its grant-aided production by Dérives for *Vidéographie*. The brothers also venture further into the reflexive mode; for instance, they introduce the film by offering background information on its genesis and on the Dérives collective.

Léon Masy, the subject of the film, his last name not fully stated in order to stress the commonality of his experience as well as to protect his privacy, was involved in the 1960–61 general strike that paralysed Belgium for two months and on which Michel based his fictional *Winter 60*. To some extent the Dardennes' film is about how that strike may be remembered. The launching of Léon's boat is the catalyst for a lyrical

meditation on the relationships between memory, place and the fate of a militant working class.

An establishing shot of churning water immediately suggests the theme of turbulence as central to this film and calls our attention to its metaphorical function. A more conventional long shot of Léon's boat cues the Dardennes' voice-over introduction of his upbringing, his training as an engineer at the Seraing Technical College, his apprenticeship to a garage, and his many years working as a skilled mechanic at the Cockerill steel plant. The company eventually sidelined him to an isolated job monitoring water flow in the foundry. Discouraged, he quit and decided to devote himself to boatbuilding instead. His ingrained know-how and continuing work ethic bear fruit in the boat that he has built in retirement, but his knowledge – and that of the Dardennes – balks at the prospect of the future.

The opening shot of liquid turbulence returns intercut with archival footage of the strike, with scenes of Léon revisiting sites of protest and resistance – such as the Place St. Lambert, the central square of Liège, still under lengthy reconstruction at the time of this film – and with a scene of his boat undertaking its maiden voyage downriver. The piercing shriek of the boat's whistle alternates with the sound of a factory siren: one is new, the other has largely vanished, but neither bears any guarantee of permanence. Like the churning water and the siren, the whistle represents a stirring statement of intent but also a warning of obstacles ahead. In this way it is reminiscent of workers' leader André Renard's call to the 1960 strikers in St. Lambert to lay down their tools but also to recognise that the unions, which opposed the decision to strike, no longer represented the will of the people.

The archival material comes from a radical documentary *Vechten voor onze rechten* (*Fighting for Our Rights*, 1962) by the Flemish filmmaker Frans Buyens, from the daily newspaper *La Wallonie*, and from a collection of the history of the Walloon regionalist movement. This archival footage shows key sites: steelworks, collieries, streets, squares and buildings. We see Liège's occupied main railway station where marchers gathered before moving on to protest at the office of a hostile newspaper. We see exterior night footage of rail sabotage, an act which forty years later causes a witness revisiting the site to wear a disguising hat and keep his back to the camera. We learn of the strength of the 1960 strike in the revelation that every single business was shut down apart from food stores to allow people the necessities of physical sustenance. And we hear a wife's testimony; as in the wartime resistance story of *The Nightingale's Song*, women were vitally involved in the strike.

In keeping with the Dardennes' wish to allow their subjects to speak freely for themselves, Léon tells his own story, while the brothers along with several of Léon's former colleagues offer a meditative counterpoint in the form of a voice-over narration addressing the past and speculating on the future of the militant tradition. Luc wryly interjects that the lyrical tone of their narration was also linked to their heavy ingestion of 'medications' while under twenty-four hour postproduction pressure to deliver the film to RTBF in time for its scheduled transmission (2005: 34). Even though each witness speaks as an individual remembering a shared past, together they convey a strong sense of their former solidarity. Shots of the boat, of seagulls (the bird of utopia)

Reliving the strike: *When Léon M's Boat First Sailed Down the River Meuse*, 1979

and of the river contribute symbolically to the questioning of the future in the light of a glorious but compromised radicalism that is fading into the past, trailing in the wake of the boat as it makes its present voyage. Unchanging in their appearance and motion, what may the river and gulls tell us? The boat, symbol of a forward movement, of a new journey, may have an answer to these questions.

The voyage of Léon's boat represents an exorcism of political ghosts. In making progress of a different kind within a familiar landscape, the boat carries its navigator in search of a new destiny. Where will it sail and what will the voyage accomplish? In shots reminiscent of Vertov's *Chelovek s Kinoapparatom* (*Man With a Movie Camera*, 1929) we see the circularity of waves in motion, factory wheels, truck wheels and the boat's wheel. Will the circle be unbroken? Shots of water pounding beneath the boat recall the forcefulness of the strike but now suggest its free passage in the context of pleasurable spare-time adventure. What was once a journey of critical struggle is being undertaken in a relative limbo of retirement. The value and meaning of work, and the fight to protect it, has been leisurely transformed.

The film also questions the conventional recording of testimony. The Dardennes set this testimony in a dramatic-poetic context in order to offset any tendency to revert to a dogmatic or predictable discourse that no longer resonates in a post-industrial void. Thus they seek to transcend the limitations of the militant video form in which they had begun their filmmaking career. The forward drive of the narrative corresponds directly to the movement of Léon and his boat towards an unknown destination, while

the hermeneutic field of the film contains a series of recurrent images at once local and universal, literal and symbolic in their meanings.

The film's interactive and reflexive documentary modes permit the Dardennes to question both Léon *and* themselves on how to review what happened in 1960. One shot shows the brothers at an editing table working with archival footage. What do those images mean when they are selected for use in a commemorative montage? Similarly, there is a shot of the Seraing steelworks seen through the boat's bridge window, as if framed by a screen and thus already removed into the realm of archival imagery. The loop of memory and representation implicates subject and filmmaker alike; both are products of the same regional history. Léon M., the skilled industrial worker and radical activist turned master boat builder, prepares at ease to discover a new world, new circumstances and new encounters. This ironic play on utopian idealism is how the Dardennes choose to remember political militancy and to ponder its fate in an age that threatens to bury it in the past. In this respect, as Jacqueline Aubenas suggests, the brothers' gaze is 'not that of Karl Marx but of Ernst Bloch' (2008: 23). However, it is one of a re-envisioned Bloch whose radical utopianism embraces the role of the more recent past in shaping the present and a possible future.

Is Léon's voyage symbolically a final disorientation of the old revolutionary discourse or a return to insurrection, a rebirth of the militant spirit in a new age? The boat carrying this embodied spirit-memory down the Meuse may or may not escape the bounds of industrial geography to discover new vistas. As the narrator asks, will the boat sail so far only to make a turn for home? Will it get stuck in the locks? Or will it follow the gull whose wings point towards the shores of utopia? The ending of the film supposes the calm after a storm but also confirms that the answers to these hypothetical questions may have to wait for new knowledge to be gained.

For the War to End, the Walls Had to Crumble

The third documentary to materialise from the workers' movement video project, *For the War to End, the Walls Had to Crumble*, bears another Gatti-influenced title, with biblical associations of Joshua, who in the words of the popular song, 'fit the battle of Jericho and the walls came tumbling down'. The Dardennes shifted from the use of half-inch to three-quarter inch professional quality U-Matic videotape and from black and white to colour. Though the editing remained a simple matter of cuts and shot assembly, their use of U-Matic represented a small technical progression and reflected the greater means available to them in a co-production between Dérives, RTBF and the Fleur Maigre Cooperative. The brothers enlarged their film unit to include a cameraman, a sound engineer, two sound mixers and an editor. They resorted again to the film archives of Buyens, a director as committed as themselves to leftist commemorative projects and to film as instrumental in promoting social and intellectual change.

For the War to End… follows the two previous films in presenting a memory of collective action as a set of individual voices. Some of these individuals cope with the weight of that history more philosophically than others. By showing the tension between memory and history, the film demystifies the former militant activity and the

Edmond G. recalls his clandestine activities: *For the War to End, the Walls Had to Crumble*, 1980

documentary project itself. In this respect the film indirectly invokes some of Godard's experimental video work of the 1970s with Anne-Marie Miéville as well as the work of Chris Marker, notably *Le Fond de l'air est rouge* (*The Base of the Air is Red*, 1977), a compilation film tracing the fortunes of international leftist politics from 1967 to 1970.

The protagonist of *For the War to End...* is Edmond G., a former electrical and blast furnace worker at the Cockerill steel plant in Seraing who, from 1961 to 1969, participated in the production and distribution of *La Voix ouvrière* (*The Workers' Voice*), an underground newspaper that circulated within the factory. He was dismissed from his job following his journalistic activities. The brothers had interviewed him for their first video project and came upon him again when he was reduced to panhandling at the main rail station in Liège. Now, twenty years later, he revisits the sites that precipitated his clandestine operation – the plant itself and those of the 1960 strike – and retraces the strategic, logistical and physical steps taken by himself and his collaborators as they produced and distributed their publication.

His story parallels that of Léon M. but with the important difference that Edmond agrees to re-enact seven times for the Dardennes' camera his daily ritual of walking the perimeter of the plant. This multiple circumambulation refers again to the biblical story of Joshua, who won the battle of Jericho on the seventh day of its siege by commanding his army to shout down the city walls after having circled them seven times.[3] Edmond's symbolic 'shout' is the voice of the newspaper that tried to bring down

the local industrial establishment. His habitual return to the historic location reveals him as less free of his former political commitment than Léon, who puts his experience and energy instead into the task of boat building. Yet Léon's optimistic journey by boat into an unknown future reconnects him symbolically with the purposeful idealism of the 1960 militants, while Edmond – prefiguring Rosetta's obsessive routine – spends his time walking in circles, endlessly retreading the mill, seemingly unable to remove himself from the overwhelming and ghostly presence of the derelict steelworks.

True to the reflexive mode, the film suggests three possible starting points: a set of titles in red, or a blend of past and present images, or the testimony of a witness. The witness is Edmond; in a tracking shot alongside the industrial site, he recounts the 1960 march through Seraing and the decision to regroup after the strike and to produce a paper. Anchored by Edmond's narration and his commemorative materials, the Dardennes establish a dialectical tension between then and now, between archival image and profilmic event. By this method they keep questioning the play of memory as an activator of present action and future intention. Lateral tracking shots emphasise the continuity of the physical space; it remains as before, but the times have changed. How can memory therefore be useful here and now?

The red-lettered title shot occurs about ten minutes into the film, by which time the viewer has had an opportunity to register the spatio-temporal coordinates of the text. We see haunting shots of the deserted steelworks where the only sound is of bird song and the only occupant is a cat 'listening' to the history lesson we are being offered. Matching shots of continuing steel production in certain places indicate that the industry is not completely dead but on life support. This combination of shots proves that the film is no exercise in nostalgia for what has disappeared. Rather, it focuses our attention on what remains and encourages us to ask how private and public spheres may still interact. Ironically, the main steelworks site is now considered to be a part of the Walloon industrial heritage and is potentially open as a tourist attraction. We sense that Edmond would be a perfect if partial guide.

We visit another key site in recounting the story: Edmond's house where he and his comrades wrote the newspaper and coordinated its distribution. The table from 1960 remains in use for reading, writing and playing chess – a curious reminder of how inanimate objects resist change and may become valuable repositories of memory. Edmond's chess matches with his friends symbolise the strategy and tactics of the struggle they undertook. They believed that their paper communicated information better than did the union at a time when a radical sector of the work force was preparing itself for another strike after the union had conceded ground won in 1960–61. To enhance its appeal to the workers, the paper included satirical columns, poems and songs. But as the threat of unemployment loomed larger over the steelworks, the dream of a second general strike faded along with the paper, to be replaced by discouragement and fatigue.

By persuading Edmond to re-enact his early morning distribution of the newspaper at various points around the steelworks, the Dardennes employ another progressive documentary method: the dramatic reconstruction of events. They use a variant of this method, since Edmond is not a professional actor (though this need not be the

case) and in any case performs this ritual of his own free will on each day of his life. At one point we hear Jean-Pierre telling Edmond that they need another take, and this seemingly random moment problematises the entire reconstructive process. How exactly does the process function as a documentary act and what may it achieve? By adopting the interactive mode the brothers enter into a sustained dialogue with their subjects and thus remain aware of the power relations inherent in the interview format, as Michel Foucault has shown in his analysis of the secularised confessional mode in Western culture (1980: 57–67). The brothers further implicate themselves in the documentary process by inserting into the final cut the additional take of Edmond's reenactment and the time code of the videotape.

In a lengthy sequence Edmond explains the history of several years that were filled with 'harassment' yet were also 'the most exhilarating of our lives', years in which – recalling the words of Léon M. and his friends – there was a 'real climate of fraternity'. He explains his disguise in cap and raincoat as a way of avoiding detection while distributing the paper. We 'go back' with him to Seraing at five in the morning when the day shift began, a time for the paper's agents to appear at various factory doors. He describes the whole operation in metaphors of war, and his account is followed by a montage of violent sounds: sirens, guns, explosions, telecommunication signals and machine noise. At this point the Dardennes recapture the *élan* of Soviet agitprop film.

Edmond regularly meets his co-editors Arthur and Henri in a café. We see one of them playing an organ at home to evoke his memory of the experience; like Léon M., he has released himself more than Edmond from the grip of the past. For the film, Edmond and his fellow editors regroup to walk around the walls again, mobilised in one more return to a site now occupied only by the cat, who cannot answer their questions about the meaning of the finally locked factory gates. The film ends with Edmond – coffee thermos in hand, still wearing the same hat and jacket as he did more than a decade earlier – leaving his home to drive to 'work' in a poignant travesty of a routine that is now a palimpsest traced on a site of ruin. In a long shot we observe his car passing under a bridge in the distance. The landscape has barely changed; the times have, dramatically. Has Edmond changed too, and how? The shot fades to an empty frame of reference, a black hole of memory.

* * *

The Dardennes sensed a need to make these three films, since few had spoken of the acts of the Resistance, or of 1960, or of the secret newspaper. They wished these voices to be heard for the sake of historical documentation and to the benefit of an enquiry into changes wrought by the passing of time as well as into the fate of active resistance. Avoiding the lures of revolutionary myth and triumphalist discourse – one reason why Buyens' *Fighting for Our Rights* was less credible and less useful two decades later – the brothers respected the integrity of their subjects' testimonies by allowing them to tell the story of their own struggles against oppression.

Despite a limited audience at the time, these films 'halfway between poetic essay and militant cinema' represent, writes Marc-Emmanuel Mélon, 'a decisive turning-point in the history of the documentary in Belgium' in their movement from a transparent observational approach to an interactive one whose 'theatricalisation of witnesses' guarantees an authentic discourse (1999: 148).

Before making another documentary, the Dardennes joined forces with Gatti once more by co-producing his fiction feature *Nous étions tous des noms d'arbres* (*We Were All Names of Trees* aka *The Writing on the Wall*, 1981) shot in Northern Ireland and Belgium. Luc was first assistant editor and Jean-Pierre was first assistant cameraman; each also played a British soldier in crowd scenes. Gatti praised their perseverance and dedication to the task, and he considers these qualities to have contributed much to their emergence as major filmmakers. He used only three professional actors, another example to the brothers for whom the tough thirteen-week shoot was a steep but valuable learning curve ahead of their own adventures in fiction. In their documentary work and in *Falsch* they acknowledge their debt to Gatti especially in his method of recalling the past to confront the present. But they also knew they needed to break away from his sphere of influence, to cut filial ties in a search for their own artistic identity, and thereby to transcend both documentary form and ideological fixation.

R… No Longer Answers

R… ne répond plus (*R… No Longer Answers*, 1981), about the free radio movement, continues the Dardennes' sceptical view of the gap between idealism and contemporary social reality. Though they again employ the interactive and reflexive modes, this documentary no longer focuses on individuals remembering their own experiences. The focus rather is on current spokespersons for the free radio movement that bloomed internationally in the early 1980s as a result of governmental deregulation of the airwaves and of dissatisfaction with an increasingly bland broadcasting establishment. The brothers relinquish their own voice-over narration leaving the stage to seven individuals, known as 'Les K' ('Kafka' is a fitting allusion), whose disjointed and paradoxical discourse links the various scenes.

As in *For the War to End…*, the brothers received production support for *R… No Longer Answers* from a state-funded organisation, the Centre Bruxellois de l'Audiovisuel (CBA), established in 1978 in Brussels. The CBA was followed in 1980 by Wallonie Image Production (WIP) based in Liège. These production workshops still function as umbrella organisations for numerous companies such as Dérives, which appeared after 1980 beneath the WIP banner. The creation of the workshops enabled Belgian documentarians to develop the use of higher-end video and to forge new collaborative understandings with television companies in the heightened competitiveness of the 1980s media market. Again the brothers chose to work in colour and with three-quarter inch professional quality U-Matic videotape. The higher level of overall support enabled them to extend their unit to include a camera assistant, two sound assistants and an assistant director, René Begon. They now had a small and dedicated technical team as they edged closer to the challenge of making fiction films.

R... No Longer Answers looks at the activities of seven free radio stations in Belgium, Germany, Italy, Switzerland and France and assesses how valuable and effective these initiatives have been. A first wave of free radio came in the late 1970s and a second in the early 1980s. We may see this movement as a successor to the alternative broadcasting and narrowcasting initiatives of the 1960s and 1970s such as offshore pirate radio stations and citizens' band frequencies. An interview with an Italian free radio provider suggests that the movement was partly an attempt to counter a dominant television that had led to the qualitative downgrading of radio. Following the legalisation of French free radio in 1982, most of the other countries where it had operated followed suit and it was largely assimilated into established broadcasting systems.

The Dardennes concentrate on the present in this documentary, while remembering implicitly the history of broadcasting as a series of technological and conceptual advances. In this case the present seems to yield less than the past. 'R...' ('reality', 'radio', 'receiver') no longer answers. In the 1980s – a decade of ideologically-driven individualism and social dislocation – the 'reality' of most citizens no longer responds to the growing noise of established radio, yet the alternative voice of free radio finds itself muted, isolated, losing contact and finally going off the air. There is a pervasive sense of a babble in which 'real' programming is at a premium. Free radio risks becoming much the same as established radio or even television (a decade later, on the 1992 album *Human Touch*, Bruce Springsteen would sing of '57 channels and nothin' on'). As the film ends, shots of drawings of empty studio space suggest a blueprint, a project under construction. But we are left with no more than a simulacrum. 'Reality' appears to have gone elsewhere.

As in their two previous films, the Dardennes question a liberationist myth that reveals itself in the present as politically naïve and practically ineffective. By the brothers' own admission it is a more pessimistic and disillusioned film than either *When Léon M's Boat* or *For the War to End...*, since the free radio movement of the 1980s suffers from a greater gap being opened between its ideology and the technology used to communicate it. Free radio can do little else than appeal to a presumed listener discontent with available programming and to a sense of collective solidarity based on dated *shibboleths* (liberation, love, rebellion, guerilla counterculture) of post-1968 revolutionary politics. On hearing the slogan 'free radios were born because the mass media no longer knew how to make love', we sense some old wine being poured into new bottles. The film suggests that free radio fails as a radical social and cultural initiative as long as it retains an outmoded discourse. No matter how liberating – at least by the standards of 1980 – the mobile technology and independent identity of free radio may seem to be, there is no denying the odds against its success given the power of the commercial mainstream media as opposed to its limited reach and influence. The free stations reject this mainstream yet must also solicit advertisers in order to finance themselves. To make more radio available to the listener in a democratic and communal spirit is laudable but insufficient, and it may create even more indifferent babble that will culminate in frustrated silence.

An establishing shot introduces a man in his workshop speaking of free radio as primarily a political act. Mobile and portable, it is also a tactical act practiced by

Free radio: *R … No Longer Answers*, 1981

pedestrians, bicyclists, automobile drivers and passengers on trains. For some of these practitioners free radio appears to be akin to a religious mission. In one scene a man climbs to a hilltop in a snowstorm in order to operate a transmitter. It is as if he seeks symbolically to plant a cross on the peak. The scene also symbolises the effort to make oneself heard through a blanket of white noise/snow. Shots of steeples seen from the hilltop further connect with the former communicative power and authority of the church.

Free radio draws to some extent on cross-border cooperation, but there is an equal emphasis on the local and regional as sites of contestation especially for minority languages and dialects. For instance, one station broadcasts both in French and in the Alsatian-German dialect. An interesting parallel between this film and *For the War to End…* is the use of free radio by an anti-nuclear pressure group in need of information that they believe will not be forthcoming from the established media. This reminds us of Edmond and his colleagues seeking to disseminate the 'truth' to their fellow steel workers via an underground newspaper in the absence of reliable information from both company management and union leadership. A further similarity is the necessarily secretive nature of these illegal operations. In Zurich, for instance, participants in free radio are interviewed with their backs to the camera or in silhouette in a standard gesture of trust and discretion on the part of the documentarian.

In its uneasy blend of sound and silence, the film's Godardian style captures the sporadic and vulnerable life of free radios – a form of mass communication prone to breakdowns, raids and suppressions as well as to eventual takeovers by established

broadcasting companies. Let us remember that by the 1980s countercultural capitalism as an economic micro system was nothing new.

R… No Longer Answers presents a repetitive pattern of images and sounds that suggests, as does the (hi)story of *For the War to End…*, a vicious circle of determined yet ultimately futile action. The film seems to lack the structural balance of other documentaries by the Dardennes, yet perhaps it has to be as confused and uncertain in linking its various parts as are the free radio practitioners themselves in the face of rapid technical, economic and political changes.

Lessons from a University on the Fly

In *Leçons d'une université volante* (*Lessons from a University on the Fly*, 1982), a film reminiscent of *The Nightingale's Song*, the Dardennes revert to the unearthing of past experiences in the context of present political realities. They also revert to a simpler interactive mode built around the testimony of a series of witnesses in conventional interview situations. They used BVU (Broadcast Video U-Matic) for the first time, as it offered better colour resolution and less surface noise, and made the entire film themselves without a crew despite production support from the CBA and Médiaform workshops.

The film consists of five nine-minute episodes and was shown immediately after the evening newscast on RTBF-Liège. A group of Polish immigrants to Belgium tell of their geographical origins and their decisions to leave Poland for the Liège area at various times from the 1930s to the 1980s for reasons as various as Nazism, communism, anti-Semitism and the recent national upheaval. Jean-Pierre says that 'our idea was to show how this ultranationalist country had been a land not of refuge but of exile from the first departures in the 1930s to the present day' ('*Luc et Jean-Pierre Dardenne*' 1996–97: 82). Once again the brothers felt obliged to respond to 'reality', to represent the memory of exile from a native land proud of its national identity. What renders this set of testimonies dramatic is its filming at the time of the Solidarity movement's intervention in Polish national life and the subsequent *coup d'état* of 1981, a historic event recognised as the first major step toward the dismantling of the Iron Curtain and the democratisation of central and eastern Europe.

The title of the film refers to the late nineteenth-century underground educational networks that resumed in the late 1970s during the germination of Solidarity. The phrase 'on the fly' also plays on the act of flight under duress from a native land and harks back to the itinerant consciousness-raising practiced by Gatti during the brothers' membership of his troupe.

Each episode begins identically with a shot of the Solidarity logo on an abstract painterly background followed by a superimposed montage: a still photograph of a railway locomotive; shots of tanks in Budapest in 1956, Prague in 1968, Kabul in 1979 and present-day Warsaw; and a map of the USSR followed by one of Poland. The iconic image of the train traces a progression from the revolutionary ideals of Bolshevik agitprop to the international enforcement of Soviet authority and to the nascent reemergence of Poland as a sovereign state freed of its dependence on the

Soviet bloc. This introductory montage of images carries a voice-over narration: 'That is a locomotive. In Stalin's language, it is the locomotive of the revolution, his chief engineers Khrushchev and Brezhnev.'

In 'Lesson 1' four witnesses introduce themselves. Two were born in Poland, the other two in Belgium as descendants of immigrant miners whose presence in the Walloon coalfields dates back to the 1920s. They discuss the Solidarity leader Lech Walesa and the international support given to his movement. The interview takes place in a room where the witnesses sit around a table covered with a newspaper and a large map of Europe. A voice-over interpreter puts their statements into French. The brothers intervene little in these interviews, placing their emphasis on maps, documents and graphic materials that locate the act of remembrance in specific histories and geographies and that offer a set of visual correlatives to the oral discourse of memory.

'Lesson 2' begins with a close-up of a record player as we hear music coming from it. The camera pulls back to reveal a young Jewish immigrant with the European map from the previous episode spread out on the bed in his lodgings. A 1968 refugee from Lodz, the young man, a drama student, recounts 'ten years of struggle against everything that surrounded him' especially an upsurge of anti-Semitism. His double pain is of political and religious exile. Almost the entire interview consists of a static shot of the man narrating his story with occasional cuts to the map and to the disc on the turntable. The episode closes with the end of a Yiddish song on the disc.

Another single witness, an older man, also contemplates the map in 'Lesson 3'. He had been active in the peasant resistance and came to Belgium in May 1945 to escape the threat of communism. In his new surroundings he worked for *Narodowiec*, a Polish-language daily newspaper. He displays a variety of *samizdat* publications, while the distinctive sound of a manual typewriter accompanies his testimony. As in *The Nightingale's Song*, the role of women in this movement was important; the episode ends with a still photograph of a woman also formerly active in peasant politics but now interned with her husband. The witness is one who got away.

'Lesson 4' returns us to the group in 'Lesson 1'. They listen pensively, sadly and at times indignantly to a broadcast by Radio Warsaw coming in and out of a transistor radio. This radio, in close-up, is instrumental in connecting the historic events unfolding elsewhere with the personal histories of these representative *émigré* Poles sitting in a room in Belgium. They comment wryly on the reactionary tone of the official discourse, which had finally allowed some truth to emerge from a thirty-year period of carefully censored speech. The episode closes with the end of the news broadcast and the radio is switched off. As in *R … No Longer Answers*, silence takes over and the future remains unclear.

In 'Lesson 5' we meet a man who came from Wroclaw to Liège in 1957 at the invitation of his sister. He worked at the Cheratte colliery until its closure in 1977. Since then he has been involved in folkloric associations, in Polish choirs, and in teaching the Polish language to adults in evening classes. We see him standing by a blackboard on which he has chalked a short, anonymous four-line poem of which the last two lines read 'Each nation has its motherland/Only Poland is in its tomb'. We learn that the Catholic Church became a sanctuary for the Polish language, as at

first German then Russian was insisted upon in every official situation. After 1948 all foreign languages other than Russian were suppressed. The episode ends with the man reciting the poem.

Though *Lessons…* may seem to be a minor achievement by the Dardennes amid the development of their more sophisticated documentary work, its theme remains important to their later fiction films, notably *The Promise* and *The Silence of Lorna* which both deal with migration, in the former partially and in the latter exclusively from former Soviet bloc countries. In *Lessons…* the brothers display their deepening understanding of transnational movement, of its corresponding identity problems, and of the conditions of exile and refuge that deeply mark those two later films.

Look at Jonathan

The Dardennes' final documentary, *Look at Jonathan*, re-focuses on an individual, in this case a well-known cultural figure in Wallonia, the left-wing playwright Jean Louvet around whom the brothers reopen their enquiry into the work of memory and the fate of revolutionary activism. By also revealing the brothers' continuing interest in theatre from their time with Gatti, the film looks forward three years to *Falsch*, an adaptation of a play by another Belgian francophone writer, René Kalisky.

Look at Jonathan, again made in colour on U-Matic BVU, was co-produced by Dérives, WIP, No-Télé in Tournai and RTBF in collaboration with three regional cultural centres, and received grant aid from the Ministry of the French Community of Belgium. These production details illustrate an advantageous situation for documentary filmmakers in Belgium at the time: a joint venture between the brothers' own production collective, an overarching Walloon production workshop, a local access television station, a national public broadcaster and community organisations – all beneficiaries of state and regional support in the form of subsidies and grants. The film's production values were higher than before, a slightly larger crew was used, and the soundtrack contains music excerpted from works by Ravel, Stockhausen, Krzysztof Penderecki and Marius Constant.

The Dardennes first met Louvet while researching an unfinished project on four generations of workers in La Louvière, a central Walloon industrial town known for its political radicalism and for being a focal point of the surrealist movement in Hainaut province in the 1930s and 1940s. Louvet, who founded the Proletarian Theatre in La Louvière, had written a play entitled *Conversation en Wallonie* (*Conversation in Wallonia*, 1978), which traces thirty years in the life of Jonathan, a coal miner's son who has become a schoolteacher. Jonathan questions his origins and ponders the fate of the working-class community that formed him and above which he has raised himself. The father/son conflict between Jonathan and his father Grégoire anticipates those in *Falsch* between Jakob and Joseph, in *The Promise* between Roger and Igor, and in *The Son* between Olivier and Francis, his substitute son.

On seeing Louvet's play in Liège, the Dardennes found that its theme corresponded to their own investigations of the past as understood through the work of memory. The film presented them with an opportunity to extend this enquiry by examining

Shadow boxing: *Look at Jonathan*, 1983

Jean Louvet, writer in a video age: *Look at Jonathan*, 1983

the political past in the context of a literary career. Despite his reputation as a public figure of political and artistic conviction, Louvet felt that his voice had been 'stolen' from him by the changing times and that he needed somehow to recover it. His testimony operates on two levels via his interview speech and his dialogue from the play, in which Jonathan functions as his alter ego. The film benefits from re-enacted excerpts of the play performed inside a derelict warehouse in Chaudfontaine, outside Liège. By filming in this bleak setting, the brothers add more poignancy to an already distanced and fragmented dramatic script. The play of memory in the film abuts in disjointed language, in awkward silences, in a sense of entrapment and impotence symbolised by shots of a lone boxer urgently striking at shadows in a ring and at the end on a deserted station platform.

Louvet's story moves from fullness to emptiness, from radical commitment to serious doubt in the present climate of rust belt depression, collapse of traditional communal values, loss of faith in a socialist utopia and late capitalist triumphalism. In this world few heroes remain among many ghosts of a more certain past. In his interview he acknowledges that his literary work, principally in the theatre, has evolved from a traditional to a 'modern' Marxist vision in order to remain effective. This revised work must account for discourses of the body, love, desire and death operating within

the 'radical democratic imaginary' of post-Marxist theory. Jonathan's dialogue with his dead father becomes, in the apt formulation of Jacques Dubois, 'Freud questioning Marx and asking him to account for himself' (1997: 254). Answering his mother, who rejects her husband's story, Jonathan asserts that 'it's normal for a son to follow his father's work', but it is equally clear that the bond between successive generations of the Walloon working class no longer exists any more than does the old guarantee of work in a tightly protected workplace. By recognising these changed circumstances, Louvet has turned his back on 'fables'; his literary language must now represent the 'heart-rending flashes' of a personal voice. He speaks of a 'return to the subject' by moving away from objective ideological goals towards the unpredictable imperatives of the self. The grand narrative of the proletarian revolution has ended in an empty boxing ring, in a discombobulated text, in a succession of cries in the dark.

The title of the film 'looks' two ways, playing on the meanings of *regarder* as 'to look at' and 'to consider', inviting us to observe Jonathan/Louvet in action and at the same time to reflect on his story. The film concerns the way we consider family, work, politics, landscapes and art whose formerly seamless relations have disintegrated in the postmodern dawn. To accord with Louvet's negative mood, the Dardennes avoid a bright, confident look, darkening their images instead, making them ominous and strange. *Look at Jonathan* elegises the dream of art, politics and personal fulfilment. It also reveals a troubling amnesia, an uncertain solitude and a missing challenge. The boxer swings in a void.

The key metaphor of the film is a journey, in this instance one made by train as the Dardennes interview Louvet during a trip through Wallonia. The starting and stopping of the train along the way is analogous to the rise and fall of a theatre curtain signalling breaks in a dramatic performance. The train bears a reference to Louvet's early politically committed play *Le Train du bon dieu* (*The Good Lord's Train*, 1976) based on the disillusioning 1960 strike. The play's title invokes a popular symbol of the communist revolution as representing a journey into a better world; it reminds us directly of the opening shots of *Lessons...* and indirectly of shots of free radio idealists trying to maintain contact with each other while riding trains in *R... No Longer Answers*. The train was a revolutionary instrument of revolution in the 1920s when 'cine-trains' equipped with complete film production and exhibition facilities spread propaganda across the Soviet Union. In the context of the Dardennes' film, the train also calls attention to the part the dense Belgian rail network played in developing and maintaining the Walloon industrial sector by transporting its products and conveying its population to and from its places of employment. Furthermore, these images connect the Dardennes to other Belgian visual artists, such as the surrealist painter Paul Delvaux and the magic realist filmmaker André Delvaux, for whom the mystique of trains, stations and railway journeys have played an important part in the construction of their fantastic imaginaries.

At one point in this journey, the predominantly dark mood is offset by 'footage' of the mesmeric steps of the Gilles de Binche, the celebrated harlequins of a town in the heart of the industrial belt. As they strut their stuff, expressing the continuing vibrancy of Walloon popular culture amid chronic socio-economic woes, the camera pulls back to reveal Louvet in the crowd milling around the Gilles and joining in their dance.

Almost a decade later the brothers would film a similar scene at the end of *You're on My Mind*. As the hypnotic drumbeat of the carnival band slows, the train slows with it, a potent metaphor of progress interrupted.

In audiovisual interplay of this kind the film stands as the most reflexive of the Dardennes' documentaries. An initial pan of industrial landscape and river outlines the familiar markers of the brothers' personal world. As the film calmly invites us to enter this world, we are challenged by the symbolic use of red titles and the wail of factory sirens on the soundtrack. The practice of such distancing effects, found to differing degrees in the Dardennes' films thus far and learned from European *cinéma vérité* as well as from Brecht and Gatti, is augmented in the film by titles such as 'Night Speaks to Night', 'The Sidewalks Are Empty' and 'Solitary Words Awaiting History'. The brothers introduce various metatextual elements such as the use of multiple television monitors, like those ranged inside an appliance store, in a parody of our homogenised and repetitive visual culture. These images accompany Louvet's testimony filmed in the theatre of the Sart Tilman campus of the University of Liège. The blurred landscape seen through a window of the moving train becomes an equivalent to the 'noise' depicted on the television screens. And it foreshadows the last shot of the film: a blurred image of the boxer, a final focal loss.

Images of the present intermingle with archival footage throughout the film. The physical form of this benighted region remains much the same: river, railway, bridge, street, factory and house. But life here is different now. The Dardennes repeat a question they have asked in most of their documentaries. Given a very different world taking shape in the last thirty years, how can we possibly reconcile the past to the present? Will anyone emerge from the shadows of the deserted station platform to challenge the eager boxer? Will *the* train still come? Will any train come? If so, where will it go? As with Léon M. sailing his boat down the Meuse, a destination – even the prospect of a promised land – may still exist. Meanwhile, there are no signs at all.

An accomplished work, *Look at Jonathan* nonetheless leaves us with a feeling of intellectual and formal exhaustion. We sense that the brothers have come to the end of their sustained documentary project and are impatient to exceed the limits of nonfictional form. These fraternal 'boxers' are warming up for the challenge of making realistic, responsible and beautiful fiction films.

* * *

If we accept that documentary cinema is a realist practice and that the Dardennes' work hinges on a notion of social realism, and if we accept equally that cinematic realism is not a static or absolute concept, then we may see the brothers experimenting within a progressive context of interactive and reflexive documentary modes. Furthermore, given the theme of responsibility that is at the heart of their major work, it is unsurprising that they concern themselves with the ethics of their own documentary practice. This concern manifests itself in a consistent quest for fairness, justice and understanding in the representation of their subjects especially those whose voices might otherwise be ignored or discounted.

Throughout their documentary career the Dardennes have striven to be respectful of the integrity of their interlocutors' narratives of war, revolutionary politics, refuge, exile and artistic crisis. By inserting themselves into their documentaries the brothers avoid becoming inscrutable and privileged authorities lurking beyond the frame. Their sense of responsibility to their subjects is also a gesture of solidarity, a tacit reassurance that observer and questioner share a regional identity and the knowledge of a common background. This is particularly true of the films about fellow natives – the Resistance workers, Léon M., Edmond G. and Jean Louvet – but it extends to the Polish immigrants as fellow Walloon citizens and to the purveyors of free radio as countercultural activists in the brothers' own earlier style. When we overhear Jean-Pierre telling Edmond to get ready for another take, it might seem a conceit or even a slight condescension, but it becomes instead a mark of identification with the subject, a confirmation that the brothers find themselves in the same frame as him. It is also an unwitting comment on their rigorous pursuit of documentary excellence.

In 1984, still interested in pursuing the theme of revolutionary utopias in the present day, the Dardennes wrote a script for a feature-length film-opera entitled *Ernst Bloch, or Enquiry into the Body of Prometheus*. This project was intended to further the aesthetic experiment of *Look at Jonathan* and would feature the writing of Gatti and Heiner Müller as well as the music of Henri Pousseur. Bloch, who died in 1977, is an important figure in the intellectual life of the Dardennes especially for his utopian ideas, though these were questioned by orthodox Marxists to whom Bloch's intellectual roots in romantic nature philosophy and interests in psychology and pre-capitalist societies were among several highly suspect attributes. Bloch believed that the everyday life of the individual was the starting point of any utopian enquiry, an approach shared by the brothers and one, as Douglas Kellner points out, that links Bloch to the ideas of Lefebvre and the Situationists. Bloch believed that culture always contains utopian energies of great emancipatory potential. Like his fellow Marxist eccentric Benjamin, he was excited by the cinema; despite his open-minded view of popular culture, his vision of realist film – like that of the Dardennes, but in a vein of neo-Marxist cultural critique similar to that of the Frankfurt School – opposed the falsities of the Hollywood machine.

Above all, it is Bloch's overarching principle of hope that appeals most to the brothers and finds expression in the tone and narrative structure of their films. As Luc explains, 'I would say that the idea of Bloch's that we kept in our work was that utopia, for him, is like a nucleus, and he even speaks of "cyst"; it is something which, in individual or collective actions that occur at a given moment in history, eludes the historical moment when those events occur, when those words are spoken' ('*Luc et Jean-Pierre Dardenne*' 1996–97: 34). Bloch's eternally springing hope – articulated by all cultural forms throughout history – sustains an inevitable and necessary movement towards an always desired but ever deferred 'no place' of the future; though always politically driven, his analysis of the present as a latent and tending state did not endear him to the dialectical materialists. We may discern a connection between Bloch's transcendentalism and the face to face encounter of Levinas, yet the political element always present in Bloch's vision adds a dimension to our understanding of the

Dardennes' ethical impetus that we do not find in Levinas's thought. As Kellner puts it, 'Bloch's cultural hermeneutic is … deeply political and cultural studies for him is … intimately bound up with political practice'. Unfortunately, the complicated Bloch project came to naught. By this time the Dardennes were on the verge of launching their fiction filmmaking career. In 1986 *Falsch* became the first of eight such films to date. Shifting into fiction permitted the brothers to rethink completely their approach to the representation of the real.

Notes

1 See also, for instance, Michael Renov (1993), John Corner (1996) and Bill Nichols (2001).

2 The relations between cinema, television and video had been little theorised at the time of the Dardennes' documentary phase. Two influential English-language studies – Raymond Williams (1974) and John Ellis (1982) – coincided with the beginning and end of that phase.

3 See *Joshua*, 6.

CHAPTER FOUR

Foraying into Fiction, 1986–92

FALSCH; THEY'RE RUNNING … EVERYONE'S RUNNING; YOU'RE ON MY MIND.

Falsch

A superficial view of *Falsch* (1986), the Dardennes' first and most formalistic fiction film, might be that it is anomalous to a career marked by a distinctive realist style. On closer inspection the film follows logically from their documentary work by continuing to ask questions of history and memory and by introducing the theme of personal responsibility that underlies all their subsequent work.[1] It follows too from the influence of Gatti on their work and from their earlier attempt to relate aspects of theatre to film in *Look at Jonathan*.

Based on a play by the Belgian author René Kalisky (1936–81), the film tells of the Falschs, a Jewish family from Berlin broken up in 1938 by the Nazis. The family reunites thirty years later for one night together in a remote airport, the occasion triggered by the return from the USA of the 'last of the Falschs', the prodigal son Joseph (Bruno Cremer). But Joe's reunion with these thirteen people takes place in unusual circumstances: they are all dead, including Joe, who collapses on disembarking the aircraft that has finally brought him 'home'. The reunion is a renewed dance of death; it may also be seen as Joe's life flashing before his eyes before he succumbs. It becomes an all-night party – a celebration of their love for one another and for their togetherness as victims of the Holocaust – but also a tribunal, a final reckoning within the family, an ultimate exposure of their individual and collective innocence and guilt, responsibility and irresponsibility, love and hate. It becomes a psychodrama enacted in a dead zone where time has stopped for all of them and an impossible exorcism of a history they cannot escape.

Falsch was one of two unpublished plays, the last accomplishments of Kalisky's foreshortened career. The play was suggested to the Dardennes by Marc Quaghebeur, author, critic and director of the Archives and Museum of Literature at the Royal Library in Brussels. An enthusiastic proponent of Belgian francophone litera-

ture, Quaghebeur was eager to see film versions of Belgian plays. Already attracted to some of Kalisky's themes, the brothers had contemplated filming his *Aïda vaincue* (*Aïda Vanquished*, 1982) and *Sur les ruines de Carthage* (*On the Ruins of Carthage*, 1980). They felt that the language of these two plays shared certain cinematic qualities with that of *Falsch*; for instance, in an equivalent of nonlinear editing and in an implied music rather like a soundtrack. Moreover, they discovered in *Falsch* a remembrance of victims that resembled some of their own documentary work. The play had not thitherto been produced on stage, further encouraging the brothers to 'look for a style, a cinematic language arising from this text' (Dardenne and Dardenne 1986: 3). Drawn to the challenging drama of the Falsch family, they were intrigued particularly by the difficult relationship between Joe and his father Jakob (Christian Maillet), and by the character of Lilli (Jacqueline Bollen), Joe's pre-war lover whose skin he had left Berlin to save, she the daughter of a Nazi official and the lone Gentile outsider at this last gathering.[2]

Sensing the difficulty of adapting the play to the screen but wishing to avoid producing an unimaginative piece of filmed theatre, the Dardennes wrote five versions of the script in close consultation with Kalisky's widow before settling on one. Despite a need to cut much dialogue from the four-hour play, every word spoken in the film remained that of the author, as the brothers strove to preserve the beauty and power of Kalisky's language while making the story plausible as a cinematic work. Thus began their film-scripting experience, which would go successively from, in their words, 'giving an account' of this literary text to working with an established screenwriter (*You're on My Mind*) and to writing their own original screenplay (*The Promise*).

The only historical date in *Falsch* is 1938 when the family spent its last Sabbath together in Berlin. A medical student at that time, Joe decided to leave for New York to save Lilli from trouble over their affair. Accompanying him were his two brothers: Georg (John Dobrynine), a painter, and Gustav (Christian Crahay), an actor. By emigrating they escaped the Holocaust, but their father Jakob chose to stay in Berlin. He, his wife Rachel (Bérangère Dautun), her sister and Jakob's mistress Mina (Nicole Colchat), and his youngest children – Ben (Jean Mallamaci), an aspiring musician, and Bela (Millie Dardenne) – perished in concentration camps. The same fate befell Jakob's eldest son Oskar (François Sikivie), a jeweller, and his wife Daniela (Marie-Rose Roland). The only survivors were Jakob's brother Ruben (André Laenaerts) and his wife Natalia (Gisèle Oudart), who escaped to England, failed to settle in Palestine after the war, and eventually returned to Berlin. Lilli, whom we first see arriving at the airport alone by taxi and gazing through the wire fencing – ever the outsider looking in – died in an Allied bombing raid.

Throughout a bittersweet night in the airport the family engages in joyful embraces, tearful reconciliations and shared laughter; also in interrogations, accusations and recriminations. At the beginning and end Joe asks his father to listen to him, but he speaks in a void, his belated explanation of his actions making no more difference than anything said by anyone else during the night. Joe's tone is one of regret and loss, and though he claims still to love life, he acknowledges he has wasted much of it in selfish acts and attitudes. He attempts to transfer to his father his own guilt for having

Brothers leaving home: (l. to r.) Joseph (Bruno Cremer), Georg (John Dobrynine), Gustav (Christian Crahay), *Falsch*, 1986

survived by asking Jakob the key question (asked by his mother too) of why he chose to stay in Berlin. But the 'trial' of the father is a false (*falsch*) process, as it is meaningless beyond the boundaries of a family reunion that has come too late for all of them and cannot alter their fate.

The three *émigré* brothers place much of the blame on their relatives for what they perceive as loyalty to a German rather than a Jewish identity especially in the case of their Uncle Oskar – 'a fucking Jew in leather shorts', says Georg. Even the surviving Uncle Ruben and Aunt Natalia are described by Georg as 'the real Jews – very German'. And despite the battle between Rachel and Mina for Jakob's affections, it emerges that Mina facilitated the three brothers' emigration to the USA. Towards the end of the film Joe turns on his brothers, revealing the realities of their American lives: Georg's suicide after drug addiction and Gustav's failure as an actor to transcend forty-five 'German stereotype' roles in second-rate movies, at which point, during a face-off in the airport toilets, Joe washes off Gustav's blackface makeup that has masked his true racial identity.[3]

Framed by an illusory freedom of physical movement within the *huit clos* of the airport, the dialogue between the characters becomes a tense squaring of accounts in which apportioning and absolving of blame are in equal measure. All said and done, Joe collapses 'again' on the tarmac, as the plane that brought him there waits to resume its flight. Despite an initial impression of joy and conviviality, the 'heavenly' airport turns into an inescapable hell as the film comes to a bleak and nihilistic end. The party is over, the family has 'again' reached the end of its line (Joe had no children), and its burning questions will always still be asked and never answered. The final shot is of

'Why did we stay in Berlin?' Rachel (Bérangère Dautun) and daughter Bela (Millie Dardenne), *Falsch*, 1986

little Bela looking out to sea through a giant telescope. She sees a ferry boat carrying other people away. The shot ends in a freeze-frame reminiscent of the final shot of François Truffaut's *Les Quatre Cent Coups* (*The Four Hundred Blows*, 1959) in which thirteen-year-old Antoine Doinel, already a social victim, tries to escape his fate but on reaching the sea runs out of places to go.

The film is devoid of historical or geographical markers other than those asso-ciated with the family's memories of togetherness and dispersal: 1938, Berlin, New York. And 1978, the implied year of the reunion, has no historical meaning, since the gathering is imaginary and occurs in an anonymous airport.[4] Belgian playwright and Seraing native Jean-Marie Piemme remarks that both play and film transcend the Jewish context to address broader issues: relationship to the father, family secrets and the individual mocked by history (in Aubenas 2008: 76). As a 'Holocaust' film, *Falsch* is no more than a story of a comfortable bourgeois family that passively resisted the threat of Nazism. It bears comparison with Vittorio De Sica's *Il Giardino dei Finzi-Contini* (*The Garden of the Finzi-Continis*, 1970) or, in Adolf Nysenholc's view, with Luchino Visconti's *Götterdämmerung* (*The Damned*, 1969) – but for Jews instead of the Gentiles in Visconti's film. Nysenholc argues that *Falsch* cannot speak for the Jewish Holocaust experience, as the family members 'became their own executioners' ('*Luc et Jean-Pierre Dardenne*' 1996–97: 25).

From both symbolic and practical standpoints, the Dardennes chose a suitable loca-tion for the drama by filming it entirely in an airport at night. An airport is a place of endless exchange: greetings and farewells, departures and returns, motion and stasis. Depending on circumstance, it may be a place of pleasure or pain. Its large spaces

may be exhilarating or claustrophobic, but at least they offered the brothers a variety of interior and exterior scenes that resulted in a more expansive *mise-en-scène* than the play's nightclub setting would have allowed. They were also able to shoot the film inexpensively in a short period of time. A Franco-Belgian co-production with Belgian ministerial support, it cost €420,000. Conscious of budgetary constraints, the brothers prepared all the technical details in advance in order to save precious time on the set. They economised further by shooting 16mm film using the new Kodak 7292 colour stock recommended for its high definition and later blowing it up to 35mm. After only two days of rehearsal, they shot between 21.00 and 05.00 hours in fifteen nights over three weeks mainly at Ostend Airport, deliberately chosen to be small and nondescript, and at Beauvais-Tillé Airport, a short distance away in France.

Cremer (d. 2010), one of France's leading stage actors, known for his Shakespearean roles and for his distinctive television portrayal of Simenon's detective hero Maigret, helped finance the film. A few weeks before shooting was to begin, the Dardennes had still not cast the role of Joe. Cremer, whom they foresaw in the part but had hesitated to approach, readily accepted their invitation and declared himself challenged by the role and by the peculiar demands of film acting. The same applied to most of the remaining cast of thirteen, of which all but two members had little film acting experience. At the same time, to work with professional actors was a challenge to the brothers and an important step in discovering how to make fiction films.

The stylised form of *Falsch* sets it apart from every other fiction film by the Dardennes. This form is apparent from the beginning, as we witness the murky twilight landing of a four-engine Viscount airliner, a plane long in commercial service and belonging seemingly to no specific time period. The brothers furthered this sense of timelessness by using classic male and female tailoring to create costumes that are as little period specific as possible, while the use of *tableaux vivants* heightens the dreamlike mood. *Falsch* is reminiscent of *L'Année dernière à Marienbad* (*Last Year at Marienbad*, Alain Resnais, 1961), a similarly moody film about the play of memory and perception in personal relationships among a group of people gathered at a spa hotel. From an exterior shot of the grounded airliner, the brothers cut to the arrival hall as the lights are gradually switched on suggesting symbolically as well as literally that things are about to be illuminated, that character and spectator alike will be enlightened. The roller-skated 'employee' switching them on is no less than the painter Georg Falsch whose graceful movements lend a strangely balletic quality to the action. As we hear his first words – 'Music, Ben, music!' – to his younger musician brother lost in the camps, we realise that Georg, in true American show business style, is orchestrating a musical production in which his entire family will perform; 'I convoke all the Falschs', he goes on to say.

In its musical artifice and enclosed settings a notable similarity exists between *Falsch* and a film by another Belgian director. Chantal Akerman's *Golden Eighties* (*Window Shopping*, 1986) takes place in another kind of hell, a Brussels shopping mall redolent of the narcissism and flashy consumerism of that decade. And in its drama of the meeting of two lovers after many years apart, Akerman's film further resembles *Falsch* by meditating poignantly on reunion and on the indelible effect of the past.

The music in *Falsch*, an eclectic mixture of popular and classical, alternates with sound effects created by the drone of the aircraft and the crashing of waves on the adjacent North Sea coast. Sound and music interweave with the register of human voices to create an unusual ambient atmosphere, to which the lighting also contributes. Its eerie quality, dominated by exterior blue and interior yellow, is the satisfying aesthetic result of a largely economic choice to shoot the film in available light. The cinematographer, Walther Vanden Ende, aimed for a studio light somewhere between artificial and real, one that would draw together the worlds of theatre and film. The presence of huge plate-glass windows makes seamless the interior and exterior spaces of a film where past and present, life and death, nature and artifice coexist. As the drama intensifies and more individuals are cornered, put on the spot, and unmasked, the interior action moves from the larger space of the arrival hall to smaller spaces such as the duty-free shop, corridors, staircases and eventually toilets, normally a place of privacy and refuge but where all the characters crowd together in a condensed image of their common entrapment.

Eager to explore the relationships between theatre and cinema, the Dardennes divided the play into twenty-four sequences for the purpose of visual representation and to reflect the absence of a conventional plot. In their camerawork – repeated tracking shots, close-ups, pans and reframings – and their discontinuous editing, the brothers open up the 'impossible' space of the drama. Faced with the problem of how to represent the past without resorting to flashbacks, they opt for a 'time lag between the voices and the bodies in the image, which is fixed not by a technical process but by the play of the actors themselves' (Dardenne and Dardenne 1986: 18). The net result is a circulation of voices – solo, in unison, on- and off-camera – that matches the physical circulation within the 'free' space of the film. The Dardennes conjure a meaningful cinematic experience from a lock-down encounter that is both the eternal reunion of the family and a false dawn, a cruel illusion, a figment of Joe's fatal imagination. *Falsch* is a difficult film to appreciate on first viewing, as it was also a difficult film for the brothers to make, but it contains subtleties and surprises that may reward the careful viewer of a night of joyful despair.

They're Running … Everyone's Running

We may understand the Dardennes' desire to do something less serious after the intensity of making *Falsch*. So they came up with the delightfully madcap *Il court, il court le monde* (*They're Running … Everyone's Running*, 1988). This fiction film, their only short one to date and their first wholly original screenplay, swaps their trademark documentary realism for an absurdist satire on the distracting pace of contemporary life especially in the frenetic realm of media production. The satire embraces romantic and political clichés as well as the cults of speed and vision themselves. The idea behind the film comes from the work of the French postmodern philosopher Paul Virilio, who shows particular interest in questions of speed and in the 'dictatorship of movement' that complicates our lives while purporting to save our time. The film lives up to its title by running to a mere ten minutes of mayhem that recalls the traditions of slap-

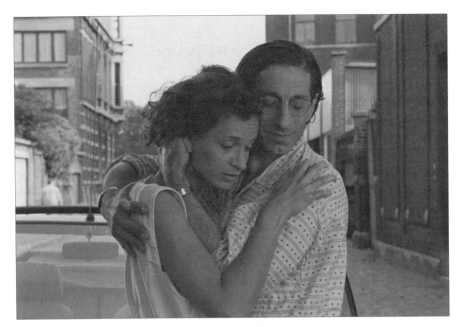

John (John Dobrynine) and Sophie (Pascale Tison): *They're Running ... Everyone's Running*, 1988

stick and screwball comedy. In a film caricaturing media professionals under constant strain, the brothers engage in a bout of self-mockery that also reminds them of their own wish to avoid many of the pressures of commercial film production and to see things in a proper light.

John (John Dobrynine) is a television director making a programme on the subject of speed. He leaves the studio following a phone call from his girl friend Sophie (Pascale Tison) but on his way home his car is rear-ended by another. While John is away, his producer (Christian Maillet) begins to re-edit John's film by removing sexual and political content that he fears will not please the sponsors of the programme. Meanwhile, having reached his apartment, John hears the crash of a motor accident. From his window he sees that it involves Sophie, who has run over an elderly pedestrian in her haste to tell John that she is pregnant with his child.

This thin plot embraces a series of comic incidents and formal conceits to please the viewer able to keep up with the pace. At one point 'Marinetti' arrives in the studio on a motorcycle and whisks away John's shapely assistant. Later, as the elderly accident victim comes to, he utters 'to see or not to see, that is the question'. His parody of Hamlet's famous line refers not only to the question of driving or walking without due care and attention but also to that of seeing clearly where one is going in every aspect of life. His statement also concerns the question of final cut, of what may be omitted for prudish, politically correct, or purely commercial reasons. And it is also about the question of a rendezvous, of a network, of who sees whom, when, and for which purposes. That the Dardennes had not yet answered the question of their own artistic vision became clear in the making of their next film.

You're on My Mind

The subject of this film seemed perfect for the Dardennes: a personal drama enacted against a visible background of decline in the Walloon industrial region, an environment and a situation they know very well. In the event *You're on My Mind* (1992), the brothers' first film shot in 35mm, proved to be an uneven attempt at a romantic social realist film. They learned a salutary lesson in lack of artistic control; it prompted a phase of self-examination leading to a total makeover of their philosophy and method of filmmaking. Disappointing as it was, *You're on My Mind* cleared the way for the startling originality and freshness of *The Promise* and subsequent films.

The film's reception was poor from critics and audiences alike. Jacqueline Aubenas, for instance, damns it with faint praise: 'good workmanship, classical, with a made-for-television efficiency' (2008: 107). A common view is that the film, in dealing with a situation that began in the 1970s and peaked at the beginning of the 1980s, came a decade too late. Marc-Emmanuel Mélon, however, suggests it may have come too early, at a time when the Dardennes were not yet ready to fuse their realist aesthetic and their ethical consciousness in an innovative and effective way (in '*Luc et Jean-Pierre Dardenne*' 1996–97: 17).

You're on My Mind tells the story of Fabrice (Robin Renucci), a steelworker of thirty-five who, along with many of his colleagues, loses his job when the company decides to close the mill. We discover how this loss affects both him and his relationships with his wife Céline (Fabienne Babe) and others close to him. It is a drama of private lives within that of a broader community. The fate of this community depends to a great extent on the fate of the mill, a scenario that corresponds closely to the experience of the Liège-Seraing conurbation in the early 1980s.[5]

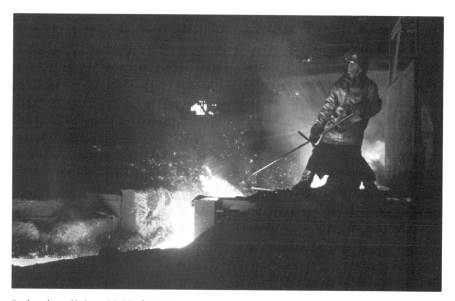

Steel working: *You're on My Mind*, 1992

In 1980–81 the giant steel company Cockerill-Sambre opted for a 'Japanese plan' involving extensive downsizing in the Liège-Seraing area despite good productivity levels relative to other sectors of the industry. As if this were not hard enough for the workforce to swallow, it became clear by 1982 that this reorganisation was the prelude to a final closure of Cockerill-Sambre operations in the region. All of this coincided with the early signs of political power being devolved to Wallonia. It seemed as if the joint forces of capital and the federal Belgian state were preparing to divest themselves as far as possible of responsibility for the continuing socio-economic welfare of the region. This ominous turn of events led regional artists and intellectuals to draw up the Walloon Manifesto in 1983.

By exposing the contradictions of the capitalist system and foregrounding one of the last major political protests by members of the Walloon working class, *You're on My Mind* takes its lead from an important historical juncture. Early scenes depict mass rallies with street banners proclaiming '*Non Au Plan Acier*' ('No to the Steel Plan') and wall graffiti asserting '*Seraing Vivra*' ('Seraing Will Live'). Cockerill-Sambre is re-named 'Sidermeuse' in the film. These examples demonstrate how difficult it was for the Dardennes to find a balance between the 'truth' of 'documentary' images and the dramatic requirements of a fiction film. Furthermore, the idea of workers' solidarity as a given is undermined by brief early scenes of conflicts between the dismissed workers and their union representatives, who were perceived to have colluded with the company in its closure plan.

In the wake of Fabrice's dismissal the film rapidly forsakes the collective drama of workplace and street for a focus on the tensions that develop within his family. As Fabrice grows moody and self-absorbed, two love triangles develop around the desirable Céline. The first, presented as a real threat, involves Fabrice's brother Laurent (Pietro Pizzuti), who seeks initially to convince Céline that he has always loved her only to relinquish her when he discovers his brother down and out in a wayside bar and brothel aptly named 'La Sirène'. Laurent decides to tell Céline of Fabrice's whereabouts in the hope that she will appeal to her husband's better judgement. The second triangle, an apparent figment of Fabrice's increasingly paranoid imagination, involves an Englishman, Jack Brendon (Pier Paquette), who is warmly encouraging Céline to forge her own career using the English she has acquired in evening classes.

Fabrice sinks into denial of his new situation, while everyone around him tries to retool and move ahead. Laurent, who runs a high-tech print shop, offers his brother a job that is haughtily rejected as not allowing him enough space, at least compared to the vast but equally confining space of the foundry. Laurent retorts sarcastically by asking him how much space he needs. We see that it is Laurent who now produces the Seraing carnival posters formerly the task of the traditional print shops and linked indelibly in process and idea to the history of communal pride and self-expression. Laurent taunts Fabrice over the ghost of their father, a proud steelworker in his day. This moment recalls *Look at Jonathan*, in which the son struggles to escape the twin shadows of his coalmining father and of the political allegiances that inspired him, shadows that nonetheless represent for the confused son almost the only fixed points in a brave new world.

Fabrice's pride prevents him from facing up to his situation. After contemptuously dismissing a job offer at a car wash, he grudgingly accepts a temporary position as a night watchman on a slag heap, a dead-end occupation guarding the remains of a dying industry from further slippage. Stuck inside a poky hut that makes Laurent's print shop seem all the more spacious, Fabrice's only companions are a black marketeer and a local tart, each propositioning him to his further self-disgust and scorn for others.

The family name of Fabrice and Laurent identifies them as descended from Italian immigrants who came *en masse* to the Walloon region after World War Two mainly to work in the coal mines. Céline's father Marek (Vladimir Kotliarov alias Tolsty) is a Polish immigrant. After the mines closed, some of those immigrants and their offspring moved into other skilled industrial sectors where jobs were still available; others entered into trade or white-collar and professional occupations.

Fabrice's personal crisis stems directly from the loss of his job at the mill. In addition to this traumatic event, various other things go wrong or remind him of the realities of his situation. His young son Martin (Stéphane Pondeville) gets trapped on a runaway locomotive at the steelworks and is saved only by Fabrice's desperate intervention. After presenting Martin with a pair of clogs, Marek dies outside his daughter's and son-in-law's new riverfront home. At Fabrice's lugubrious birthday party, the flames of the candles on his cake are snuffed out like the fires of the closing mill. In an effort to teach Martin a lasting generational link, Fabrice takes him on a tour of the mill, but it is now an abandoned site inhabited only by a cat (a reference to *For the War to End*). He proudly shows his son a block of steel containing the remains of his father, who fell into a molten pit, but this well-intended gesture confirms the pervasive sense of meaningless endings. Like a wounded animal, Fabrice lashes out verbally and physically at Céline accusing her of infidelity with Brendon. She threatens to leave. At a communal 'English evening' Fabrice announces he will retrain in a factory in Manchester, but it turns out to be a bluff. To add insult to injury, his car refuses to start.

Humiliated and downcast, Fabrice leaves home and takes a room at 'La Sirène' where he forgets his contempt for his slag heap companions by succumbing to the overtures of its resident females and by working on a road gang organised by the same black marketeer. The theme of illegal labour and its ethical implications looks ahead to a fuller treatment in *The Promise*. When it seems that Fabrice has completely lost his self-respect, he challenges his boss over the ill-treatment of an immigrant co-worker. After a fist fight, he loses his job on the gang, but his refusal to kowtow to his boss reawakens in him a sense of pride and responsibility.

In the film's conclusion he returns to Seraing where the carnival is in full swing. He reunites with Céline and with Martin, who struts in the procession wearing the clogs his grandfather gave him. He tosses an orange to his father, who in turn throws it to his wife. The sharing of the fruit offers a symbol of renewed family life. Fabrice also reunites with his former colleagues and with his community in the ritual of the carnival. As in *Look at Jonathan*, when Louvet joins the Gilles of Binche in their hypnotic motion, the carnival is one of the few remaining bonding experiences for all, an uplifting and exhilarating sign of identity and fraternity within an otherwise depressed and alienated sector of society. The film thus ends with a communal solidarity restored, if only at

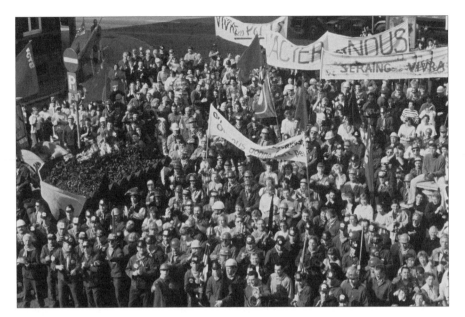

Solidarity's last gasp: *You're on My Mind*, 1992

play, and with the promise of domestic order to be restored for Fabrice. The steel mill, however, will not be restored; Fabrice will not return there, nor will Martin continue to carry the generational flame. That succession has come to an end.

The conventional narrative closure indicates the problems faced by the Dardennes in a film that was neither fully under their artistic control nor an accurate representation of their intentions. Too many fingers were in the pie. They had to accept the input of their co-producers from Belgium, France and Luxembourg, of ministerial bodies, and of the trade union – all of which lent financial support to the film – as well as of the actors and crew, whose employment did not always reflect the brothers' own preferences. Considerable differences of opinion arose between the brothers and their co-producers as to how the film should be made and look as a finished article. Rather in the manner of contracted directors in the studio era, the brothers felt they lacked freedom of choice regarding the script, cast, sets and film crew. It was, they said, a film made 'not against us, but without us' (in Cummings 2006b).

According to Luc, they were 'paralysed' by the weight of a technique that imparted a glossy commercial quality to the film. Yorgos Arvanitis was brought in as a 'name' cinematographer, but his concept of the imagery was not one that they felt suited the film. For instance, the establishing shot, a track across the Seraing steelworks, sets the pattern for a series of industrial landscapes and riverscapes that 'smother human faces and bodies' (2005: 170) by their sheer dimensions and picturesque familiarity. Moreover, the brothers did not use a video monitor, as they had done on *Falsch*, and lacking an instrument that would become an integral part of their subsequent practice seriously impeded their collaboration. Their background as videomakers even rendered them suspect in the eyes of some cinema professionals working on the film.

The idea for the film, originally to have been another documentary entitled *Vulcain chômeur* (*Vulcan Unemployed*), came from Henri Storck. The subject was the state of the Walloon steel industry in 1984, but after much research and planning that project was dropped in favour of a fictional scenario. The Dardennes outlined several different and unrelated screenplays: one, dealing with a father/son conflict, would reemerge in *The Promise*; another, about exiled workers, would reemerge in *The Silence of Lorna*; yet another, about kidnapping, would play out in the child ransom theme of *The Child*. Eventually they returned to *Vulcan Unemployed* and began to transform it into *You're on My Mind*. Louvet came in as screenplay consultant, while the brothers agreed to share the writing task with Jean Gruault, an experienced screenwriter, who had written for Truffaut, Resnais and Rossellini. Gruault, whose mother was from the Walloon industrial region, was fascinated by the subject. From all accounts the three got on very well together, but the writing process was slow and marked by disagreements among them and by repeated concessions made to the investors in the film. Between February 1988 and February 1989 they wrote five versions of the story. The brothers' only good memory of making the film was of working with Gruault who, writes Luc, 'taught us how to extract a fictional character from reality and to be wary of grandiloquence' (2005: 17). This experience undoubtedly helped build their confidence in writing their own subsequent scripts. Gruault readily admits that the brothers could have done it alone, that he wondered at times why he was there, and that he believes he taught the brothers nothing at all.

A further constraint on the brothers was the co-producers' wish to use established actors such as Renucci and Babe. Though they are good actors, Babe's performance early on, when her sex appeal is accentuated, seems a little contrived, as in the scene where she practices her English while flitting about her home. She improves as her role becomes less decorative and more serious.

Though the narrative tends to the melodramatic – the romantic triangles and Fabrice's descent into hell are both rather far-fetched – it presents a credible situation for the two main characters. However, their private drama driven by a conventional plot mechanism overwhelms the public drama of an entire community in crisis. For Gruault, the prominence of a love story with a happy ending was inevitable in the context of a commercially geared production, but he acknowledges that the true themes of the film are death and defeat.

The musical score by the maverick Flemish composer Wim Mertens is strange and inventive – for instance, in industrial shots it uses classical themes *à la* Stanley Kubrick in *2001: A Space Odyssey* (1968) – but the brothers dispensed with background music thereafter as inimical to the spirit of their films and reintroduced it only at the end of *The Silence of Lorna*.

Despite the exigencies of its production and the brothers' profound disappointment at its outcome, *You're on My Mind* is by no means a complete failure. The film has some memorable scenes and, if over spectacular and formulaic, is often visually striking – for instance, in the slag heap scene. And it presents in taut fictional form several themes familiar from their earlier work: the loss of individual and communal identities, the weight of the past and the failure of political resistance. As Luc's diary

entry reads: 'a worker has become a man alone, member of a species in the course of disappearing. It's what we wanted to show in the film *You're on My Mind*. In this process of disappearance, is there a heritage [and] of what?' (2005: 16).

Chastened by the experience of making *You're on My Mind* and beset by self-doubt, the Dardennes spent the next four years re-thinking their cinematic practice but remaining committed to a social realist cinema of ethical concerns. Luc writes of how determined they were to regain full control of their work and to counter the 'affectation' and 'mannerism' prevalent in the film industry. They sought to recover a naked simplicity by renouncing 'that whole discourse … that says what cinema is, what it isn't and what it should be' (2005: 14). Staking all on their next film *The Promise*, it vindicated the sea change in their method and catapulted them to international recognition.

Notes

1 The themes of exile and migration allied to the dream of a better life, strongly represented in *The Promise* and *The Silence of Lorna*, also bear comparison with two other Belgian films: *Bruxelles-Transit* (Samy Szlingerbaum, 1980) and *Histoires d'Amérique: Food, Family and Philosophy* (Chantal Akerman, 1989). Both concern the Jewish refugee experience: Szlingerbaum's with a Polish family settling in post-war Brussels, Akerman's with Jews living in New York. And both pose questions of history and memory.

2 Compare, for instance, the love affair between a Jewish boy and a Nazi girl in *The Reader* (Stephen Daldry, 2008).

3 The theme of false identity is at the heart of *Toto le héros* (*Toto the Hero*, Jaco Van Dormael, 1991) whose international success helped draw attention to the work of new Belgian directors.

4 The venue was a New York nightclub in Kalisky's play. Quaghebeur states that Kalisky had toyed with a revised version to be set elsewhere.

5 A similar concern with intersecting personal and political issues in a context of post-industrial unemployment and failure of union leadership is central to three of Ken Loach's films: *Raining Stones* (1993), *Bread and Roses* (2000) and *The Navigators* (2001). As Jacob Leigh (2002: 177) points out, Loach's films of the 1990s onward show him, like the Dardennes, beginning 'to work more in the mainstream tradition of narrative cinema, in the tradition of European realist film-makers' and influenced by the Italian Neo-Realists and by the Czech and French new waves.

Breakthrough: The Promise, *1996*

One of the first positive signs to emerge from the Dardennes' period of rethinking their film practice was the creation in 1994 of Les Films du Fleuve, their own production company for fiction films. The name bears witness to the central place of the River (*fleuve*) Meuse in their work and today the brothers' headquarters on the Quai de Gaulle, housing both Les Films du Fleuve and Dérives, overlooks the river flowing through the 'Fiery City' (*cité ardente*) of Liège.

After the compromises of *You're on My Mind* the brothers regained a sense of freedom in their filmmaking. As the first production of Les Films du Fleuve, *The Promise* differs from it and from *Falsch* in being relatively simple – not to be mistaken for unsophisticated – and the first full-length fiction film scripted entirely by the brothers. They understood that creating stories based on their own knowledge of life in the region could form the bedrock of their cinema. By choosing to work outside the established film industry, they were able to start making personal films inspired by people and places they know in their heads and hearts. They also understood that they preferred to spend time working closely with their actors rather than being more detached from them as in *You're on My Mind*. This preference in turn prompted them to reposition their camera so that it might also capture a physical proximity to the actors. And they understood that by concentrating closely on bodies and objects they could conceal anything that did not serve their aesthetic purpose.

They realised too that they could function best by operating as independently as possible. In 1996 Luc noted their need to refuse any 'benevolent entourage' or 'court' and to 'remain a solitary pair' (2005: 61). So they consolidated their close-knit team, of which the principals continue to be Alain Marcoen for cinematography, Benoît Dervaux for camera, Igor Gabriel for set design, Jean-Pierre Duret for sound and Marie-Hélène Dozo for editing. With this team in place the Dardennes' trademark film style emerged in *The Promise*. Prepared to give up filmmaking altogether if the

film proved unsuccessful, the brothers little imagined that it would win twenty international prizes including that of the Directors' Fortnight at the Cannes festival.

The Promise focuses on a teenager, Igor (Jérémie Renier), caught up in his father's opportunistic and heartless exploitation of a group of immigrant workers from various countries. One of them, an African from Burkina Faso named Hamidou Badolo (Rasmané Ouedraogo), falls from a scaffold during a panic over an imminent visit from labour inspectors at a site where Igor's father, Roger (Olivier Gourmet) employs them illegally on a residential construction project. With his dying words Hamidou asks Igor to promise to look after his wife Assita (Assita Ouedraogo) and their baby child. Igor's filial bond gradually weakens as he turns his youthful and formerly misspent energies towards keeping his promise. Torn between his new commitment and the continuing demands of his father, who conceals Hamidou's death from both his widow and the authorities so as to protect his clandestine business, Igor is forced into an ethical awakening that marks his passage into young manhood.

The screenplay of *The Promise* was inspired by a dialogue on guilt between Marcel and his mother in Dostoyevsky's *The Brothers Karamazov* (1866) and by the work of Toni Morrison especially *Sula* (1973) and *Song of Solomon* (1977). The brothers credit Morrison for their ideas about rhythm, tone, the character of Assita and beginning a scene abruptly without prior exposition. In *Sula*, Eva kills her son Plum anticipating the theme of murder in several Dardenne films beginning with *The Promise*; in scenes between Eva and her absentee husband Boy Boy the nape of the neck and the back are emphasised anticipating *The Son*. In *Song of Solomon*, the question of taking or saving a life is asked, while the father/son tension between Macon and Milkman Dead as well as the biblical and mythological names of the characters all contribute to the novel's influence on the Dardennes.

The brothers speak of their childhood reading of the Bible and of how they use its stories to represent an ungodly modern world. They had toyed with the idea of filming an unconventional version of the life of Christ: one imagines something like Pier Paolo Pasolini's earthy and socially conscious approach in *Il Vangelo Secondo Matteo* (*The Gospel According to St. Matthew*, 1964). One example of an inspiring story is that of Isaac naïvely following Abraham to the place of slaughter while unaware of his father's intention to sacrifice him to God. In *The Promise*, a naïve Igor finds himself obliged to help his father hide the body of Hamidou; in *The Son*, Francis naïvely accompanies Olivier to the timber yard unaware of his father figure's hidden agenda.

The Promise has several interlinking themes: love, honour, duty, loyalty, hope and responsibility to others. They fuse in Igor's promise, yet there is no easy closure or sentimental ending to the film, only a sense that Igor has acknowledged and assumed his moral responsibility. That he who must keep his promise is a diffident fifteen-year-old makes the situation all the more poignant. By the end of the film we see a glimmer of hope for personal change that recalls the endings of Kurosawa's *Rashomon* and *Ikuru* in which a belated moral awakening offers an uplifting note to an otherwise dispiriting story.

The philosophy of Levinas, who died while the film was being shot, underlies the Dardennes' approach to the theme of responsibility in an encounter with the other.

Luc states that the entire film is an effort to reach the elusive face to face encounter proposed by Levinas. After several scenes between Igor and Assita when he cannot look directly at her, he does so in the final scene at the rail station. However, we should beware of interpreting this positive confrontation as an attempt to illustrate the face to face encounter, for it remains a transcendent experience and is empirically unverifiable. The crucial scenes between Igor and Hamidou and between Igor and Assita merely hint at this ultimate encounter, one that goes far beyond the restricted physical exchange of looks.

Work – or rather, the lack of it – is central to *The Promise*, as in all the Dardennes' later films. Characters emerge and define themselves mainly through the movements and gestures of their labour whether it be legal or illegal, regular or occasional, collaborative or lone. This reveals the influence of the brothers' own background where hard physical labour was fundamental in creating the identity and unity of their region. Much of the verisimilitude and intensity of their films derives from honestly portraying individuals whose life crises are caused by a need to do almost anything for money in order to survive. However, the brothers consider the new urban underclass to be either ignored or treated as a charitable cause by much cinema and television, so they carefully avoid placing their characters, black or white, foreign or Belgian, within a discourse that marks them simply as victims.

The Promise uncovers the exploitative, uncertain, often dangerous world of transient and migrant workers. The film belongs to a subgenre of the cinema of immigrant experience and of which notable (British) examples include *Moonlighting* (Jerzy Skolimowski, 1982), *Last Resort* (Pawel Pawlikowski, 2000),[1] *Dirty Pretty Things* (Stephen Frears, 2002, also concerned with organised crime), *In This World* (Michael Winterbottom, 2002, a docudrama shot on digital video), *What Means Motley?* (John Ketchum and John Riley, 2006) and *It's a Free World* (Ken Loach, 2007). Winterbottom has also made a Hollywood science-fiction film on the subject, *Code 46* (2003).

In *The Promise*, the theme of illegal aliens struggling first to survive and then to settle in a host country looks forward to *The Silence of Lorna,* while both films expose the powerful presence of organised crime, domestic and foreign, in urban areas racked by economic decline. Luc observes how the 'faithless' and the 'lawless' have proliferated in these areas where a social subsector of grafters, opportunists and racketeers has constructed an underground economy. One symptom of this general malaise is the renting of shelter at extortionate rates. The brothers had met one such landlord while scouting locations for *You're on My Mind*. This individual had bought up and partitioned three old houses in Seraing, recruiting his tenants in Liège notably among illegal aliens arriving at the main rail station. During the mid-1990s asylum seekers could not obtain identity papers in Liège, but Seraing accepted them, so they were immediately directed there. In 1998 the brothers, at considerable risk to themselves, took one such illegal alien under their wing 'for humanitarian reasons' and gave the proceeds of a *Rosetta* pre-premiere in Liège to the Argent Fou Collective that supported such victims of the system (see Renette *et al.* 2000).

The abovementioned landlord helped the brothers create the character of Roger, played by Gourmet, a product of Liège theatre whose only previous film role had

been a cameo appearance in *Le Huitième Jour* (*The Eighth Day*, 1996) directed by fellow Belgian Jaco Van Dormael. The international success of Van Dormael's first feature *Toto le héros* (*Toto the Hero*, 1991) paved the way for the further recognition of new Belgian cinema in the films of the Dardennes. Along with Renier and Rongione (*Rosetta*, *The Silence of Lorna*), Gourmet is an actor with whom the brothers feel comfortable enough to work on more than one occasion.

The Promise depicts the uneasy coexistence of native Belgians and immigrant workers in an area where unemployment currently runs between 20 and 30 per cent of the population. A long history exists of immigration to the Walloon industrial region to fill jobs in the now defunct coal mines, steel mills and other factories.[2] Since the 1960s, following the decline of the heavy industries and the decrease in immigration of the earliest ethnic groups (Italian, Polish and Czech), Belgium has become, writes Lieve Spaas, 'an amalgam of peoples who bear the marks of postcolonial relocation ... a mosaic of different groups of people, for whom Belgium is a place rather than a nation' (2000: 8). This resurgent immigration – corresponding to the currency of national displacement, global labour mobility and relaxation of border controls – has brought to Belgium, as elsewhere, many people from central and eastern Europe, from the Middle East, and from former European colonies in Africa.[3]

This influx of displaced persons gives Roger an opportunity to earn a living from human trafficking. The opening scene of *The Promise*, which shows a group of transient workers climbing down from an automobile transporter in front of a disused factory, powerfully contrasts the reality of post-industrial society with its more settled if often equally exploitative predecessor. The scene is suffused with irony, as are Igor's welcoming words – 'big *usines*, *beaucoup* money' – to the exhausted and bewildered newcomers. Roger and Igor believe that their shrewdness in employing these aliens cheaply will reward them in a community where steady jobs in traditional workplaces have all but disappeared. Neither of them bargains for the implications of explaining to the authorities a death among their charges. The exploitation of others for personal gain and the eventual disposal in concrete of Hamidou's body offer a chilling parallel to the notorious Marc Dutroux paedophile murders of the 1990s, which occurred in the Charleroi area not far from or unlike Liège-Seraing. Belgians viewed these outrages as symptomatic of a general collapse of social and moral values.

Luc speaks of having taken up 'this present phenomenon of a virulent social decomposition' ('*Luc et Jean-Pierre Dardenne*' 1996–97: 8), but *The Promise* only implies the social situation that throws Roger and the migrant workers together. The Dardennes typically offer no narrative exposition; everything is embodied in the action of the film. But this method does not empty their films of socio-political content; rather, as Dimitri Coutiez believes is the case in any film, it transposes a conception of the social to its representation (1996–97: 80). For instance, in one scene Roger, whose current income is off the record, signs on at the unemployment office. Coming from the traditional working class, he has a memory of regular work and a residual sense of his right to unemployment benefit. Otherwise he sees no point in remembering the past, which makes no difference to his present situation, one in which he has been relegated to a marginal position within his native environment. We see him acting uncomfortably

when obliged to visit the hospital and the police station, places of established authority and symbols of a public order to which he no longer subscribes. Yet, like many others of his ilk, he has learned to turn his marginal status into organising an unofficial and highly profitable business. In a manner that echoes the practices of unscrupulous captains of industry, he knows how to divide and conquer those who depend on him for their living and on whom he also now depends for his own livelihood. What he discovers he cannot control after Hamidou's death are the reactions of Igor and Assita, the twin spanners thrown into his works.

Phillip Lopate (2003: 25) sees a 'pat division between evil Belgians and noble blacks' as a weakness in *The Promise*. But I think he misrecognises that despite their nefarious activities, Roger and his associates understand as well as do their dependent workers the imperatives of daily life in these declining post-industrial communities. In struggling to keep their heads above water by whatever means possible, all show themselves to be, as Luc writes of Rosetta, total products of the 'brutal competition demanded by the ultraliberal economy of our times' (2005: 78). Luc says, 'Roger is Fabrice five years later' ('*Luc et Jean-Pierre Dardenne*' 1996–97: 19), but in narrative time it is closer to fifteen years; huge changes have occurred in the meantime. The period between 1980 – the time of the story of *You're on My Mind* – and the mid-1990s produced a definitive collapse of old working-class formations and their replacement by a new 'classless' society of those who have work and those who have not. In 1980 the unfamiliar prospect of redundancy paralyses Fabrice leaving him depressed, resentful and bewildered. By the mid-1990s this pattern of unemployment is chronic, and we see that Roger prefers to swim than sink. But in the absence of a regular and legitimate occupation, he must rely on his own shady enterprise.

Roger turns to benefit fraud, slum landlording, dealing in false papers and employment of illegal labour. His new social identity lies in living from hand to mouth; there is no recollection of anything else. Roger views his workers as no more than human merchandise, easily acquired, exchangeable and disposable. They need shelter, so he pays wages from one hand and takes rent with the other. This emphasis on pecuniary value finds visual expression in many shots of cash changing hands: Igor going through the wallet of the elderly lady he has robbed at the garage where he works, Roger doling out money to his motley gang of foreign workers.

Roger is corrupt, cynical, expedient and ruthless if necessary, but he is not entirely unsympathetic. As Jean-Pierre puts it, 'the figure of Roger is one of ordinary evil, it's not an extraterrestrial, and it's not a monster. We wanted it to be someone who is as ordinary as possible and for whom the viewer can even, at certain moments, feel affection' ('*Luc et Jean-Pierre Dardenne*' 1996–97: 28). He shows that he is capable of loving and caring for his son with whom he has a close bond. With no sign of a mother around, Roger is Igor's security. Though their daily life appears rough and monotonous, they take their pleasures too; the Dardennes carefully include scenes of the two enjoying themselves. Roger reinforces their bond by giving Igor a signet-ring, by scrubbing him clean in the shower, by giving him a tattoo, by letting him drive their van, and by taking him out to a *café chantant* where he offers him the experience of cigarettes, beer and women. As well as caring for him, Roger hopes to initiate Igor

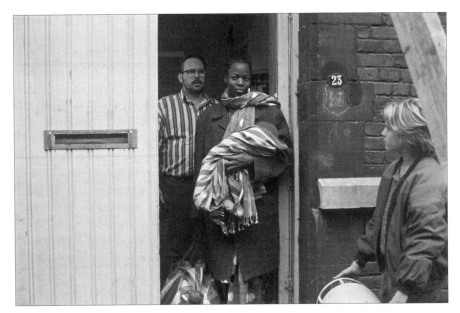

Igor (Jérémie Renier) must choose between father Roger (Olivier Gourmet) and immigrant Assita (Assita Ouedraogo): *The Promise*, 1996

into manly ways even wanting him to think of them as friends rather than as father and son. He urges Igor to call him 'Roger' and not 'Papa'. But this attitude is difficult for Igor to accept; it becomes part of a problem between them rather than a solution. Masked by their camaraderie, an insecurity born of an unusual set of circumstances gradually undermines their united front. Despite his rough-hewn affection and his effort to get Igor to stand on his own, Roger remains possessive, afraid of losing him to the garage where he is apprenticed or to friends of his own age with whom he likes to race a go-kart. Constructed from odds and ends, the go-kart represents the art of bricolage that characterises their world, where one ingeniously makes something out of nothing. In return for his devotion Roger expects Igor to be loyal to him and always available to help him in his enterprise. Igor breaks this implicit promise once he realises its full and sinister implications.

In the cinema of the Dardennes this rupture of a traditional father/son relationship begins symbolically in the documentaries on Léon M. and Edmond G. with the loss of a radical father figure represented, for instance, by Marx or by a local hero such as the Walloon socialist leader Renard. In the case of Louvet, the figure is his own father, an industrial worker in whose footsteps his son declines to follow. For Fabrice's son, in *You're on My Mind*, that option no longer exists. A rupture also occurs in *Falsch* between Joe and Jakob when the family splits up before the outbreak of World War Two; the son chooses to leave for the USA, the father to stay in Berlin.

The Promise develops many aspects of the Dardennes' earlier work despite its fresh style and unconventional narrative structure. A theme of the collapse of traditional class values remains implicitly from previous films, but the focus has shifted to a new

underclass exemplified by Roger and his gaggle of transient workers. While previous films deal in various ways with ghosts of the past, *The Promise* is very much of the present and, as its title suggests, also of the future. As well as the specific promise made by Igor to Hamidou, it represents the universal promise of a young man growing out of an opportunistic way of life into a decent and caring one. The fading memory of a powerful Walloon working class is ineffective against current social and economic odds, but in Igor its code of solidarity and responsibility to others may survive in a new guise.

A hardened innocent at fifteen, Igor knows the worth in hard times of his apprenticeship to an auto mechanic, but his father's expectations combined with his own desire for boyhood pleasures weaken his will to persevere. A number of scenes occur in which Igor begins to doubt his father's activities: one is in a café where he witnesses immigrant workers falling into a police trap set up by Roger; another is when he is dispatched to collect rent from the tenants of Roger's dilapidated boarding-house. Caught uneasily between childhood and an awakening manhood, he first defies his father by fashioning a tourniquet to save Hamidou's life. Roger overrules him and allows the injured man to bleed to death before summarily burying his body in a pile of concrete. For Igor this is a traumatic and defining experience, one that sets him on a changed path as he strives to keep his vow to the dead man. Overcoming the shock of alterity, Igor's word to Hamidou creates a bond with Assita at the same time as it weakens his bond with Roger. He knows he must leave his father's world of expediency, dissimulation and indifference to others and enter a new moral space.[4] In a tragicomic scene in the garage where he worked, Igor chains Roger in order to escape his demands. Eventually he kills his father symbolically by telling Assita the truth about her husband's death.

Though the relationship between Igor and Roger is at the heart of *The Promise*, the one between Igor and Assita propels the plot, for it is Igor's attitude and behaviour toward her that allows him gradually to resolve his ethical crisis and become a different person. Even before Hamidou exacts the promise, Igor shows an interest in the African family, spying on Assita performing animist rituals in their rented room. After his promise he slowly awakens to the meaning of the vow. His voyeuristic curiosity about Assita turns into active support that she reciprocates by unconsciously becoming a mother figure to compensate for the loss of his father. A peculiar mixture of respect, companionship, suspicion, antagonism and mutual vulnerability characterises the difficult forging of a bond between them. He gives Assita money; in return his father beats him. When she insists that her husband will return, Roger tries to drive her away by paying an accomplice to intimidate her and then by sending her a bogus telegram from Hamidou in Cologne and offering to drive her there. Igor refuses to go along with this dishonest plan by hijacking their van. He tells Assita the truth about the Cologne ruse but remains reluctant to betray his father over the death, though he agrees to take an increasingly angry Assita to the police station, buys her food, and lodges her overnight by breaking into the garage where he had been employed. He helps her when her baby falls ill despite being blamed by her for the child's condition. He repairs her African statuette, which had been broken when motorcycle hooligans attacked her. It is an

object that symbolises his bond with her as much as the signet-ring he received from his father, which he pawns in order to buy Assita a train ticket to join her relatives in Italy. As they approach the station platform, Igor confesses that Hamidou is dead and that Roger concealed the fact to save his own skin. Able now to look each other unflinchingly in the eye, they leave the station together. The Dardennes typically opt for an open ending, but no matter how hard the road ahead may be for both of them we sense a mutual understanding and a true friendship being formed.

Hamidou and Assita Badolo come to Europe from Burkina Faso, a former French colony that is one of the poorest nations in Africa. Apart from sharing the French language, they are less at home in Belgium than immigrants from the former Belgian territories of Congo, Rwanda and Burundi, who at least have established distinctive postcolonial communities in Belgian cities, notably in the Matongé quarter of Brussels. For the Badolos, as for the other migrants in Roger's grip, the title of the film ironically promises a new life in a promised land, but for them it is a land not of fine chocolates and medieval art but of urban bleakness and daily grind. The couple shares Roger's accommodation with Kurds, Romanians, ex-Yugoslavs, Chinese and a Sikh. Detached from their own cultures and struggling to adapt to an alien environment, they remain easy targets for exploitation outside the laws of the country to which they have migrated. They lack any security given that, as Hardt and Negri contend, 'the universal applicability of human rights clearly cannot be realised as long as it has no legal institutional structure and relies instead on the dominant nation-states' (2004: 275). Hardt and Negri further suggest that migrants in a globalised world compensate for their material destitution by bringing their knowledge, languages, skills, desires, 'an entire world' with them; an ironic situation occurs: 'the great global centers of wealth that call on migrants to fill a lack in their economies get more than they bargained for, since the immigrants invest the entire society with their subversive desires ... All of the multitude is productive and all of it is poor' (2004: 133–4).

Migrants can survive too. Assita displays dignity, pride and resourcefulness, a combination of qualities not lost on Igor as his formerly condescending interest in her as an exotic female specimen becomes a genuine concern and respect for her. Unbowed by circumstances, Assita continues to practice her own way of life in a rundown corner of Belgium. As Levinas asserts, 'he or she who emigrates is fully human: the migration of man does not destroy, does not demolish the meaning of being' (1998: 117).

As well as representing a profound ethical question in an everyday context and portraying marginal urban life in the postmodern age, a new and distinctive film style elevates *The Promise* from one more social realist exercise among many to an original work of cinematic art. Retaining a strong documentary impulse from their early work, the Dardennes unveil a cinema that grasps body and matter as the primary means of expressing their ideas. This involves detailed filming of persons and objects, so they use the close-up extensively. Almost a decade later, complaining of the screenplay of *The Child* as too bound by ideas and by the psychology of the characters, Luc insists 'we must find objects, small concrete acts, accessories, manipulations of accessories, things, stratagems' (2005: 158). He believes that cinema essentially films 'very concrete things', such as the escape rope fashioned by Fontaine out of pieces of sheet and iron

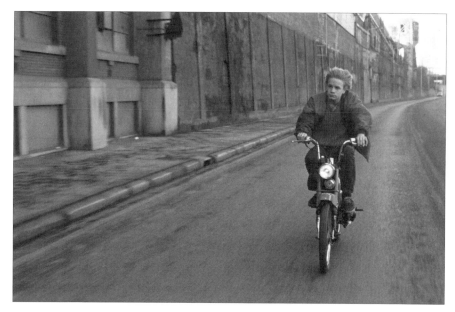

Igor (Jérémie Renier) cruises the post-industrial void: *The Promise*, 1996

wire from his mattress in Bresson's *A Man Escaped*. From their own films, he cites as one example the eraser fluid with which Igor masks his decaying teeth. Such an apparently insignificant detail conveys a particular condition far better than would several lines of explanatory dialogue.

The same principle applies to the settings. Having been trapped by the identifiable spectacle of industrial decline in *You're on My Mind*, the brothers were careful in *The Promise* to separate the human body from its surrounding landscape: 'Jean-Pierre found good settings which will relieve the film of the Walloon imagery in which some would have liked to enclose us. We're seeking a mixture and indeterminacy appropriate to our times in the places, faces, bodies, and clothes' (2005: 55). Their imagery remains intensely realistic, and if you happen to know the Liège area you may recognise the yellow buses or some riverside views, but the hypothetical setting could be anywhere such socio-economic conditions prevail. Using a modicum of long shots, the brothers shoot many scenes in a truncated urban wasteland of anonymous, ordinary spaces.

The success of this telescopic approach – allowing the viewer to become an intimate witness of daily life in a nondescript location – depends also on the mobility of the Dardennes' camera and its proximity to objects and persons. This style relies heavily on implying the space beyond the frame, a space that purposely hides more than it shows. In *You're on My Mind* the brothers had felt constrained to fill the frame with contextual information, but in *The Promise* they often create a centrifugal motion. From a close-up of an object – for instance, the wallet stolen by Igor from a customer at the garage or the wheelbarrow used to carry Hamidou's corpse – a shot may spread out to reveal a face, a hand, an entire body or elements of a background. Aware of a 'resistance' of the real world beyond the frame, the brothers decline its constant invitation to be viewed

and captured. Their camera placement and movement correspond rather to the physical configuration and displacement of their characters, which may be neither comfortable nor predictable. The camera draws the viewer abruptly into the thick of the action, a technique the brothers learned partly from Bresson. The viewpoint they create – a variant of the fly on the wall technique in documentary film – is that of an unsuspecting witness, an innocent bystander caught uneasily between neutrality and implication.

The original style of *The Promise* derives from the Dardennes' *mise-en-scène* rather than from their editing, much of which takes place within the shot. They preferred single takes in order to capture the fresh, spontaneous and surprising elements of a particular scene. Unlike subsequent films, no scenes in *The Promise* were rewritten or reshot during production, but the brothers prepared and rehearsed each shot at length in order to maximise the ability of the images to 'speak' for themselves. In turn this reduced the need to depend on explicit dialogue in forming the hermeneutic field of the film. For Jean-Pierre, 'a film is the story of how it has been shot' (in Danvers).

The truculent realism of *The Promise*, which sets the tone for all subsequent films by the Dardennes, compensates for the flaws of *You're on My Mind* by challenging the prevalent mode of commercial cinema and by resisting what the brothers call the 'torpor' of its stereotyped imagery and star system. By refusing to participate in the 'vast cloning enterprise' that bedevils current cinema, they find themselves able to resist conventional narratives, overblown production values and fashionable techno- logical effects. Luc suggests, for example, that they are akin to the *Dogme* 95 group in being 'filmmakers from two small countries who have discovered the form of their cinema from the poverty of their means' (2005: 104). *The Promise* announced the Dardennes to the international film world as uncompromising realist auteurs with an ethic of human responsibility and a distinctive cinematic vision. They did not rest on their laurels; this film was the starting point of a major career.

Notes

1 The allegorical style and anti-sociological bent of Pawlikowski's film led him to state that it was not about refugees as such but about modes of human interaction in threatening and uncomfortable situations. Much the same may be said of *The Promise* and *The Silence of Lorna*.

2 See chapter two for a discussion of films by Meyer and Bianconi related to the life of the Italian immigrant mining community.

3 Another Belgian film that deals with immigration and racism, in Brussels, is *Au delà de Gibraltar* (*Beyond Gibraltar*, Taylan Barman and Mourad Boucif, 2001). Its love story of a Maghrebian immigrant and a Belgian girl recalls Dumont's *The Life of Jesus* and other French films treating of similar themes.

4 *The Apartment* (Billy Wilder, 1960) influenced the Dardennes' thinking about the deci- sion to sever one's existing loyalties. Wilder's film depicts the moral dilemma of an ambi- tious young office worker, played by Jack Lemmon, whose unscrupulous collusion with his bosses catches up with him and forces him to make a choice that risks all he has gained from his actions.

First Palme d'Or: Rosetta, *1999*

Liberated and vindicated by the success of *The Promise*, the Dardennes spent the next three years making *Rosetta*, which furthered their personal vision of realist cinema and their concern with individuals on the socio-economic margins. In 1997, while still teaching collegiate courses and producing the work of others for Dérives and Les Films du Fleuve, the brothers began writing the story of an unemployed teenager living on a caravan site. Even after the startling originality of *The Promise*, few were ready for *Rosetta* when it materialised from another private and painstaking process by the brothers and their small team. They shot the film over an eleven-week period, seemingly more than enough time for a simple and concentrated film, but less so given that they shot a great deal of footage, including the reshooting of many sequences. As Luc says, 'We'd rather have the opportunity to reshoot a scene than to rent a crane' (in Kaufman 1999).

Gilles Jacob, executive director of the Cannes film festival, described *Rosetta* as an 'Exocet missile', and it duly shot to the coveted prize of the Palme d'Or at the 52nd festival in 1999. The first Belgian film to win the festival's top award, it also received a special mention in the contest for the Directors' Ecumenical Prize, while the actress playing Rosetta, Emilie Dequenne, carried off the award for Best Female Performance.

The success of *Rosetta* hastened the passing of a Belgian law that became known as the 'Rosetta Law'. Already in the form of a bill at the time the film was made, the statute prohibits employers from paying less than the minimum wage to teenage employees and decrees a 3 per cent minimum of young employees in any work force comprising more than fifty workers. Asking what kind of world we had created for ourselves at the end of the twentieth century, *Rosetta* sharply criticises a society that can sacrifice its willing workers on the altar of economic efficiency. Luc points out that ten thousand people live on camp sites in Belgium – 'the last step before homelessness' (in Camhi 1999). We may read the film as indicting a society that excludes those without

jobs or social status, but it rigorously avoids explicit commentary of that kind. That the brothers have no recourse to sloganeering or tub-thumping in a film that galvanised legislative action on unemployment shows that their cinema remains politically relevant and effective in an implicit way.

Again eschewing a conventional narrative to focus on the eponymous character, the brothers made what Luc calls a 'portrait of a young woman' obsessed with the search for a job and an acceptable social identity. As the film begins, seventeen-year-old Rosetta has lost her job at an ice-cream factory on the shaky grounds of being the first trainee to have completed her probationary period and so being the first to be released. The rest of the film follows her determined and furious efforts to ensure her own survival and that of her alcoholic mother (Anne Yernaux) with whom she shares meagre accommodation on a bleak caravan site. Having eventually found a new job working in a waffle factory owned by a Monsieur Gérard, she is laid off after only three days again on dubious grounds. Meanwhile, Riquet (Fabrizio Rongione), who operates one of Gérard's waffle stands, is a young man more on the take than the make, so Rosetta, desperate to secure another job, informs on him ignoring the fact that he, attracted to her, may be her only friend in need. He is fired on the spot and she duly assumes his position. Wearing a personalised apron, she finds the cramped waffle stand to be a reassuring and satisfying space where she rediscovers a modest but definite role and an identity to match. But again this job does not last. At the end of the film, back at home, she realises neither she nor her life have changed for the better. Her bad conscience over her betrayal of Riquet and her mother's apparent hopelessness trouble her to such a degree that she phones her resignation to Gérard – a bewildering and shocking moment in the film in view of all that precedes it. Exhausted and helpless, Rosetta decides to put herself and her mother out of their misery; only the fortunate arrival of Riquet prevents her from doing so. Saved by the bell – in fact by the drone of Riquet's approaching motorcycle – Rosetta, on her knees and in tears, cannot but acknowledge his concern and affection for her. As in *The Promise*, the film ends on a guarded note of hope that the two erstwhile antagonists may be able and willing to forge a mutual loyalty, trust and perhaps even love.

Sticking to their guns over casting, the Dardennes again picked an unknown nonprofessional actor for the leading role. Eighteen-year-old Dequenne only entered the frame for the part after her aunt had mailed her photo and résumé in response to the brothers' advertisement. They received two thousand photos and narrowed the field to two hundred auditioners. Dequenne had two short meetings before they invited her to spend one day with them. Impressed by her mental and physical resilience, they chose her unhesitatingly for the part. Coming from the Borinage, a depressed former coal mining area around Mons at the western end of the Walloon industrial belt, Dequenne was familiar with the type of young person she was asked to play. Rongione was another young unknown whom the brothers would later re-employ, while Gourmet reappears in a minor part as the waffle manufacturer.

By using a limited cast the Dardennes allow Rosetta to preoccupy the viewer as she storms through the film. The opening scene, where she lashes out at her adversaries verbally and physically, quickly establishes her character. She may be in an existential

crisis and faced with huge obstacles but is not in the least self-pitying or immobilised by her situation. On the contrary she is extraordinarily energetic, resourceful and determined. Proud, stubborn and unwavering – rather like some of the protagonists of Iranian director Abbas Kiarostami's films – she knows she wants a job above all and will stop at nothing to get and keep one. Allied to this mental toughness is a bodily resilience that vindicates the brothers' careful casting: Dequenne is a sturdy young woman with a face exuding both steeliness and vulnerability. In the second scene, on the bus home after losing her factory job, a lingering close-up of her face reveals a mixture of defiance and despair. Rosetta draws us to her, but few would care to cross swords with her. She betrays no weakness, coyness or self-consciousness to diminish the authenticity of her role. Her ordinary clothing (tracksuit top, plain grey skirt), lack of body ornament and of make-up reinforce the impression of an average, straightforward young woman, girlishly appealing in her own unglamorous way, who has set herself a basic mission to survive and to be recognised as an individual like anyone else. And she spends all her resources on this mission. Little wonder, then, that the jury chair at Cannes, the Canadian director David Cronenberg, described her as a 'primal life force'.

At different times we may like or dislike Rosetta. The film invites us to share her plight, so we may easily admire her courage and resilience. But she can also be an unsympathetic character, as when she persuades Gérard to hire her in place of a woman whom he has just fired for a bout of absenteeism. Though the woman protests that her baby's illness has caused her absences, Rosetta shows no sympathy for her, such is her determination to secure the job, ironically one that lasts only three days before Gérard gives it instead to his lazy son. Rosetta thereafter almost allows Riquet to drown after he has visited her at the caravan site to offer her a loan and accidentally falls into a fish pond. She clearly has her sights set on his job at the waffle stand, so after a brief hesitation she informs on his misdeeds. Even if we are on Rosetta's side, we may find it hard to identify with her at such moments.

Her attitude to her alcoholic mother – one of practical, almost instinctive, support but in which she shows little affection – is equally difficult to decipher. One reason why she cannot simply throw up her hands in this situation is her sense of responsibility to her mother with whom she conducts a love/hate relationship. Her mother, locked into a routine of sexual favours granted to the site's caretaker in return for drink, demands much care and attention. When sober, she plants vegetables that Rosetta uproots in a fit of rage at her mother's habits, and mends clothing that Rosetta tries to sell in town. Despite her disgust and anger at her mother's addiction, she remains loyal to her, ejecting the caretaker from their caravan and shouting at him that her mother is 'not a whore'. However, it is not entirely a one-way dependence. After one struggle between them, her mother pushes Rosetta into the fish pond and makes off leaving her daughter to flounder in the muddy bottom and barely able to pull herself out. In her distress, Rosetta's cries of 'Maman!' remind us that beneath her hardened exterior there still lies something of a frightened child. Shocked by her mother's apparent indifference to her fate, Rosetta goes into town to seek solace and shelter at Riquet's tiny flat, a dwelling place marginally more comfortable than her own.

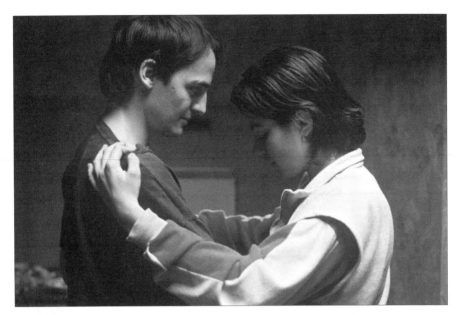

Riquet (Fabrizio Rongione) invites Rosetta (Emilie Dequenne) to dance: *Rosetta*, 1999

Though Rosetta's life allows no time for relaxation or laughter, there is a certain dark humour in the attempted suicide scene at the caravan site where the gas cylinder runs out as she and her mother await their end, and in the charmingly gauche courting scene in Riquet's apartment with his gentle but clumsy advances and her equally uncertain response to them. As Riquet unsteadily demonstrates his former skill as a scholastic gymnast, Rosetta smiles for the first time in the film. She appreciates the simple meal he prepares for her, swallows a bottleful of beer in one go, and hesitantly agrees to dance with him to the discordant taped accompaniment of a band in which he is the drummer. But when we suspect she may lose her inhibition and give herself over to sensual pleasures denied to her by her life of drudgery, her steely self-protectiveness returns. Succumbing to a violent stomach cramp, she flees the coop into the night only to return later, salvaging her pride on the pretext of having forgotten to take a new pair of boots he has offered her before acknowledging that she needs a place to stay. To his credit, Riquet does not interpret this request as a sexual invitation and he carefully provides her with bedclothes in the adjoining room he had suggested she rent. Once alone, she utters a brief, moving dialogue with her alter ego: 'Your name is Rosetta. My name is Rosetta. You have a job and a friend. I have a job and a friend. You have a normal life. You will not fall into a hole. I will not fall into a hole. Good night. Good night.'

For Rosetta, nothing matters as much as a job and the money it brings, keys to her survival in a world that threatens to crush her. She has an obsessive desire to belong; her abnormal existence fills her with a terror of disappearing completely into a void. She wants only to lead what she perceives as a normal life with basic necessities in place and to be included in a society that has excluded her through no fault of her own. Her

'normal' vision extends to her desire for 'a real job'; despite her willingness to sacrifice both her absentee mother and Riquet, she refuses his offer of sharing in his illicit earnings. As Luc explains, 'in a social situation, the market, where everyone is put into competition with everyone else – in a context where people are in permanent rivalry and organised like that by society and the economy – how is someone like Rosetta going to be able to love someone when the situation asks her to consider him as her enemy, her rival?' (in Wolfreys 2008).

Rosetta searches for work in a place where little or none is to be had. The Dardennes have witnessed closely the material and psychological effects of unemployment both generally in the local industrial sector and specifically in the case of their father, who was forced to remake his working life after being laid off at the age of fifty-two. The experience of losing a job especially without expectation of another is not only depressing, frustrating and humiliating but also likely to engender an angry and bitter attitude. The brothers had already tried to depict this situation with Fabrice in *You're on My Mind*, but unlike him, Rosetta has not even known stable employment. In her desperation she tries to storm the fortress of society but, says Luc, 'she's so obsessed with the idea that she becomes a fortress herself' (in Camhi 1999) and it almost kills her.

The lack of an explanatory context for her situation allows the Dardennes to avoid any explicit social commentary. Rosetta does not blame society, capitalism or the system for her woes. She seems willing to play the system at its own game by displaying a ruthless competitiveness and works very hard at finding or keeping a job. Rather like Bruno in *The Child*, if not as street smart as he, she has no alternative but to learn the art of *la débrouille*, of getting by in a resourceful way, of living on her wits, of using anything that becomes available to her. And though she can be as hard as nails in her attempted self-advancement, her stance, rather like that of Bruno, masks a deep vulnerability and an emotional need that reveal themselves forcibly at the end of the film.

Jonathan Rosenbaum (2000) notes the 'utter lack of didacticism' in the brothers' films. As in *The Promise*, we see this lack in the ending of *Rosetta*, which offers a moral choice but imparts no moral lesson. Rosetta returns home to find her mother unconscious on the ground. At this moment her newfound resolve and cautious optimism dissolve before her eyes, as she realises that even with a job her life is far from normal. She boils an egg, turns on the gas, and lies down to die.[1] But the quiet hiss of the escaping gas gives way to silence as the gas runs out. She visits the caretaker to collect another gas cylinder, which she hugs as doggedly as she earlier hugged a sack of flour that represented her attachment to her waffle factory job. Staggering back to the caravan to mount another attempt on her life, she collapses tearfully under the weight of the cylinder.[2] We hear the drone of a motorcycle engine approaching before seeing that Riquet has arrived in the nick of time to offer his hand. Rosetta may refuse his gesture and try to stand alone again, or she may admit his affection in order to help her ease her desperate situation and the shame of her disloyalty to him. She looks at him in an appealing manner suggestive of possible reconciliation, of a cautious hope that they may become mutually supportive at last. But the mood remains subjunctive: she may or may not overcome this crisis. The ending is neither nihilistic nor redemptory: 'ethics resolves into a question of action: what do we do?' (Frampton 2006: 147). Resisting

any form of conventional narrative closure, the Dardennes cut to black from Rosetta's gaze, and the credits roll leaving any speculation on the outcome to the viewer. In the mud of a deserted caravan site, we are reminded of the equally empty station passage where Igor owns up to Assita and possibly opens the door to a better future based on mutual affection and trust.

Rosetta's daily routine dominates the action of the film because she has no back story. At one point during the writing of nine versions of the screenplay, the Dardennes introduced the character of her father only to drop him promptly because they felt he would explain her situation. The resulting dialogue remains sparse; actions not words tell her story, and Luc comments that *Rosetta* could have been a silent film. Wary of narrative set-ups and psychological profiles especially after *You're on My Mind*, the brothers prefer to offer no expository context. As in *The Promise*, the viewer joins the film in *medias res* as Rosetta tears through the factory building for an as yet unknown reason. By introducing Rosetta as if she predates the film, the brothers display another trace of their documentary work whereby the camera captures an unreconstructed slice of life. Rosetta is too preoccupied by her situation to have the leisure to reflect on her circumstances. Similarly, we are too busy following her relentless pace and feeling her visceral energy to speculate on her background. The narrative trajectory of *Rosetta* focuses sharply on one person and thus is simpler than that of *The Promise*, whose 'infernal trio', says Luc – Igor, Roger and Assita – the brothers had to forget in order for the new film to stand on its own.

Given the influence of Levinas on the brothers, Marie-Aude Baronian suggests that the viewer's limited knowledge of Rosetta is consistent with the philosopher's vision of the other as an enigmatic individual at once familiar and strange, recognisable and inscrutable. That we are proffered so little information on her, Baronian continues, renders her 'other', thus in 'the Levinasian perspective imposing and unattainable at the same time' (2008: 154). In the philosopher's terms she takes the viewer hostage, since we are always and constantly held hostage by another whom we must encounter for any ethical code to be constituted or practiced and for any moral judgement to result.

Her expression is equally ambiguous, piercing us, nailing us to our seats, but it is also that of a frightened animal careening wildly from one place to another in search of refuge and security. With bright, wary eyes that 'look into the night of the auditorium', as Luc puts it (2005: 73), Rosetta stays on the lookout and remains in defensive mode. Installed in the waffle stand she smiles briefly at her customers until she glimpses Riquet, at which point her expression hardens so as to deal with his wounded presence, his new status of outsider as a consequence of her actions. A strange role reversal has occurred, and while we know that Riquet was fiddling the till, his misdemeanour seems minor compared to Rosetta's calculated betrayal of his confidence. Yet, as Jean-Pierre says, 'employment today is like a game of musical chairs' (in Camhi 1999). If you are eliminated from the game, the only way to get back in is to eliminate someone else.

Accelerating the innovative technique unveiled in *The Promise*, *Rosetta* is the Dardennes' most urgent and restless film. The effectiveness of their intense pursuit of Rosetta as she goes about her daily life depends to a great extent on the hyperkinetic style of the film. Their use of a handheld Super-16mm camera, unmitigated by Stead-

icam technology, defines this style along with a foreshortened focal length that brings the viewer very close to the object being filmed. The tight framing and restless camerawork recurs in *The Son*, albeit with more moments of silence and reflection, while *The Child,* though technically in the same vein, points towards the more detached and slower paced *The Silence of Lorna.*

From the opening scene in the ice-cream factory where Rosetta fights her dismissal, the viewer is taken on a shaky, bumpy, breathless ride as the camera obsessively follows the girl's body in its almost constant motion. Apart from bus rides to and from the town centre and the outskirts where she lives, Rosetta walks everywhere. Her step, quick and purposeful, is a life or death matter; Luc notes how in this respect she resembles some of Dostoyevsky's characters. Though their camera stays close to Rosetta, the brothers are careful not to let it be mistaken for her point of view. Their positioning of the camera eye close to but not entirely with Rosetta generates a productive tension between proximity and distance, between participation and observation. Answering a question about the dialogue between filmmaker and viewer, Jean-Pierre says that 'within the frame we have a little spare space for the spectator to enter the film and do their own work' (in Dawson).

Their choice of a restricted visual field within the frame creates a claustrophobic effect that expresses Rosetta's life as confined to a set of familiar places, actions and interactions with others. The physical space of the film is limited and oppressive, deliberately lacking long shots that might establish a geographical and social identity. Local people and seasoned Liège-Seraing visitors may recognise some of the banal locations that the brothers use: Mio's ice-cream factory, the bus station in Jemappe (directly opposite Seraing across the Meuse), a pond in Nandrin, a camping site in Hamoir. But to the majority of viewers these places might be anywhere in a depressed urban area.

The film basically exploits three interconnected spaces. One, a public space, consists of an anonymous town centre, a concrete jungle of highways and walkways or drab commercial streets where Rosetta searches for work. Another public space is what Jean-Pierre calls 'the no-man's-land', an intermediate zone where Rosetta takes the bus to and from the town centre. So ashamed is she of her home that on alighting from the bus she pretends to enter the gates of a residence before wheeling around to cross a dangerously busy road and disappear into a third, private space comprising woods, a fish pond and the forlorn caravan site, which she enters unnoticed through a cut she has made in a wire fence. Safely out of sight in the woods she exchanges the dress shoes of her job-seeking missions for rubber boots, the only practical footwear for her activities there and on the caravan site. She conceals the footwear in an old drainpipe, an example of the Dardennes' knack for using random objects as meaningful detail. Later, embarrassed by Riquet finding her at the site, she angrily demands to know how he got her address and flies at him like an unleashed guard dog. They wrestle each other to the ground in an implicitly erotic manner and their physical entanglement initiates an awkward and ambiguous relationship between them.

The style of *Rosetta* retains much of the documentary impulse that informs the brothers' video work and returns us to the notion of 'resistance' that lies behind their approach to *The Promise*. As in that film, the brothers' camera seeks to be in the scene

it is capturing rather than calmly detached from it. Jean-Pierre explains: '[in] the documentaries that we used to make, you go to film a reality that exists outside of you and you don't have control over it – it resists your camera. You have to take it as it is. So we try to keep that aspect of documentary [in] our fiction, to film something that resists us …. [This] opacity, this resistance, gives the truth and the life to what we're filming' (in Kaufman 1999). Thus they deliberately limit their own mobility and viewpoint during shooting – a good example in *Rosetta* being the scenes inside the caravan. Luc acknowledges that they 'organise the *mise-en-scène* in a way to somehow give the camera [a] wrong place' (in Edelmann 2007: 222). We may then understand why they prefer a difficult or 'bad' set-up for shots that nonetheless give an illusion of direct involvement in the happenings of real life to an easy set-up for 'well composed' but facile shots.[3] The brothers' unusual shot composition with its unpredictable framing and sudden movement may unnerve the viewer, but to be thus disturbed is both consequent on their technique and necessary to their aim of depicting Rosetta's daily life via the sheer force of her physical presence. Even though, in *Rosetta* for the first time, they re-shot and re-wrote certain scenes during production, the end result suggests single takes because they insist on 'resistant' camerawork and on spontaneous acting.

The turbulent style of the film may be a testing experience for the viewer and not one for the faint-hearted. And given Rosetta's extreme situation, faint-hearted she cannot afford to be. Speaking of *Rosetta* as a 'war' film, the Dardennes portray its protagonist as an urban guerilla engaged in a battle of Darwinian proportions with the conditions of her everyday life. She makes expeditionary sorties into the heart of town and at the end of the day retreats to the isolation of her base camp in the 'darkness on the edge of town', in the words of Bruce Springsteen's eponymous 1978 album, a darkness that for Rosetta as for Springsteen is as psychological and spiritual as it is physical. She has no choice but to develop a survival strategy if she is to counter a system that ignores and excludes her, but its practice takes a toll. The cause of the stomach cramps that she soothes with the warmth of a hair-dryer is unexplained. We are left to guess that they are symptoms of stress, yet she studiously avoids recourse to the palliatives of sex, drugs or drink. Her self-respect and tenacity keep her from following her mother's descent into dependence on them. She keeps herself going, literally, moving furtively through the woods, covering her tracks, holding others at bay, guarding the tools and instruments she employs in scavenging and poaching. For instance, she painstakingly fashions a bait and hook attached to a bottle she tosses into the pond.

As for the Dardennes' use of sound in *Rosetta*, an aesthetic of immediacy is again their dominant realist principle. The brothers never overdub, always opting for direct sound whether recorded wild (independently of the image) or during the shooting of a scene. In this respect, says their sound engineer Duret, interviewed by Aubenas, they are as 'devoted' to direct sound as was Renoir, who first 'understood that what occurs is unique and will never be reproducible' (2008: 177). They are so intent on getting the right sound in their films, adds Duret, that when they scout locations they listen to them as much as look at them. *Rosetta* incorporates various sounds heard on the set, a further indication that the brothers are willing to let the phenomena of the real world suffuse their films with unintentional significance. These sounds contribute greatly to

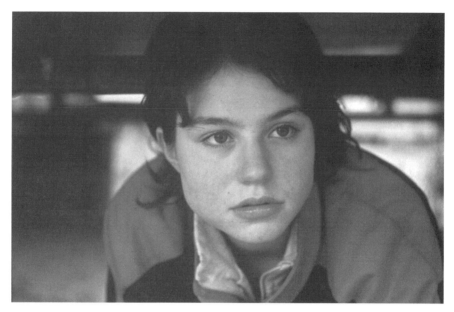

Best female performance, Cannes Festival: Emilie Dequenne as *Rosetta*, 1999

the representation of Rosetta's nerve-wracking existence: barking dogs, rustling leaves in the wood, running river water and especially the constant roar of urban traffic. Loud or soft, natural or artificial, these sounds are not conveniently filtered out to privilege dialogue or to assuage the viewer's discomfort; rather, as in documentary practice, they remain unmediated and thus intensify the realism of a scene. Moreover, some aural traces remain of scenes that the brothers discarded or condensed. For instance, the buzzing sound of Riquet's motorcycle approaching the prostrate Rosetta becomes a tense element of the last scene, but the camera remains on her and we do not see the machine at all or anything of him until the final shot.

We also hear Rosetta's often heavy breathing as the most intimate evidence of her overextended physical state. The brothers approach the shooting of a film with breathing very much in mind. To create respiration and rhythm – 'our cinematic form' says Luc (2005: 92) – within a scene is a fundamental part of their method. He confesses that a rhythm to match their portrait of Rosetta was far more difficult to find in the editing room than on the set.

The brothers use no background music in any of their films from *The Promise* to *The Child*. It is the only thing they dislike in Loach's *Raining Stones*, a film they otherwise greatly admire. They use diegetic music equally sparsely. In *Rosetta*, it occurs only in the scene at Riquet's apartment when he plays Rosetta the tape of his band and invites her to dance to it.

Carole Desbarats (2008) argues that the brothers' strict control of every aspect of *mise-en-scène* allows them to avoid generating excessive pathos in anguished scenes. Such a melodramatic recourse would be antithetical to the brothers' unflinching realism and emotional rigour. The brothers prefer what Rossellini called 'the dry eye', a

method characteristic, says Luc, of his *Germany Year Zero* as well as of Bresson and of Howard Hawks' *Scarface* (1932). The proximate camerawork invites us to share Rosetta's rage and frustration, to understand her, support her and occasionally reproach her, but not to pity her or cry for her. The brothers do not portray Rosetta as pitiable; her body language and terse words indicate how independent, tenacious and proud she remains almost to the end. Desbarats suggests that 'the feeling sought by the *mise-en-scène* is therefore not compassion but rebellion' (2008: 205). In any case, like Rosetta, we are afforded no time to reflect on the situation. There are few moments of stillness in the film and they occur mostly in places where she cannot engage with the outside world and finds a temporary breathing space: the caravan home and Riquet's flat. Bert Cardullo (2002) points out that most of the scene in the flat, unusually for the Dardennes, is a static long take in medium shot befitting the mood of a necessary break in Rosetta's furious stride. The only other times we become aware of her pausing to reflect are when she almost lets Riquet drown and when she decides to inform on him. In the first instance she throws a branch to him; in the second, her moral scruples lost in her desperation to land a job, she throws him to the wolf.

The film critic Laurent Joffrin, writing in *Le Nouvel Observateur* (7–13 October 1999) maintained that the character of Rosetta is a cinematic throwback to the novels of Zola and that her humiliating predicament echoes that of workers caught in the web of late nineteenth-century industry and its oppressive labour conditions. But the Dardennes, neither naturalists nor determinists, do not represent Rosetta as a passive victim of circumstances beyond her control. Everything may be stacked up against Rosetta at home and at work, and her future is unpredictable, but she remains a free agent of her own destiny. 'We wanted the story, the plot, the driving force to come from within her', says Luc; 'If Rosetta does something, it's because of her and she faces the consequences of what she's done. When you're poor, you can't plan your life, so you just react to what life throws at you' (in Andrew 2006). Luc prefers to see her as closer to Galy Gay – an ordinary person forced by a dehumanising system to become an effective soldier – in Brecht's *A Man's a Man* (1926) or, after reading *Madame Bovary*, as 'Emma's great-granddaughter' obsessively and defiantly chasing nonexistent work as Flaubert's heroine chases an impossible love. Both he and Jean-Pierre agree that she resembles closely another ice-cream factory worker in a similar predicament, a poor and illiterate Dutch girl in Van Der Keuken's documentary *De Nieuwe Ijstijd* (*The New Ice Age*, 1974). And it is unsurprising that critics have compared Rosetta to Mouchette – a downtrodden young woman with an invalid mother kills herself – but *Rosetta* has neither the transcendent spirituality nor the cool detachment of Bresson's film.

After *The Promise* and *Rosetta*, the brothers were asked if they might consider making a comedy next time around, to which they answered predictably in the negative. They added, however, that they love comedies – for instance, Charlie Chaplin's *The Gold Rush* (1925), which is a popular classic about a lonely outsider in a competitive free-for-all trying to stave off destitution and gain some kind of social acceptance. And, denying any opposition between art and popular cinema in their concept of filmmaking, as the master of silent comedy would have done, the brothers consider *Rosetta* to be a popular film because anyone prepared to put aside his usual expectations of the

cinematic experience can relate to its simple content. It will be a rollercoaster ride, but whoever takes it will experience a serious, vibrant and entertaining slice of an outcast teenager's life.

Notes

1 Like Olivier in *The Son* and Sonia in *The Child*, Rosetta prepares her simple rations on basic cooking equipment in spartan domestic surroundings.
2 Bert Cardullo (2002) sees her stumbling thrice beneath the weight of the cylinder as indicating Rosetta's Christ-like bearing of her own cross in the sinister Golgotha of the caravan site before her resurrection at the hands of Riquet. He further sees a religious significance in her role as waffle seller: Dutch *wafel* (wafer), ie the Eucharist.
3 Compare, for instance, Jacob Leigh on Loach, a 'key trope' of whose work is 'the rhetoric of the "unplanned" shot' (John Caughie), a method that privileges an 'action-led camera' (John Corner) by responding to rather than anticipating characters' actions and words (2002: 17).

Pushing the Envelope: The Son, *2002*

The release of *The Son* enhanced the Dardennes' growing international reputation. Olivier Gourmet's leading role in the film brought home the Best Male Performance prize from Cannes. It was the Dardennes' first film involving their French co-producing partner Denis Freyd, whom Luc calls their 'third look', and his company Archipel 35, beginning an ongoing collaboration that includes Freyd's artistic as well as financial input to the brothers' filmmaking activity. Following their usual practice the brothers took three years to make *The Son*, though they were developing its script during the filming of *Rosetta*. At first they toyed with two possible stories; having chosen one, they set it aside and took a break before resuming it definitively. *The Son* shares much with its predecessor in style and technique, albeit less frenetically paced, and continues to explore ethical issues in the lives of ordinary individuals in crisis. Writing in his diary on the eve of the millennium, Luc acknowledges that *The Son* and the two films that precede it form a kind of unplanned trilogy about rites of passage and rebirths. In retrospect we may see this thematic continuity extending to the three later films.

 The Son introduces us to Olivier (Gourmet), a carpentry instructor at a vocational training centre for recalcitrant youths. Deeply troubled by the murder of his son during the theft of a car radio and divorced as a result, Olivier fills his days with dedicated work at the centre. One day he discovers that sixteen-year-old Francis Thirion (Morgan Marinne) has enrolled in his carpentry class. Francis is unaware that Olivier knows he is the killer of his son. Racked by doubt and by resentment of the boy yet curious to know him better and willing to help him and so help himself, Olivier decides to keep him in the class, which alienates him further from his ex-wife, Magali (Isabella Soupart). Olivier and Francis develop a close but guarded working relationship that culminates in a weekend day trip together to get supplies from a timber yard. While there, Olivier tells Francis what he knows. Olivier wants only to talk openly of what happened; Francis, fearing he has been lured into a vengeful trap, leads Olivier on a chase that ends in the surrounding woods with Olivier barely refraining from physical reprisal. As in *The Promise* and *Rosetta*, the film ends indeterminately but, like Igor and

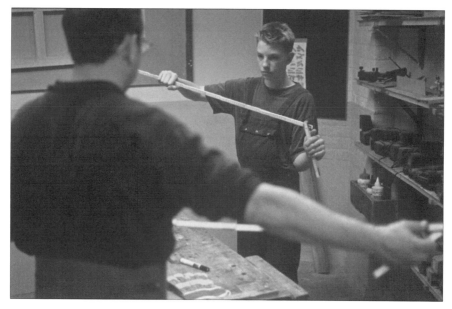
From the back: Olivier (Olivier Gourmet) instructs Francis (Morgan Marinne), *The Son*, 2002

Assita or Rosetta and Riquet, Olivier and Francis discover an opportunity for reconciliation that will depend on their acceptance of mutual respect and responsibility.

After his performance in *The Promise*, the brothers had told Gourmet they would make a film around him. *The Son* offered him a perfect role as an unfathomable individual, who is unbalanced by his son's death and struggles to understand why he thinks and acts as he does. At first the brothers envisaged him as a cook, but they preferred the idea of a carpenter as someone working with living material. Anyway, a kitchen setting would have invited the use of knives, an immediate dramatic danger sign to the brothers. That they used the actor's own name, Olivier, for his character was a measure of his fitness for the role. Indeed, the ideas of measurement, of balance in carrying and levelling wood, and of gauging distances between persons and objects are fundamental to a film about carpentry. Another factor in the brothers' choice of that craft was that Gourmet had acquired carpentry skills from his grandfather and needed only to renew them. Full faced, with eyes hidden behind thick glasses and a gruff voice that gives little away, Olivier is the epitome of an inscrutable ordinariness. Everything about him is the antithesis of glamour right down to the work clothes he always wears: blue overalls, a maroon flannel shirt and a broad brown leather belt.

The Son builds slowly and steadily to an explosive release of tension at the end. Its suspense relies on gradually revealing character rather than on conventional dramatic action. Luc views Olivier as incarnating suspense. As is their wont, the Dardennes invite the viewer to wonder repeatedly what their protagonists will do next. Will Olivier snap and wreak vengeance on Francis? Will their actions change them and how? In the Dardennes' uncertain world of limited verbal and visual information, they always offer more questions than answers. Writing in *Le Nouvel Observateur* (24–30 November

2002), the critic Pascal Mérigeau divides the plot into three stages of which the viewer and the characters share differing degrees of knowledge. In the early part of the film, the viewer knows nothing. We ask why Olivier spies on a new student. What is going on in his mind? What is his problem? For much of the film Olivier acts like a predator watching, stalking and circling his prey. We wonder fleetingly if he is a pederast such is his surreptitious fascination with the boy. The scene in which Olivier tells Magali that the new boy is their son's killer begins the second stage. The viewer now knows what Olivier knows, but Francis remains unaware of Olivier's identity, though we are entitled to think he may suspect it via his surname, a detail omitted from the film. This second stage occupies much of the film as we follow the tense, awkward interaction of the two main characters. The third stage comes at the end, in the timber yard, when Olivier reveals he is the father of Francis's victim. Everyone now knows the truth, and this sets the stage for a possibly positive turn in their relationship.

At least on the surface Olivier and Francis are more introverted and placid in nature than either Igor or Rosetta. Neither gives much away as they try to get the measure of one another. Olivier's mental turmoil produces a physical restlessness in his pursuit or evasion of his quarry – a motion captured by the Dardennes' equally restless camera. We soon understand that this normally steady, imperturbable man is in a highly abnormal state, placed under great strain by extraordinary circumstances and beset by confused emotions.

Unlike Rosetta, whose motives and actions become clear very quickly, Olivier remains an enigmatic figure. His desire to forgive Francis and become instrumental in the boy's rehabilitation conflicts with a primal urge to avenge his son's death. Proud, unbending and uneasy, he throws himself into helping his youthful trainees to learn a craft that will allow them to earn a living, to become responsible citizens, and to change from boys into men – as Roger does less altruistically to Igor in *The Promise*. As unsure as we are about Olivier's motives and inner struggle, he shows himself to be more of a mentor to these boys than a mere classroom instructor. This attribute reveals itself in a tangential scene in a café where having taken valuable time out from his classroom duties Olivier confronts the mother of one of his students for trying to distract him from his course of study. Once we witness his caring and compassionate side, we sense that he may be inclined to help than rather than hinder Francis and that he may possess a vital quality of mercy. But he must first overcome his inner resentment of the undemonstrative and surly agent of his son's death. Olivier is clearly on a short fuse and we wonder whether he can stop it from detonating. In the café outburst he shows a potentially violent side by almost throttling an interloper with the man's scarf before pushing him down roughly into a chair. And we remain unsure about this side to the very end when, after chasing Francis through the woods, he momentarily makes as if to throttle him too. By then, however, we sense that he will not kill anyone. His violent gesture represents his frustration at Francis's unwillingness to face his crime and his apparent lack of remorse for it.

Like Rosetta, if less furiously, Olivier is always on the move. The brothers' mobile camera, neither omniscient nor indifferent, follows him so closely that we literally look over his shoulder. As the camera focuses on his facial expressions and his body language,

tracking his often sudden and inexplicable movements, back and forth, up and down, in and out, it seems at once to embrace in its vision both Olivier's and our own anxiety as we seek clues to his thoughts and actions. We hurry down the corridors of the centre with him, lie on the floor of his flat with him as he does his back strengthening exercises, and rush off to the café with him. Words are few and reveal little, but what we see at close quarters bears much meaning. Luc admits to a feeling of lying 'as soon as we widen the frame too much' and adds that 'in proximity to things, between the bodies, we find perhaps a presence of human reality, a fire, a warmth' that fend off despair and give rise to a continued belief in mankind and its place in the world (2005: 139).

Marinne had appeared as a young boy in Jan Bucquoy's autobiographical satire *La Vie sexuelle des belges* (*The Sexual Life of the Belgians*, 1994), but playing Francis was his first significant film role. The Dardennes sensed his acting ability but at first were concerned by his resemblance to Renier whose filial relationship in *The Promise* threatened to haunt the new film by its similarity. But the relationship differs in *The Son* in being warily distant rather than intimate and in being symbolic rather than literal. In choosing Marinne from the final two auditioners, the brothers again showed their knack for picking an ideal actor for the part. They gave the young actor much support especially as he was afraid of Gourmet, who asked him to keep his distance so that he would not change his attitude and thus work against the interest of the film. He impressed the brothers by knowing how *not* to speak and how to gaze piercingly with 'tigerish' eyes, as they put it. Slightly built, pale-faced, sullen and monotonous – his behaviour exacerbated by sleeping medication, which also explains why he naps in the changing room at the centre and in the car – he displays less openly the rebellious attitude of Igor, Rosetta, Bruno and the latter's younger sidekick Steve. Like a wounded animal instinctively protecting itself, he also shares with those peers an outer hardness masking an inner frailty and vulnerability. He is a semi-orphan; no mention is ever made of his father – opening a door for Olivier to fill this role vicariously – and we learn that his mother spurned him after he was convicted of murdering Olivier's son, a crime that appears to have been unintentionally committed.

Olivier's ex-wife Magali disappears early in the film. Luc writes of the 'strange necessity of this exclusion of women in order for the plot to develop' (2005: 128) along the lines they felt it had to, that is, between a father who has lost his son and another 'son' rather than between a mother who has lost her son and another 'son' or even a 'daughter'. Olivier deals practically with Magali's fierce and distraught responses to his actions before she steps aside and he refocuses on his burgeoning relationship with Francis. However, while in the story, she functions as a chorus, asking many of the questions the viewer also has about Olivier's thoughts and deeds. The few scenes she shares with him are important moments in the film. The murder of their son having provoked their separation, Magali has created a new life, unlike Olivier, who remains in thrall to a painful past. She tells him she is pregnant and so ready to replace her lost and only son with the child of a new husband. Her announcement convinces Olivier to accept Francis as his student and he tells her of his discovery of the boy's identity. She reacts angrily, rejecting any involvement with the boy and accusing Olivier of being out of his mind. When Magali asks him incredulously why he is doing what he

Olivier (Olivier Gourmet) meets Francis (Morgan Marinne) at the hot dog stand: *The Son*, 2002

does and who he thinks he is, his reply is that he does not know but that he must do it. Stubborn and determined, he refuses to turn back; she considers him arrogant and reckless. Is he a masochist wishing to rub salt into his wound? Or is he engaging in a deluded form of saintly self-denial? Or is he driven by sheer curiosity? Or, more frighteningly, is he plotting an act of revenge? The viewer, now granted more knowledge of the situation, replaces Magali in accompanying Olivier and Francis on a dangerous and unpredictable journey whose course and consequence remain unpredictable to all.

On the revelation that Francis has been released from juvenile prison after serving his term for killing Olivier's son, the principal ethical issue in the film becomes more clearly defined: what should Olivier rightly do about him?[1] As in their other films, the Dardennes avoid a simplistic Manichaeism and offer no easy answers. *The Son* indirectly raises another question: what does it take for one young person to kill another? In this regard the 1993 case, in which two ten-year-old children in Liverpool kidnapped and murdered two-year-old James Bulger, bore on the brothers' conception of the film. 'What did they inherit to commit this act?' asks Luc, adding ruefully: 'state of things in our world' (2005: 20). Out of their subsequent reflections came the idea of a film dealing with infanticide and vengeance but where the main character resists an urge to kill in return. Olivier's effort to resist this urge becomes a trial of his humanity (*L'Epreuve*, 'the trial' in English, was a working title for the film) and its Old Testamental scenario reflects the brothers' awareness of the story of Abraham being commanded by God to kill his son Isaac as a test of faith but being countermanded by angelic intervention to sacrifice a sheep instead.[2] The motif of the son naïvely following his father to the killing ground also reminds us of the action of Igor until the death of Hamidou in *The Promise*.

As Olivier and Francis move slowly and awkwardly towards a likely mutual accommodation, we witness a battle of wits between them. This battle – between adult and child, between 'father' and 'son', between teacher and apprentice – plays out in various ways, whether literally, as in the scene at the timber yard, or symbolically, as in the game of table football in a café on the journey there. Throughout the film each tests the other and tries to figure him out – a difficult process given their laconic manner and self-protective veils. But the playing-field is not quite level: Olivier knows more about Francis than vice versa, though Francis seems to wish for a father figure and wonders if his teacher might be a suitable one. Even as something deep within Olivier – neither explicable nor acceptable to Magali nor much more so in his own mind – draws him to Francis, he cannot bring himself to shake hands with the boy, or to be addressed by his first name, or to buy him an apple turnover in the café *en route* to the yard.

After Olivier comes close to harming Francis in their climactic stand-off and physical struggle, they pick themselves up from the ground and try to resume their severely strained but unbroken relationship. By being willing to educate Francis in a positive spirit, to mentor as well as train him, a course of action that nonetheless gives him frequent cause for doubt and hesitation, we see Olivier reconstructing his 'fatherhood' in the most difficult and unlikely situation of tacitly inviting his son's killer to become his victim's surrogate. Even to consider such a possibility demands much of him, as it does equally of Francis, who must also show himself to be worthy of Olivier's generosity and trust.

Once the vital truth-telling has occurred – as between Igor and Assita – and no further physical injury or death has resulted from it, life may change for the better. Following a fundamental tenet of Levinasian ethics, Olivier accepts the impossibility of murder, which is, however, not a pardon of Francis, though it may constitute a form of one. As Luc insists, 'we must not fall into reconciliation where nothing unpardonable could continue to exist. […] The question of the film is one of the father and not of the pardon. Olivier, by not killing Francis, is the father who perhaps will allow Francis to renew his life' (2005: 116). No longer the abominable other in the eyes of his new 'father', Francis may re-enter the social world with Olivier's help.

In *The Son*, as in *The Promise* and *Rosetta*, the Dardennes remain wary of conventional narrative closure and again choose an open ending via a sudden and unexpected cut to black. We thus drop out of an unfinished story as we had dropped in on it at the beginning of the film. A long haul lies ahead for both Olivier and Francis. The former has not pardoned the crime to which the latter has never confessed. Yet the worst moment between them – Olivier's near strangulation of Francis – may have passed. In the final scene they resume their teamwork by binding and loading planks of wood into the trailer attached to Olivier's car. The unbound disorder of the 'wild' wood where they wrestled breathlessly in a bed of leaves has reverted to the bound order of the sawn and sorted timber of their trade. As they bind the planks – like Abraham and Isaac roping the sacrificial sheep – they become 'father' and 'son', ironically like Roger and Igor wrapping Hamidou's corpse in order to bury him, but here in concert rather than in cahoots with one another, in a potentially rewarding way that may bring them closer together rather than, as in *The Promise*, force them apart. Their mutual obligation to complete a

job properly contains an unspoken gesture of potential reconciliation between them, as if they implicitly agree on the necessity of order, limit and measure.

The carpenter figure, the symbolic cross-carrying of wood, the likely triumph of good over evil, the testing of the limits of God's grace, and the confessional aspect all tempt some critics to read *The Son* as a Christian allegory. While the Dardennes' own Catholic upbringing and biblical knowledge might lend credence to this view – and they remain open to the validity of a religious interpretation – they reject institutional religion, so the possibility of grace in their films is grounded firmly in a secular world. Luc says that their films 'are about guilt, but not about sacrifice in a Christian sense. We never sacrifice our characters – nor do we sacrifice anyone else so that they can find salvation, as religion would require' (in Romney 2006). Any 'salvation' is the result of human action, of a deliberate behavioural change. Goodwill, friendship, loyalty and acknowledgement of responsibility are keys to this change. With the possible exception of Lorna at the end, the brothers' protagonists never look to a redemptive spiritual experience as a solution to their problems. As their co-producer Freyd puts it, interviewed by Aubenas, 'it's a human faith, not a faith in God. It's a lay vision with a political conviction' (2008: 235).

The cinematic style of *The Son* has much in common with *Rosetta*. The Dardennes use many close-ups but avoid establishing shots. The framing of the image remains tight and often unstable giving rise to shot compositions that may, as in the two previous films, appear random or careless when in fact they are precise. The brothers may have mastered the illusion of spontaneity, improvisation and accidental capture of action, but they studiously plan each of their shots, some of which are extremely difficult to achieve. For instance, during the journey to the timber yard Francis climbs from the front to the back seat of the car in a single shot, which creates a powerful sense of involvement in the action despite the constraint of filming in a highly restricted space. The brothers' choice of a Minima Super-16 camera held at arm's length allows them to create an impression of constant imbalance in Olivier, 'as though', says Jean-Pierre, 'he didn't have two feet on the ground' (in Dawson). And though a restless movement characterises *The Son*, as it did *The Promise* and *Rosetta*, the film is purposely quieter and slower in pace than its two predecessors. One result is that more time and space opens up for moments of stillness and silence as, for instance, when Olivier takes Francis's keys from his locker, slips away from the centre, and enters Francis's rented room. This meditative scene, in which Olivier tries unsuccessfully to put himself in the boy's shoes, anticipates several nail-biting scenes in *The Child* when Bruno finds himself caught inside a lock-up garage and an empty flat.

An agitated movement nonetheless prevails in the film. It centres on the bodies of Olivier and Francis as they dance an 'almost caricatural ballet of confrontation', in Françoise Collin's phrase (2008: 210), moving to and fro in a cat and mouse game with each other but never in physical contact until the final struggle in the woods. For much of the film the Dardennes focus their camera on Olivier's back and the nape of his neck. The 'axis' of the film, says Luc, is in these bodily parts.[3] They represent Olivier's suffering and vulnerability but also his solidity, his thicker skin. From the first moments of the film his knowledge of his son's death and the recognition of his killer as the boy

he is being asked to take into his class become twin burdens Olivier carries on his back, in the dark bulk of which sits what Luc calls the 'human enigma'. The brothers' task, for Gourmet, was to make the 'visual baggage' of his back 'intelligent' and thus help reveal the person. To shoot a character from behind makes his actions more mysterious, destroys the illusion of omniscience, and interferes with 'normal' vision thus upsetting both perceptual and semantic expectations. This method reveals the influence on the brothers of Kieslowski regarding 'bad' camera placement, a strategy that at once creates a troubling obstacle to the viewer and a degree of knowledge of the characters. Luc compares the 'bad' view Olivier has of Francis in the centre's office at the beginning to that of Rosetta as she spies on Riquet's underhand waffle trade. The 'gap' that opens up between seeing what the character sees and not quite seeing it 'creates for the viewer the tension of the secret' shared by the characters. Luc adds that 'the more the bounds of this gap draw closer together without being able to join, the more the current of the secret that connects [the two characters] intensifies' (2005: 130).

At the beginning of the film, as in *Rosetta*, the camera follows Olivier as if it has stumbled by chance on a story already under way. As the main credits end, we see very little other than an unintelligible dark mass that slowly becomes Olivier's brown leather belt. The camera eventually pulls back to show an ordinary-looking man involved in a situation that makes him extremely uneasy. These fragmented pieces of information draw us brusquely into the situation. Shadowing him, we try to make sense of our rough and ready entrance into the world of another. Again there is no establishing shot used or any verbal or visual context offered. The film thus emerges organically from its position behind Olivier, as if, writes Daniel Frampton, it 'derives itself from him, has lived with him, will live with him' (2006: 147).

The Dardennes match this limited visual information by using only direct sound. There is no music, not even within the diegetic world. The foreground 'music' of the film – recalling *You're on My Mind* and the documentaries on Léon M., Edmond, and Louvet – is the harsh and rhythmic sound of tools and machines in use; its strident yet strangely reassuring quality provides an aural correlative to the uneasiness of Olivier and Francis. Nerves on edge, emotions barely repressed, they cling to the structure and regularity afforded them by their shared occupation. The brothers also reduce the dialogue to its bare essentials, something else they have in common with Bresson. No grand monologues, dialogues or rhetorical *tours de force* attempt to explain either the motivation of the characters or the happenings in the film. As Jean-Pierre explains, the film is 'about the difficulty of speaking for both Olivier and Francis'. And the brothers do not care for talkative cinema – 'why clutter up a film with chattering?' (in West and West 2003). Rather, they make their points cinematically via the physical actions of their characters in relation to others and to the world surrounding them. With gentle self-deprecation Luc suggests their minimalist style is formulaic, their interest going 'immediately to the essential', which in this film 'is the doubt, the hesitation, the oscillation about whether to kill or not to kill' (in Dawson).

Crucial to this mode of representation in *The Son* is the Dardennes' focus on the processes of skilled manual labour, a sphere with its own conventions, rules, habits and rhythms. The rhythm of their films always corresponds to the rhythms of daily work

– or rather, in the cases of Roger and Igor, Rosetta, and Bruno, a lack of it, though all 'work' even when officially unemployed. *The Son* differs from the other major films in portraying an example of regular, legitimate work of a kind that has all but vanished in the two films before it as well as in *The Child* and *The Silence of Lorna*. Yet, though Roger is gainfully employed at the centre, his trainees may only expect tradesman's work to follow, and the broader visual context of the film suggests the same drab urban community in decline that marks the other films. Nonetheless, in *The Son*, daily work and the discipline it imparts remain important, while the tools and accessories of the trade are equally significant: for instance, a folding ruler, a hammer, a ladder and Olivier's belt – suggested to the brothers by a memory of their father's belt – endlessly tightened and loosened in an echo of his engagement with Francis. And the precise, practical, repetitive, learned practice of the artisan is also the film practice of the brothers.[4] They are 'carpenters' too, craftsmen who are careful and proud of the accuracy and finish of their work. Their understanding of these occupational values comes from having grown up within an industrial environment whose social cement was an entire community of working people united by a common way of life. That way of life, almost lost by the early 1980s, is at the heart of three of the brothers' documentaries and *You're on My Mind*. By the time of *The Promise*, regular work is scarce and more often than not temporary or unskilled; the riskiness of untrained construction work indirectly causes Hamidou's death. For Rosetta, legitimate work of any kind is almost impossible to find, while for Bruno it is not even worth searching for. Even Lorna finds only a menial job, though – as in *The Promise* – an active circuit of illegal money-making based on undocumented aliens soon draws her in.

Resisting the lure of visual spectacle, the Dardennes again restrict the settings of *The Son* to a succession of undistinguished locations: Olivier's and Francis's small and bare living quarters, the interior of Olivier's car, several cafés, a car park, a few city streets by day and night, a country road, a timber yard. The centre – unnamed and unprepossessing apart from its valuable vocational function – is a disused school building in Liège that the brothers gained permission to use. The only exception to total location shooting is the workshop within the centre, which they reconstructed as a film set for practical reasons of camera placement and movement. The paradox of familiar anonymity is another triumph of resistant realism that raises the Dardennes' cinema from the local to the universal; everything looks utterly authentic but has no specific place. On the journey to the timber yard we see glimpses of the surrounding town and countryside from the cramped and restricted viewpoint of the pair in the car, shot in available light, and we almost feel the grey and dank late autumnal landscape: rain, mud, trees and fallen leaves. It is truly Belgium for those who know it, but sufficiently and convincingly anywhere for those who do not.

Notes

1 The question of what to do in the known and unrestricted presence of the killer of a family member is the subject of three other recent films – two American, one Norwegian – that may be compared to *The Son*. In *The Crossing Guard* (Sean Penn, 1995) Jack Nicholson

plays a grief-crazed father who has waited three years to avenge the death of his daughter at the hands of a drunken driver. As in *The Son*, his marriage has broken up as a result of his obsession and his wife has remarried. Another revenge drama, *In the Bedroom* (Todd Field, 2001) depicts the torment of a man (Tom Wilkinson) and his wife (Sissy Spacek) unable to accept the freedom of their son's accused killer bailed and protected by the influence of his family in their small-town community. In *De Usynlige* (*Troubled Water*, Erik Poppe, 2008) a man accused of killing a boy is released from prison and adopts a quiet life as a church organist until the dead boy's mother happens to encounter him.

2 *Genesis* 22: 1–16.

3 An early sign of their interest in shooting the back of a character is Luc's 1996 reference to *A Letter to Three Wives* (Joseph L. Mankiewicz, 1949): 'Linda Darnell's back and hair, alone in the frame… Awaiting a movement, awaiting a face…' (2005: 62).

4 See Philippe Reynaert (2008) for a personal reflection on this aspect.

Second Palme d'Or, The Child, *2005*

The Child carried off the top prize at the 2005 Cannes festival six years after *Rosetta* had also done so. No directors had previously received this honour in such a short period of time. In *The Child*, the Dardennes continue to portray individual lives in crisis on the margins of established society. As in *The Promise* and later in *The Silence of Lorna*, organised crime is also present in the form of human trafficking. The brothers also continue to probe ethical issues around the eventual awakening of a disturbed individual to a sense of personal responsibility in dealing with others. An early title for the film, according to Luc, was *Le Rachat*, which means both 're-purchase', referring to a crucial act that helps to transform the protagonist, and 'atonement', in a theological sense, referring to his rediscovering a moral conscience.

The film introduces us to Bruno (Jérémie Renier), a twenty-year-old urban drifter engaged in panhandling, wheeler-dealing and acts of petty crime with a small band of juvenile accomplices. Early on we see him exchanging money with his cohorts, while his eighteen-year-old girlfriend Sonia (Déborah François) and their new baby melt into the background as if insignificant to the pecuniary matter at hand. The couple names their baby Jimmy, but Bruno seems uninterested in his son other than for his role as a convenient softener to those whom he hustles for small change, so their life soon returns to a habitual pattern of impulsive behaviour and survival by any available means. As a single mother, Sonia has a sparse council flat but is behind on her rent and has been obliged to sublet it. Estranged from his own family, his father an absent figure and his mother having moved in with a new partner, Bruno is a vagrant, sleeping either in a shelter for the homeless or in a ramshackle hut on the river bank where he fashions a bed out of cardboard sheeting. One day, left in charge of Jimmy, Bruno – having heard of adoption rackets from a woman to whom he fences stolen goods – decides to sell the baby for €5,000 to a gang of traffickers, whom he travels by bus to meet in an empty flat on the edge of town. Apparently unmoved by the implications of his actions, he brandishes cash before Sonia and tells her of his deed. Unsurprisingly, she

Bruno (Jérémie Renier) recruits Steve (Jérémie Segard) for a robbery: *The Child*, 2005

collapses on the spot and has to be hospitalised. Confronted with Sonia's shocked reaction, Bruno decides to buy Jimmy back in a deal that occurs in a lock-up garage on the outskirts again reached by bus. The deal disadvantages him financially and leaves him prone to physical intimidation by thugs in the gang, who take his money – a mere €16 – leaving him indebted to the sum of five thousand. Following a brief but thorough beating by the thugs, we see Bruno lying crumpled in a passageway; the brothers shoot the incident matter-of-factly to show violence of this kind as routine on these social margins. Desperate to pay off his creditors, he tries unsuccessfully to sell the baby's pram to a merchant's wife before casing her walk to a bank with the daily takings, which she carries in a shopping bag. Having recruited one of his young *protégés*, Steve (Jérémie Segard), to assist him in robbing the woman by motor scooter, the police chase them to the river bank where they hide underwater, entering it via a collapsed metal gangplank. Steve, who almost succumbs to the freezing water, is soon arrested while Bruno looks on from a nearby hiding place. Chastened by what happens to Steve and by Sonia's outright rejection of him, Bruno finally turns himself in to save Steve and to accept responsibility for the crime. Sent to prison, he receives a visit from Sonia that results in a tearful reconciliation; at the end the viewer is left to ponder a possible turnaround in Bruno's life and in his attitude to others.

In conceiving the film the Dardennes were affected by a news item about child sales in Belgium that Jean-Pierre had read in early 2003. The river bank scene, which proves instrumental in effecting a change in Bruno, derived from another item that Jean-Pierre had read about a bag-snatching thief who had been pursued to the river and had drowned in it. They shaped characters and action by combining these elements with ideas from some of Luc's reading matter and their viewing of particular films. Luc

Sonia (Déborah François, with baby Jimmy) at odds with Bruno (Jérémie Renier): *The Child*, 2005

specifies the following influences: Pasolini's *Accatone* with its young delinquent hero trapped by his own lifestyle, ultimately exhausted and on the run; Lang's *You Only Live Once* with its partnership of two young lovers; Murnau's *Sunrise* for the slowly reconciled couple at the end when all seemed broken between them; the ending of Dostoyevsky's *Crime and Punishment* where Raskolnikov feels obliged to give himself up and cries when his girlfriend Sonia (*voilà!*) visits him in jail; and Faulkner's *Light in August* (1932) for ideas about paternity and for the image of Joe Christmas, like Bruno, always being on the move. In the link with Faulkner we see how the brothers use their home area anonymously to represent universal situations much as the American author does with his fictionalised home county in Mississippi.

In *The Child*, the Dardennes focus again on a small cast of characters. If we exclude Jimmy as being more an exchangeable object than a character, the film concerns three individuals – Bruno, Sonia and Steve – each of whom is either also a child (Steve) or at best an overgrown one (Bruno and Sonia). We see this childishness, for instance, in the scenes where Bruno and Sonia nuzzle each other in amorous horseplay, and where Bruno and Steve tease each other over farting from eating school dinner sauerkraut. For Jimmy, the brothers used two fake babies in two dangerous scenes where Sonia carries Jimmy on a moped and along a busy road. Otherwise, they kept the live baby's hands as visible as possible to reassure the viewer that a real baby was being filmed. Altogether more than twenty babies were used throughout production so as to maintain a consistent size, though only fifteen of them appear on screen.

Bruno's immaturity makes him as much the 'child' of the title as his helpless son. Impulsive, self-centred and opportunistic, he lives in what Luc calls 'immediateness' – the constant present of the high-technology generation – by going with the flow and

believing he can look after himself at the expense of others. Dressed for street action – in a porkpie hat, tee-shirt, leather jacket, jeans and trainers[1] – he runs his mini-empire of petty crime with a dash of bravura, his vanity bolstered by the servility of his schoolboy accomplices. In this regard Luc points out the reality of gangs conveniently using juveniles, who are immune to prosecution. Bruno contemptuously dismisses legitimate employment – perhaps in reaction to its scarcity – and perceives his illegal activities as a better occupation, pursuing them methodically with mobile phone at the ready and another deal always on the tip of his tongue. There is a certain irony in the mobile phone, a symbol of late capitalist technology, as vital to Bruno's micro economy no matter the cost to use the device or to keep it charged.

In Bruno's expedient philosophy everything has a price. With little thought of tomorrow he acquires or disposes of anything that money buys or that will earn him more of it. This attitude dictates his behaviour toward others. Though he is an irresponsible drifter, he is capable of tenderness toward Sonia, shown in acts of sudden generosity such as buying her a leather jacket like his own and renting a convertible for a day to take her on a joy ride. He is also gentle with Jimmy, even in the terrible act of selling him readily for cash. However, at that point any broad tolerance we may have of Bruno's occasionally endearing impulsiveness abruptly disappears. As Luc tells Frédéric Bonnaud, 'how could our society possibly produce someone like that?' Bruno's callous act quickly rebounds on him. He suffers a huge loss in dealing with the child traffickers, who extort interest on their own losses from him and force him to steal a large sum in order to pay them back. Obliged also to sell his prize possessions (the pram, the leather jacket), he has to settle for a lower bargaining price. He is also a victim of his own convenient mendacity. As Sonia tells him, 'you lie like you breathe'. He lies to her on his whereabouts while selling Jimmy, to the police when interrogated outside the hospital after Sonia's collapse, to the traffickers by saying that Sonia had changed her mind, and to his mother about what had happened in order to secure an alibi from her.

In planning *The Child*, the Dardennes did not at first consider Renier for the role of Bruno, which may seem strange in retrospect given his pitch-perfect performance. Renier was twenty-three at the time; since appearing as Igor in *The Promise*, he had acquired a measure of acting technique and experience. The brothers feared it might interfere with their quest for an actor who could be suitably ingenuous in the part. However, in remembering Renier's lightheartedness and gentle clowning on the set, they realised he could be an ideal Bruno. Moreover, he already knew their methods and would require minimal direction.

Like Emilie Dequenne in *Rosetta*, the Dardennes found the *ingénue* they were seeking in another nonprofessional debutante, Déborah François. The casting procedure was again painstaking. They received six hundred responses to their press and radio calls for the part. This number was cut from one hundred and fifty aspirants, each of whom was filmed in turn, to ten, each of whom spent a half day with the brothers. After spending two days with the final two auditioners, they offered François the part of Sonia.

Sonia, like Rosetta, has no back story. The brothers never talked about Sonia's past between themselves or with their actors; she remained a mysterious figure. We first see

her in the street, a mini-skirted blonde whose unadorned prettiness masks a tougher customer than meets the eye. In her unglamorous and repetitive routine of pushing a pram determinedly and offhandedly around town, Sonia is a maternal version of Rosetta on her equally tireless daily commute to and from the centre of town. The Dardennes had observed a girl of fifteen or sixteen pushing a pram violently in the Rue du Molinay in Seraing; at one stage the working title of the film was 'Girl with a Pram'. By transposing their 'documentary' observation into a defining element of realist fiction, they captured the spirit of everyday life in those surroundings. The pram, by the way, may be the most notable to appear in cinema since the one descending the Odessa Steps in Sergei Eisenstein's *Bronenosets Potyomkin* (*Battleship Potemkin*, 1927). François plays Sonia ordinarily – that is to say, realistically – and exactly like that girl in Seraing, yet in so doing she embodies countless other young urban women of similar type and situation.

Despite appearances, Sonia has to be strong-minded to deal with Bruno's caprices and to support herself and her child in their penurious circumstances. Even so, she has an emotional and physical breakdown on learning of Bruno's sale of their son. Once Jimmy is safely back in her arms, she retreats to the relative safety of her flat whence she angrily keeps Bruno at a distance, the traumatic experience understandably having hardened her heart. During a bus ride home from the hospital she ignores him before ejecting him (and the pram) from the flat and refusing point blank his pathetic pleas for help and forgiveness. Only at the end do we sense a possibility of her forgiveness of him. Sonia remains a central character – she is in all the major scenes of the film bar one (that involving the robbery by scooter) – but the Dardennes are careful not to make her too present or too influential on Bruno, so that we do not perceive the power of her love (*La Force de l'amour* was another early working title) to be the sole factor in changing him at the end. This tactic recalls Magali's removal from *The Son* before she would inevitably bear further on Olivier's attitude and conduct. Sonia is fairly passive throughout the film, reacting variously to Bruno's unpredictable behaviour but not directing it in any significant way.

After the sale of Jimmy, the Dardennes begin the hard task of rehabilitating Bruno in the eyes of the viewer as well as in those of Sonia. Bruno reacts to Sonia's collapse by changing his mind on the sale, though his reaction is more out of fear of being apprehended for the crime he has committed than out of consideration for her and the child. He lies to the police by claiming the child is not his own, that it was stolen not sold, and that Sonia is the liar trying to get him sent down so that she will be free to have sex with other young men. Henceforth he starts to unravel, as his despair and vulnerability take him over; like a wounded beast he crawls to his river bank refuge. Exhausted, hungry, dishevelled and bruised by the traffickers, he pleads vainly for Sonia's forgiveness. But it is not her feelings for him but his eventual awareness – barely registered at a conscious level – of the effects of his own actions on her and especially on Steve that brings him to his senses.

The repercussion of Steve's near drowning and subsequent apprehension by the police is a turning point for Bruno. Though he does not sense anything heroic in his rescue of Steve from the river, he appears genuinely disturbed as he watches Steve

being led away by the law. The Dardennes capture this moment masterfully in an over-the-shoulder long shot that reveals as much of Bruno's state of mind as of the scene being enacted in the background. And if there is little other than the fraught re-purchase of Jimmy to suggest beforehand that Bruno will alter his ways, he shows now that he understands his moral obligation to others by accepting responsibility for the shopping bag theft and so saving Steve from criminal proceedings.

As the slight, malleable schoolboy Steve – an Artful Dodger to Bruno's young Fagin – Segard, another nonprofessional debutant like Renier and Marinne in their first parts for the Dardennes, both of whom he resembles physically, offers a fine balance of adolescent brazenness and childlike helplessness, as in the scene where having almost drowned and frozen to death he whimpers in pain and fear while receiving 'paternal' care from Bruno rather as did Igor from Roger early in *The Promise*. This scene caused Segard and Renier to be hospitalised briefly after swallowing the heavily polluted river water. And in one school scene we see Steve dressed in workshop overalls rather like Francis in *The Son*.

Again playing a thief, Segard reappears – as does Dequenne – in *Dans l'obscurité* (*Darkness*, 2007). This three-minute short consisting of a single handheld tracking shot was the Dardennes' contribution among thirty-five filmmakers to a compendium film in celebration of cinema at Cannes in that year. Even within the narrow scope of this project, the brothers suggest a transformation of the young man as a result of his unlawful act. Having crept up to a girl immersed in a movie (unsurprisingly Bresson's *Balthazar*, 1966) being shown in a cinema, he tries to take a wallet from her handbag. However, she grabs his hand, joins it to hers, and together they give themselves over to the fictional world onscreen. Even in such illicit, suspicious circumstances of ill intent toward another person, the perpetrator has to face his responsibility and some kind of mutual accord is reached.

Returning to *The Child*, it is a film in which everything including human life has a price. Commenting on the constant movement in the Dardennes' films and on the marked causality of *The Child*, J. Hoberman (2006) describes it as an 'action film – or, better, a transaction film', the second term deftly reflecting its central concern with various monetary deals. This preoccupation with acquiring and spending money as fundamental to the survival strategies of individual characters manifests itself in each of the brothers' major films with the exception of *The Son*, and we witness numerous close-ups involving monetary exchange.

To follow Hoberman's idea, all the major films involve interpersonal transactions based on a necessary responsibility to others. Often these transactions are completed or at least properly initiated by the end of the film. They take the form of an awareness that emerges slowly and almost imperceptibly in the course of the narrative. At the end of *The Child* we find Bruno in prison, the consequence of having turned himself in for the handbag robbery in order to get Steve off the hook. When Sonia visits him in the final scene, he dissolves into tears – a mixture of relief and remorse – and the film ends with a two-shot of them crying and embracing. By these actions Bruno seeks Sonia's forgiveness and appears to regret his selfish and immoral conduct but, as in *The Son*, no pardon is delivered or guaranteed by anything either has said or done. In order to pass

from a carefree adolescence to a responsible adulthood, Bruno must recognise both a partner who appears willing – despite all she has suffered from his misguided actions – to give him another chance and a son whom he can no longer disclaim.

The open ending counteracts a melodramatic interpretation of the shared tears between Bruno and Sonia. Though I acknowledge earlier that melodramatic elements may operate within social realist cinema, they remain conspicuously absent from the Dardennes' films. Even if the brothers think of Murnau's *Sunrise* – a full-on melodrama with a repentant male hero – every time they start working on a new film, a tearful ending need not signify a melodramatic turn. In the final scene of *The Child*, the brothers instructed their two actors to approach the scene as openly as possible without knowing exactly whether the outcome of their meeting would be reconciliation or rejection. The resulting tearful ending, of which the eighteenth take went into the can, testifies to a personal and broadly spiritual awakening without emotional artifice or forced moralism. Luc writes of the 'resurrection' of Bruno and of the influence on *The Child* of Chalier's suggestion in her treatise that the 'pure nakedness' of human tears may bring about an experience of 'fragile happiness' and a 'trembling before the hope of life' (2005: 148). Given the frequent comparison of the Dardennes' moral universe with that of Bresson, the film associated most often with the ending of *The Child* is *Pickpocket* in which the eponymous thief Michel, having renounced his life of crime, breaks down in prison during his girlfriend's visit and embraces her in a spirit of cautious optimism. However, as much as the brothers know and admire Bresson's film, they insist that the parallels only became apparent to them after their own film was finished and that their original ending – with Bruno being killed off – would have been far harsher than the French director's happier dénouement. Another auteurist classic springs to mind: Federico Fellini's *La Strada* (*The Road*, 1954), at the end of which the defiantly macho and seemingly insensitive Zampano is alone on a beach sobbing over the death of his abused companion Gelsomina.

Beyond the theme of individual responsibility, *The Child* follows *The Promise*, *Rosetta*, and *The Silence of Lorna* in being about the survival strategies of disadvantaged individuals who adopt a daily routine appropriate to their own desires and needs. The Dardennes depict the lives of these individuals against a backdrop of urban communities devastated by economic decline and social ills. The rough and ready milieu inhabited by Bruno and Sonia – like that of Rosetta, Lorna and, to a lesser extent, Roger and Igor – is one of a largely unemployed underclass whose lifestyle reflects its lowly status.[2] The verbal, behavioural and sartorial peculiarities of this milieu often invite a comical or satirical representation as, for instance, in Mike Leigh's *High Hopes* (1988) and *Life is Sweet* (1990).[3] However, the Dardennes refuse to condescend to or caricature their working-class protagonists just as they refuse to portray them as either hopeless ne'er-do-wells or helpless victims of socio-economic change. Dismissing as 'bourgeois-conservative' several reviews of *The Child* that express a strong distaste for the film and especially for Bruno's stupidity and moral depravity, Brian Gibson (2006) admires the brothers' attempt to 'expose the bottom end of the capitalist system – Bruno sees a potential profit in everything'. His 'heartless act' of selling his son 'is only the logical, trickle-down ebb of a heartless system'. And despite their otherwise bleak

situations Bruno and Sonia remain engagingly lively. For instance, the cardboard bed that Bruno erects in the hut by the river may seem like a coffin enclosing him, as if he is slowly killing himself, but remarkably he is up and at 'work' early the next day by visiting the school playground to engage Steve in the next (and fateful) 'job' of robbing the merchant's wife, which they do by means of a scooter hired from Steve's brother. Frédéric Bonnaud, interviewing the Dardennes, suggests that the main characters resemble survivors of a nuclear disaster in a science fiction film inhabiting an area that is no longer habitable. The brothers agree that these characters are survivors of a contemporary catastrophe, the 'excluded' living 'on the edge' and outside the system. Yet they retain a 'life force' and a 'freedom' despite their socio-economic irrelevance, and the brothers demand that this liberating force manifest itself in every scene otherwise they drop it, reshoot it, or even find a new location for it.

Shot over a twelve-week period in Super-16mm, *The Child* maintains for the most part the Dardennes' trademark style established in *The Promise*. From the opening shot of Sonia carrying Jimmy up a flight of stairs to her temporarily appropriated flat, the brothers' highly mobile camera with its awkward framings – what they might gleefully call 'bad' images – pitches the viewer into the turbulent physical world of the characters without any establishing reference points. And though we follow their movements less urgently than in *Rosetta* or *The Son*, we still experience the action *with* Bruno and Sonia as they chase one another for fun, or Bruno and Steve as they tear through the streets on their scooter (recalling Igor's moped and go-kart expeditions in *The Promise*). Though these streets and other depressed urban spaces remain carefully unidentified, the viewer may easily recognise their unappealing ordinariness as typical of such areas almost anywhere in Western Europe. The River Meuse originally entered the film solely as a place for the pram to be washed (the scene was cut), but its bank came to play an important part in the film not only as the location of Bruno's refuge and headquarters of his gang's activities but also as a reminder of where trade and industry once thrived. A new enterprise – Bruno's little band of thieves – now operates there in ad hoc fashion. It is not a picturesque spot, and the brothers are careful not to create a broader, identifiable context by revealing too much of it. Instead, as elsewhere in their films, we get brief glimpses of these drab and generic surroundings. The demoralising anonymity of these places emerges strongly in many scenes. For instance, in the second scene, a tight shot reveals Sonia, babe in arms, making a call at an outdoor public phone in a strong wind before crossing a busy road. Later, when Sonia collapses and Bruno carries her from the river bank like a giant rag doll, cars flash by on a road but none of their occupants stop to offer help.

Another similarity to previous films is the paucity of dialogue whereby words often follow the action rather than prompt a subsequent shot. The brothers' cinematography and *mise-en-scène* combine to make the script fit the film rather than the other way round. Much of the rhythmic momentum of the film derives from repeated shots of actions, gestures, objects and places. For instance, towards the end, when Bruno tries to visit Sonia to seek her forgiveness, we see him climb the stairs to her flat five times in almost identical shots. And though the brothers widen the frame, their camera never retreats to a point of diminishing the characters in the overpowering anonymity

of their surroundings. Rather, from various distances, it continues to concentrate on their expressions, gestures and movements. And it never loses sight of their accessories, which Luc maintains is 'the essence of cinema' (2005: 158). As with Rosetta or Olivier, we become familiar with the details of their clothing and with the paraphernalia of their daily life. One such accessory, Bruno's ubiquitous mobile phone, is also his one necessity, since to survive in an urban jungle means even those on the lowest rung need their operational phones. The brothers create suspense less by means of editing than by an insistent *mise-en-scène* built around long takes in real time. The still, slow, silent scenes of the baby sale and re-purchase, for instance, are excruciatingly tense. Each scene takes place in two adjacent spaces and, since no face-to-face encounter occurs in either of them, all dialogue is by phone or from opposite sides of a wall. There is no music in the film apart from a Strauss waltz heard on the radio of the rented convertible. The ironies abound: a destitute drifter equipped with a mobile phone drives a luxury car around town and happens to listen to classical music. But consumer culture depends on its universal appeal; as long as Bruno has cash in hand, he can buy fashionable clothes and rent a car, even while sleeping rough and having no thought of the morrow.

Though *The Child* is comparable to its forerunners in many respects, it has a more measured pulse especially in the second half of the film when the action slows down, the atmosphere grows calmer, and the camera pulls back to frame more contemplative medium or long shots. Having declared a desire to 'write' less and 'record' more with their camera, the Dardennes close *The Child* with an almost classical two-shot of Bruno and Sonia that anticipates a further stylistic shift in the next film they would bring to the screen.

Notes

1 The Dardennes feared the hat risked caricaturing Bruno, so they re-wrote the scene where he deals with the fence to have him throw in his precious hat, which like anything else is potentially saleable.

2 A term peculiar to Belgian French, *baraki* (British rough equivalent: chav) describes smugly uncouth and irreverent individuals, particularly younger ones, belonging to this milieu and found primarily in rundown post-industrial areas of Wallonia. In dress and outlook Bruno conforms somewhat to type but goes beyond it in being both jobless and homeless. However, *baraki* (like 'chav' or 'trailer trash') is open to criticism for being a term used condescendingly by those in more comfortable walks of life. Among 'northernist' films, *Eldorado*, *The Carriers Are Waiting* and *The Life of Jesus* (see chapter two) depict *baraki* culture, though more grotesquely *chez* Lanners and Mariage than in Dumont's severer view.

3 Other instances of humourous working-class portrayals are British television series such as *Bread* (1986–91), *Rab C. Nesbitt* (1988–99; 2008–), *The Royle Family* (1998–2000; 2006–) and *Little Britain* (2003–06).

CHAPTER NINE

A Minor Shift: The Silence of Lorna, *2008*

In the view of the Dardennes, 'money rules the relationships between us, and it changes things' (in Abeel 2008). A close-up of bank notes exchanging hands, a familiar image in their films and a nod to the first scene of Bresson's *Money*, opens *The Silence of Lorna*. The characters in this film inhabit a world like that of Bruno in *The Child* or Roger and Igor in *The Promise*, one where everything has a price. It is a fearsome world wherein opportunism and exploitation are the names of the game, while moral principle and human decency struggle to find a place.

Though not received with universal critical acclaim at the Cannes festival in 2008, *The Silence of Lorna* won the Best Screenplay prize for the brothers. Lorna (Arta Dobroschi), a young Albanian immigrant whose pursuit of a dream of improving her life draws her into organised criminal activities, arrives in a large Belgian city with her boyfriend Sokol (Alban Ukaj), an itinerant worker. Her illegal entry already links her to a Russian gang that liaises via a local fixer, Fabio (Fabrizio Rongione). Lorna and Sokol have set their hearts on opening a snack bar in the city. In order to acquire Belgian citizenship, she readily becomes a pawn of the gang by agreeing to marry and then divorce Claudy (Jérémie Renier), a Belgian heroin addict whom the gang will also reward in cash to feed his habit. Lorna understands that the gang's plan for her marriage of convenience includes overdosing Claudy to death and recouping his promised cut, then remarrying her to another illegal immigrant, a Russian mobster also seeking Belgian nationality. As her strictly businesslike relationship with Claudy becomes an emotional attachment, the plan to eliminate him repels her and she proposes fast-track divorce instead, but the gang rejects this option as even too lengthy a process and too likely to prompt background investigations by the law. Troubled by her bad conscience but determined to hold on to her dream, which she knows is dependent on the deal she has struck with the gang, she remains silent on the plan. She tries everything in her power, including seducing him, to keep the newly clean Claudy from using again, which she knows will seal his fate, but the gang kills him anyway. Following his death,

Lorna (Arta Dobroshi) meets her Russian 'intended': *The Silence of Lorna*, 2008

chastened and changed by her experience, Lorna tries to dissociate herself from the gang. This leads her Russian 'fiancé' to back out of the arrangement; Fabio and Sokol also turn on her, leaving her dream of a new life in tatters. Hustled out of town by Fabio's sidekick Spirou (Morgan Marinne), who evades her questions, she fears for her life. Using a halt to urinate amid trees as a ploy, she arms herself with a stone with which she knocks Spirou out and runs from what she knows to be an attempt either to kill her or to return her forcibly to Albania. At the end of the film she wanders through a wood in a deranged state, taking refuge overnight in a bare cabin where she continues to 'talk' to the child she wrongly believes she is carrying by the late lamented Claudy. Her future prospects, like those of all the Dardennes' protagonists, remain unclear.

The Dardennes heard a story in 2002 from a Brussels prostitute whose brother, a junkie, had been approached by the Albanian mafia and offered a similar deal. And after *Rosetta* they wanted sooner or later to make another film about a young woman. The backdrop to *The Silence of Lorna*, as to *The Promise*, is the ruthless market in illegal immigration, a major problem in Belgium as elsewhere. The brothers also researched the divorce laws especially those relating to arranged marriages. However, the focus of the film is neither on those issues nor on the netherworld of drug addiction but on Lorna and the transformative crisis she must face. The brothers do not invite us to take sides or pass judgement but simply to share her story. And, like *The Child*, it is partly a love story, between Lorna and Sokol, but also briefly and significantly between her and Claudy. As a crime drama with noirish overtones, it is also the closest the brothers have come to making a genre film, a minor shift in approach that is reflected in the style of the film.

In searching for the right actors for the film, the brothers adopted their usual exhaustive casting procedure. For Lorna they wanted an eastern European but not

a citizen of the European Union, as the character needed to be an undocumented entrant to Belgium. The brothers first sent an assistant on a casting trip to Pristina, Skopje and Tirana where one hundred actors, both professional and nonprofessional, auditioned. Once the brothers had singled out Dobroshi, a 29-year-old Kosovar of Albanian origin and a professional in both cinema and theatre, they travelled to Sarajevo to spend one day with her. Suitably impressed, they invited her to Liège where she interacted with Renier and Rongione before being offered the part. She returned to Belgium two months ahead of the film's production in order to acquaint herself better with the French language. According to the brothers, she fitted the bill perfectly, her blend of coolness and gentleness plus her simple beauty being exactly what they had in mind for the character.

Despite her exotic origin, the brothers typically avoided any back story to Lorna. She comes to Belgium for a singular purpose and the film picks her story up at that point. They also wanted to avoid the cliché of an illegal female from Eastern Europe being a prostitute, so they portray her as a menial worker in a dry cleaning shop, a kind of Albanian Rosetta imbued with the same determination to make something of herself but minus the aggressive, desperate energy of her fictional predecessor. Lorna has a more subdued personality than Rosetta but like her, she is a tough customer. Her open expression, beautiful face and ingenuous air mask a similarly steely resolve to succeed on her own terms. Older and more mature than Rosetta, she is a young woman in her twenties with some life experience behind her; by comparison, Rosetta is still a girl. Lorna is thus more able to deal with mental and physical pressures until a crisis of conscience overtakes her and sends her into a tailspin.

Apart from Ukaj, the Dardennes rely on their small contingent of tried and trusted actors. Renier makes a quick return as Claudy; Rongione, having already played a thug in *The Child*, returns as Fabio; Marinne returns as his laconic accomplice; and Gourmet reprises his cameo appearance in *The Child*, again as a police inspector. After gathering their team of actors, the brothers rehearsed them for two and a half months. Renier diplomatically describes the acting experience in this film as a process of 'group research'; Jean-Pierre, known to be anxious and doubtful during shooting, suggests that the experimental openness of the rehearsal phase was the best part of the entire process.

A recurrent theme of the Dardennes' films is the killing of others and the ethical crisis it presents. Lorna becomes the brothers' latest protagonist to face the responsibility of being implicated in the death of another human being. Her silence appears to be the only possible response to a precarious situation in which she risks losing all. To protect herself and her immigrant dream she must eliminate any nostalgia for her homeland and keep the guilty secret she has been forced to share. Lorna believes she can get what she wants by hook (Claudy's drug addiction) or by crook (collaboration with the gang). But the more she stays silent about the gang's machinations and her own part in them, the more it troubles her conscience, especially after Claudy – for whom she has unexpectedly developed a measure of respect and affection – dies at the hands of the gang. The film dramatises the struggle within Lorna between her basic decency and compassion on the one hand and her opportunistic complicity with evil

on the other hand, a struggle that drives her eventually into a derangement that may or may not prove to be her salvation. Seen in this light, the film contains elements of classical and modern tragedy. One reviewer in the French newspaper *Libération* calls the film 'a Dostoyevsky in Liège in the age of globalised flux', while Luc refers frequently to Shakespeare; at the end, we sense an Ophelia/Lear hybrid at large, a deluded lover and 'mother' wandering distractedly in the wild.

As the film progresses, Lorna's belief that she is carrying Claudy's child becomes obsessive and largely dictates her ultimate attitude and behaviour. Nonetheless, her seduction of him in their shared flat, albeit useful as a narrative device to facilitate her phantom pregnancy, seems unconvincing in view of preceding events. At first she treats him with barely veiled contempt. Knowing that he is a necessary step on her path to self-advancement, she tolerates his aimless presence in the flat but insists it is merely a temporary arrangement. Claudy sleeps on a mattress in the living room so as not to disturb her at night when she, at least, needs to rise early for her job at the dry cleaners. Claudy understands the arrangement – after all, he receives money for drugs in exchange for his willingness to marry and divorce Lorna – but he yearns for human kindness and support from anyone who happens to be in close proximity to him. However, she coldly rejects his desperate pleas for help and refuses at first to lock him inside the flat to prevent the gang's pushers getting to him.

Claudy clings physically to Lorna, who repeatedly ignores his distress. After one struggle between them that leaves him lying on the floor, she realises that unless he stays clean he will die at the hands of the pushers, who are hovering like hawks over their prey. She suddenly undresses and approaches Claudy, who responds eagerly to her advances. Their brief coupling suggests a desperate measure on her part to distract him from his addictive behaviour rather than a genuine sexual desire on her part, even though his pathetic state has touched her heart. Expedient as she is, she has a steady partner in Sokol and does not appear to be someone who would blithely have sex with another man. Unless, that is, the scene suggests that her all too rare meetings with Sokol have created an unbearable physical need. The unanticipated intimacy nonetheless thaws relations between them. In addition to stirrings of mutual affection, Lorna senses that beneath his wrecked exterior Claudy is basically a decent human being and that, like her, he is on his own. The brothers acknowledge that 'her gesture toward him is mysterious and can't be explained' and that 'it mystifies her, too' (in Abeel 2008). It exemplifies the human tendency occasionally to be impulsive, to do something without quite knowing why.

Conscious of Claudy's imminent elimination by the gang, she responds to his desperate appeal and begins to help him in small ways by agreeing, for instance, to collect his pain medication from the pharmacy. She feels that he does not deserve to die because the gang finds it more convenient that he should do so. In order to hasten a divorce and save him from his fate, she asks him to punch her in the face, which he refuses to do, saying that he has never struck a woman. Lorna promptly bangs her forehead against the wall in one of the most shocking moments of the film. Now with the false evidence she needs, she tries to persuade Fabio to let the divorce case proceed, but he and the mobsters view Claudy only as a worthless junkie, a mere pawn in their

Lorna (Arta Dobroshi) confronts Claudy (Jérémie Renier): *The Silence of Lorna*, 2008

game. They prefer an 'accidental' death by overdose to lengthy and suspicious legal proceedings, as it will expedite the Russian's quest for legal status, will save them an additional €5,000 promised to Claudy, and being a predictable and common occurrence will prove the most effective way of disposing of him without drawing official attention.

As was required of Magali in *The Son*, Claudy disappears abruptly from the film, in this case so that the focus may remain on how Lorna deals with his death and tries to salvage her scheme of self-betterment. Our knowledge of his death comes suddenly and indirectly after we have seen him bravely attempting to fight his addiction. Recalling *Ladri di Biciclette* (*Bicycle Thieves*, 1948), De Sica's great Neo-Realist film about survival against the odds, he rides off on a bicycle he has picked up cheaply, after telling Lorna that he needs to fill his day with simple goals that include visiting her at her workplace. In the next scene Lorna is back in the flat sorting out Claudy's clothes. Though the Dardennes' narratives are often elliptical, at first we are confused, as we know he is no longer in hospital or needing fresh clothing, and we wonder why Lorna is thus engaged. It comes as a shock to learn that he is dead and that she is preparing to dress him in his funeral clothes. However, the scene is dramatically sound: as in classical tragedy, the death occurs offstage. It would not be the style of the brothers, ever wary of lurid spectacle, to have shown a criminal over-dosing scene, and they had no reason to show it, since their focus remains sharply on Lorna and how she copes with this turn of events. Anyway, as Luc declares in reference to their deliberately obscure images of Hamidou's burial in *The Promise*, evil is 'unimaginable'. Murder is so ethically and aesthetically repulsive to the brothers that they find it impossible to film.

Lorna's slow but inexorable awakening into a sense of responsibility follows the death of Claudy. Though distressed and angry over the unnecessary killing of a person she has grown to care about, she reluctantly keeps her side of the bargain knowing that the Russian's cash will facilitate her own commercial aspirations. Furthermore, when the police question her about Claudy's death, she follows Bruno in *The Child* by lying unhesitatingly to them. Close to achieving her immediate goal, she remains ambivalent about her involvement with the gang. Elated by the prospect of opening her snack bar with Sokol, she secures the keys to the place they have settled on and inspects it, relaying its dimensions enthusiastically to him by phone. There she experiences two dizzy spells probably caused by fatigue and overexcitement, which she soon interprets as signs of a pregnancy. The spells may equally be psychosomatic symptoms that subconsciously begin to reveal her sense of guilt, since she knows that she could have saved Claudy by squealing on the gang. As her guilt increases, her desire to renegotiate terms with the Russian to include the child she obstinately believes she is carrying may also be seen as a subconscious attempt on her part to wreck the deal and release herself from its obligations.

Her newfound loyalty to Claudy, an innocent man who has died an unnecessary death, manifests itself primarily in her belief that she is pregnant by him, a belief that may also manifest her sense of guilt: 'the return of the ghost of Claudy in her belly', says Luc (in Concannon 2008). Even though the doctors reassure her to the contrary, she insists on wanting the child and tries to use her 'pregnancy' as a bargaining chip with her Russian 'fiancé' to the disgust of Fabio, who sees her as reneging on her promise to play her allotted part in the intrigue. Once the Russian hears about pregnancy and possible child support, he wants nothing to do with any proposed rearrangement and pulls out of the whole deal. At this point, everything starts to unravel. As a result of the Russian's withdrawal and with it his cash payment to Lorna for her part in the second phase of the plot, she and Sokol have to cancel the loan on the purchase of their snack bar. Fabio and Sokol take their cuts and abandon Lorna, who finds herself alone and back to square one. To make matters worse Fabio and the gang, fearful that she may blow the whistle on them, perceive her as a liability and drive her out of town in a car ostensibly to smuggle her back to Albania. But Lorna now has Belgian citizenship, if little else, and knows that she need not be repatriated. The tense journey from city to country leading to the climax of the film resembles that undertaken by Olivier and Francis in *The Son*.

The uncertain ending is in common with the previous four films. We know only that Lorna has changed and has turned her back on irresponsible and immoral actions. This ending, however, is unusual and strange for the Dardennes in its fantastic quality. Like a modern-day Red Riding Hood, Lorna loses herself in the deep woods hearing Claudy's voice in the cry of a bird and speaking reassuringly to his 'child'. As darkness falls, she breaks into a hut for shelter and builds a fire to stay warm. In the final shot of the film, she lies down to sleep, telling the 'child' that they will find a way to survive. Strains of the slow second movement of Beethoven's piano sonata number 32 in C minor accompany this shot – another surprise for the viewer familiar with the absence of background music from the brothers' films. This particular musical choice

bears the trace of Luc's preferred method of scriptwriting. In 1996 he writes that without knowing why, 'I need to read and listen to music (Beethoven's piano sonatas and concertos) before launching into the writing of a screenplay' (2005: 64). In the final shot the brothers again cut to black before letting the credits roll. In many ways this poignant and reflective moment recalls more than any other the scene in *Rosetta* when, after her equally extraordinary self-dialogue in Riquet's flat, Rosetta falls happily asleep.

Lorna's experiences of the gang and of Claudy's death shock her to the point of losing her former self. We might say, along with several critics, that she liberates herself from her oppressors, who used her albeit with her consent, and is now truly independent for the first time. We might also perceive her derangement as transporting her from the sullied world of criminal conspiracy to a mystical state of grace whereby she freely indulges her fantasy of a better life alone but safe with her 'baby' in the warm, dark womblike hut in the middle of nowhere. In conceiving Igor in *The Promise*, Luc had written of an Isaac-like 'innocence' that is beyond intrigue, and he speaks of Lorna's apparent madness as 'a proof of her humanity' and of her naïvety whereby 'there is no other solution than to become the mother of this child' (in Concannon 2008). Her feral state signifies her escape from the physically and mentally constrained life she has hitherto known in Belgium into a resigned, innocent and simple existence in an unbounded natural space. According to this reading, we must then view this conclusion as the most spiritualised of any Dardennes' film so far. For instance, in his review for the *New York Times*, A. O. Scott (2009) writes of 'religious overtones that seem to grow more explicit with each new movie'. For Scott, this film, 'with a narrative that turns partly on a mysterious pregnancy, evokes, subtly but unmistakably, a range of maternal Biblical associations not limited to the tale of the Nativity'. Prompted by some phrases of Kierkegaard in *The Sickness unto Death*, Luc only suggests that in a godless world Lorna may be 'a kind of believer' (2005: 180).

Such comment is fair enough, but if we prefer a more realistic account of the ending, then Lorna is suffering a nervous breakdown. It is understandable in a clinical sense that she collapses beneath the weighty blows of Claudy's death, Sokol's departure and the gang's threat to her life. Perhaps the gang does not intend to kill her, but her uncertainty over its motives drives her into a paranoid state. Far from representing a triumphant escape, her flight into the woods may offer only a temporary respite. Once she emerges, the gang may track her down. If she avoids the gang, she remains a vulnerable young immigrant in a hard and unwelcoming world. And even if her feelings of guilt may have an ultimately positive effect on her life, she is now another unemployed female Belgian – a Rosetta by any other name – and by no means yet out of the woods. She finds herself still trapped in what Dave Calhoun (2008), writing about the film as a whole, calls 'the grey area that lies between desperation and responsibility'. Like Rosetta on her knees in the caravan site mud, Lorna is at her wits' end. But while Riquet is on hand to help Rosetta back onto her feet, Lorna's only companion is the memory of Claudy, the 'child' safe inside her. Asserting that they are crafters of realist fictions and neither documentarians any longer nor mere naturalistic observers, the brothers admit that in reality Lorna would probably have

been eliminated by the gang and that the 'power of fiction' permits her to reach the hut where at least she has a chance to survive. 'That's what interested us', says Jean-Pierre, 'to see how in our story we could give Lorna the ability to change. [...] In telling the truth about social relations, fiction allows you to push things further, even if only that we film things prohibited in documentaries; we can go places where the documentary can't go, we can film situations that, morally, you wouldn't allow yourself to shoot in a documentary' (in Walsh 2008a).

Where does this leave the revelation marking each of the Dardennes' major films? The brothers remain interested in possible atonement for guilt; Rossellini's *Europa 51* helped them focus on a moral crisis faced by a woman and to develop such a situation into Lorna's story.[1] An ethical awakening of a protagonist occurs in all the brothers' major films through a Levinasian encounter, a conditional accommodation to another person based on newly discovered understanding and respect. The endings of these films suggest that the protagonist may be able to face an uncertain future in the confidence of another: Igor with Assita, Rosetta with Riquet, Olivier with Francis, Bruno with Sonia, and Cyril with Samantha in *The Kid with a Bike*. The person who changes Lorna's attitude is Claudy, but he does not survive to help her move forward in her transformed state of mind. Responsible only to herself, she understands that no personal gain, monetary or otherwise, is worth the expense of another's life. It is perhaps for this reason that she dreams of Claudy's child coming into the world to accompany her. Her redemption will be complete in her assumption of responsibility for a child in whom Claudy will be resurrected.

To the viewer familiar with the Dardennes' previous films, *The Silence of Lorna* seems at once characteristic of their work and yet subtly different from its predecessors in tone, narrative structure and visual style. The brothers choose less to innovate than to vary slightly their artistic approach. It was the first of their major films not to be shot in Seraing, but in Liège – 'ten kilometres away', remarks Jean-Pierre drily – in order to impart a bigger city atmosphere more in tune with the immigrant experience in both its possibilities and pitfalls, with the generic setting of noir crime dramas, with the reality of more people out and about after dark in clubs and bars than (unsurprisingly) in Seraing, and with the character of Lorna herself, who keeps a still centre within the bustle of city life and the constant contact with strangers. The setting again remains anonymous to avoid any localising identification and is intended to represent any large post-industrial city of its type. Careful also to avoid any scenes suggesting a more fashionable, updated or picturesque side of Liège, the brothers choose mundane locations to reflect the social margin on which Lorna and her associates live.

If we venture to view *The Silence of Lorna* as a social realist Russian mafia film, we may understand why it comes closer to film noir than any other film the Dardennes have hitherto made. Luc stresses that Lorna is far from being a typical noir heroine – sexually attractive as she is, Lorna is no spider woman – but the gangsters, the night scenes, the air of subterfuge and suspense combine to lend the film some distinct genre qualities. And the class-based context of deprivation, substance abuse and social marginality contributes to the noirish atmosphere, rather in the manner – if less fatalistically – of the novels of David Goodis and some of the films adapted from them.[2] In

Thom Andersen's view, *The Silence of Lorna* bears comparison with a number of Hollywood noirs – for instance, Jean Negulesco's *Nobody Lives Forever* (1946) – and with Bresson's own noir phase represented by *Les Anges du Péché* (*The Angels of Sin*, 1943) and *Les Dames du Bois de Boulogne* (*The Ladies of the Bois de Boulogne*, 1945).

Given the Dardennes' insistence on the priority of action in creating meaning, Andersen proceeds to argue – from a Deleuzian view of the dissociation between perception and action in Neo-Realist cinema – that the brothers, who are ostensibly purveyors of what he calls 'neo-Neo-Realism', break with that cinematic tradition, since they 'responded to the triumph of liberalism not with Neo-Realist despair but with a scrupulous examination of its workings on a human level, and they discovered that film noir was a useful idiom for their explorations' (2009: 27). He offers a useful template for the discussion of genre elements in *The Silence of Lorna* and implicitly extends his argument to the action-based transcendence of Neo-Realism in their previous films.

Befitting a film that flirts with genre, the Dardennes construct the narrative of *The Silence of Lorna* more conventionally and elaborately than in any film since *The Promise*. The quality of the brothers' screenplay, which is more contrived than in the past and reaches its apogee in Lorna's final monologue, was recognised by its win in that category at Cannes. The *mise-en-scène* is correspondingly more open and flexible. Yet the film remains claustrophobic in mood, playing heavily on images of imprisonment and restriction that are also reminiscent of film noir. The glimpses we get of Lorna's flat, of the dry cleaners where she works, and of the café where she meets her Russian 'fiancé' present spaces that echo the necessarily constricted lives these characters lead.

Most significantly in respect of visual style, the Dardennes' camera is less mobile and is positioned further away from their protagonists than before. Though the brothers still eschew establishing shots – the opening shot of money being passed by hand again plants us amid mysterious events and persons – their camera moves more calmly and slowly. Their shot compositions are consequently stiller than before, though the camera often wavers in framing and reframing its subject. Lorna is on screen almost throughout the film and the camera observes her as intently as she stares back at it. Her facial expressions receive greater emphasis than her physical movements, so the camera has less need to follow closely in her footsteps for the viewer to understand her situation and empathise with her. Jean-Pierre explains that 'it was necessary to watch and look at Lorna and not be present in her energy' – unlike with Rosetta or Olivier, for instance – and to observe her moving among and interacting with others within the space of the city, to show her as one individual among many (in Concannon 2008).

These minor shifts in visual style also correspond to the Dardennes' decision to shoot for the first time on 35mm film having unsatisfactorily tried 16mm and five different digital cameras. They were predisposed to try 35mm given their interest in making a slightly different kind of film. Despite several drawbacks, such as five-minute reels, of 35mm to their habit of continuous filming, they chose a Cinecam camera that Dervaux carried on his shoulder but with which he did not walk around. Several other reasons influenced their choice, such as the greater ease of making prints from

35mm than from blown-up 16mm negatives, but it was the superiority of night shots in 35mm that clinched it.

The theme of illegal immigration places *The Silence of Lorna*, like *The Promise*, in a general category of films that present an alternative discourse on the subject to that offered by politicians and the mass media. This category – consisting of documentaries, fiction films and hybrids of the two – overwhelmingly represents the experience of the immigrant from a more sympathetic viewpoint than an official one. Characterised by a dominant realist mode, the category nonetheless invites the use of melodramatic or fantastic elements.[3] It would not be the way of the Dardennes to address explicitly the issue of illegal immigration, yet *The Silence of Lorna* leaves no doubt about how vulnerable such immigrants are to exploitation by criminal elements in the urban underworld. They are often also subjected to prejudicial treatment by public authorities, but the brothers are wary, as in earlier films, of showing the police or health services with which Lorna has contact as stereotypically harsh, unfair or uncaring. That the law enforcement and medical personnel are shown as relatively benign allows, as Emilie Bickerton (2009) points out, the gang to stand out all the more starkly as vicious and ruthless. The restrained depiction of doctors, nurses and police officers partly suggests that they are unexcited by cases that they have seen many times before. An instance of this is when the polite but sceptical police officer who files Lorna's domestic violence complaint states that self-mutilation is a common ploy on the part of plaintiffs and therefore does not guarantee a desired outcome. Similarly, the two officers who interview Lorna after Claudy's death are insistent but gentle and deferential in their questioning. And each incident serves to lessen our sympathy for Lorna's situation, for while we understand her growing fear, we recoil from her self-serving lies.

The viewer's ambivalent response to the actions of the Dardennes' protagonists is a key factor in the effectiveness of their films as realist dramas. The dog-eat-dog world these characters inhabit is a morally nuanced one in which socially and economically disadvantaged individuals – Roger, Igor, Rosetta, Olivier, Francis, Bruno, Sonia, Lorna and Cyril – do what they feel they must to protect their own interests. That our sympathy for them is equally nuanced prevents the films from descending into melodramas of sadness and pity. No determinists, these brothers: even individuals at the bottom of the social pile remain free if limited in their choices. And though their choices may be morally dubious, we find ourselves grudgingly admiring these individuals for their unorthodox initiatives and their efforts to survive. Lorna finds herself in difficult circumstances, but we remember that she has entered Belgium illegally and of her own free will. We may secretly want this outwardly appealing young woman to succeed in her aspirations, but we know that beneath her exterior lies a hardheaded, calculating person who is unafraid to exploit others to her own advantage.

The Dardennes do not wish us to see Lorna or any of their other protagonists as helpless victims of the contemporary world system and its new order, but their films undoubtedly suggest the deleterious effects of that system on individuals living on the social and economic margins. An indirect interrogation of the dearth of fair and just political initiatives to address the problem of the disempowered underclass permeates and pervades the brothers' films. Without offering any trite or easy solutions to this

state of affairs, they engage us closely with their characters' troubled lives, prompting us to question the wider causes of their troubles and suggesting the transformative potential of their encounters with others.

Notes

1 See Kristin Thompson and David Bordwell (1994: 424–5) for a commentary on Rossellini's three films with Ingrid Bergman about 'a woman's gradual discovery of moral awareness' (the other two are *Stromboli*, 1949, and *Voyage to Italy*, 1954). The authors also mention – this would be chapter and verse for the Dardennes – that Rossellini 'was resolutely anti-spectacle. "If I mistakenly make a beautiful shot", he once remarked, "I cut it out"'.

2 See, for instance, *The Burglar* (Paul Wendkos, 1957), *Tirez sur le pianiste* (*Shoot the Piano Player*, François Truffaut, 1960) and *La Lune dans le caniveau* (*The Moon in the Gutter*, Jean-Jacques Beneix, 1983). In *The Silence of Lorna*, the Dardennes, like Truffaut in *Shoot the Piano Player*, introduce some unconventional jump cuts seemingly to subvert any genre expectations.

3 See chapter five.

The Kid with a Bike, *2011*

The Kid with a Bike (*Le Gamin au vélo*, 2011) takes a step beyond *The Silence of Lorna* in refining the Dardennes' realist style. Though the film mirrors elements of their earlier works, the brothers succeed in the difficult task of presenting freshly and engagingly another set of familiar characters moving amid familiar settings and faced with familiar crises in their lives. By continuing to resist the conventions of mainstream cinema and to combine acute social observation with humanistic allegory, they have mastered the art of creating tough, uncompromising and unsentimental films that touch the heart as well as the mind. This latest example of their responsible realism won the the Grand Prix at Cannes in 2011, the festival's second highest award and one it shared with a Turkish film, Nuri Bilge Ceylan's *Bir Zamanlar Anadolu'da* (*Once Upon a Time in Anatolia*, 2011).

 The Kid with a Bike originates in the story of an abandoned boy that the Dardennes heard from a female judge in Japan in 2002. They developed the idea of a film about a boy trapped by violence and about a sympathetic woman who helps to liberate him. The resulting film is again a product of long gestation culminating in one year to write the screenplay. Their intensive pre-production included six weeks of rehearsal, much of it on set and in costume. They shot the film in 55 days and with a running time of 87 minutes it is the shortest of their major works. As in *The Silence of Lorna*, they modulate their visual style to allow for a measure of lyricism while resting within the naturalistic parameters that have rendered their films such candid and convincing visions of life on the social margins. The film revisits the spectre of unemployed youth and of ordinary people striving to survive in a post-industrial environment, though the Belgian social welfare and legal systems are shown, as in *The Silence of Lorna*, to function as well as may be expected in difficult times. *The Kid with a Bike* offers another deftly constructed and pitch-perfect narrative of crisis in the lives of their disadvantaged protagonists and of its conditional resolution through the values of love, compassion and respect.

Guy (Jérémie Renier) and Cyril (Thomas Doret) share fleeting togetherness: *The Kid with a Bike*, 2011

Placed temporarily in a children's home by his drifting and indifferent father Guy Catoul (Jérémie Renier), the priority of restless and rebellious 11-year-old Cyril (Thomas Doret) is to return to him (there is no sign of a mother). Cyril tries to escape from the home then plays truant from school to search for him at their flat in a high-rise building on a peripheral housing estate, an abode that his father has vacated, and to recover the bicycle that Guy has sold to help make ends meet. Cyril evades his pursuing counsellors by gaining false entry to a medical centre in the building. When they catch up with him, he grabs hold of a patient pulling her to the floor. Struck by the anguish of the child who has fallen into her lap, the woman, a local hairdresser named Samantha (Cécile de France) repurchases Cyril's bike from its latest owner, returns it to him at the home, and accepts his immediate request for her to foster him at weekends. Reunited with his precious bike, on which he regains a degree of self-identity, Cyril appears to be on the verge of better things, especially when Samantha locates his father and takes the boy to see him at a restaurant where he is prepping for its owner, a woman with whom he appears to be living. Guy, however, shatters Cyril's illusions by disowning him, a shock that Samantha also struggles to absorb and one that leads indirectly to a break-up with her boyfriend Gilles (Laurent Caron). Desperate for any father figure, Cyril falls in with a gang of youths whose drug-dealing kingpin Wes (Egon Di Mateo) slyly ingratiates himself with the boy in order to groom him for criminal activity. When the violent robbery of a local newsagent (Fabrizio Rongione) goes wrong, Wes abandons Cyril. After failing to hand over the stolen money to his father in a last-ditch effort to reconnect with him, Cyril has nowhere to go except back to Samantha. He apologises to her for having hurt her arm in an earlier struggle and expresses his wish to live with her permanently in an exchange

that ends in an embrace. Cyril finally accepts Samantha's genuine feeling for him and, as their bond strengthens in a manner reminiscent of that between Igor and Assita in *The Promise*, they begin to enjoy life together. As towards the end of *The Child* when Bruno faces the music, we witness due legal process whereby Samantha agrees to defray the damages caused by the robbery in return for Cyril's apology to the newsagent, one that his son, also assaulted by Cyril during the robbery, refuses to accept. Sent out by Samantha to buy charcoal for a barbecue that she has planned for that evening with some likeable neighbourhood youngsters, Cyril encounters the newsagent and his son. After the son pushes Cyril from his bike and chases him into the adjacent forest – as Olivier pursues Francis at the end of *The Son* – he is knocked out by a stone thrown by his assailant whose father quickly arrives on the scene and concocts an alibi to use in the event of Cyril's death. To their relief he comes round, groggily refuses the offer of medical help from the pair, and rides off determined not to miss the evening's engagement. As Cyril exits the frame, the Dardennes cut to black: their ending is typically uncertain but cautiously hopeful.

In casting the film the Dardennes recalled from *The Silence of Lorna* two of their usual thespian suspects (Renier and Rongione), while Olivier Gourmet again makes a token appearance, this time as a café owner to whom Cyril appeals in vain for information about his father's whereabouts. However, the two main parts belong to newcomers to their films. Once more, the brothers draw an outstanding debut performance from a young actor. The fifth to be auditioned from around 150 respondents to a press advertisement, Doret quickly impressed them with an immediate grasp of the part, a power of concentration, and a remarkable ability to learn his lines. Displaying great mental and physical stamina, Doret skilfully conveys Cyril's defiance, guile and sheer vulnerability – a peculiar blend of strength and weakness that marks the younger protagonists of the brothers' previous films: Igor, Rosetta, Francis, Bruno, Sonia, Steve, even Lorna to some extent.

Creating empathy for Cyril by focusing on his expression – now sad, now grimly determined – the Dardennes immediately pitch us, like Samantha, into his crisis. Despite his abrasiveness we want to know what is tormenting this unhappy child, who recalls Rosetta in his furious and single-minded pursuit of a goal. Adrift in a world bereft of parental concern, he shares with her a willful detachment from others as well as a feral quality that reflects a barely suppressed panic. After Samantha returns his bike, he uses it to circle then pursue her car like an animal stalking its prey. Obstinate, impetuous, deeply disturbed by his situation, and prone to sudden mood swings, Cyril is constantly on the move, like Rosetta, darting here and there, crossing busy roads or, like Igor on his moped in *The Promise*, haring through the local streets on his bike. The vehicle not only affords him a reassuring sense of independence and release but also serves to link all the characters in the film. As a realist fable with a poetic touch, *The Kid with a Bike* nods again to De Sica's celebrated take on a similar theme. It is *Bicycle Thieves* with a twist: in place of a father and son searching for a stolen bike, a son on his bike searches for a lost father.

Cyril relies on newer technology too. He, like Bruno, is a child of his time in possessing an all-important mobile phone – supplied by Samantha – and armed with

which he combs the town on his bike tracing his father at a café, a bakery and a filling station. In the course of these enquiries, he suffers further disillusionment on learning from an advertisement in the filling station window a fact that he had not believed to be possible: his cash-hungry father had sold his bike.

Particularly like Igor or Bruno, Cyril is capable of cunning. In an early scene he tricks his teacher by opening and closing a toilet door then exiting the school building and taking a bus to the estate where he hopes to find his father still in residence. We recall that bus journeys are central to facilitating the activities of Rosetta and Bruno, and the Dardennes' use of local buses is an exemplary realist tactic. Nothing melodramatic happens on them, but they function nonetheless as vital means to ends in the impecunious world of the brothers' young protagonists. We are a long way from the hurtling bus in *Speed* (Jan de Bont, 1994). Samantha and Gilles later take Cyril to a funfair where he demands to enjoy a ride alone. Forced to share the ride with Gilles, Cyril leaps from the car and disappears into the darkness beyond the bright lights and blaring music. Again, nothing melodramatic occurs on the ride, but it is a pivotal moment in our understanding of Cyril's resentment of Gilles as his rival for Samantha's affection. In another scene Cyril's counsellors, after apprehending him in the medical centre, allow him to revisit the flat, an eerily quiet and empty space reminiscent of the location of the first baby exchange scene in *The Child*. Following the boy as he inspects every room, we share his incredulity and disappointment. Such scenes demonstrate the brothers' skill in imbuing events in mundane settings with emotional and narratival significance.

The Belgian actress Cécile de France made her name in Alexandre Aja's *Haute Tension* (*High Tension*, 2003) and has appeared more recently, for instance, in Clint Eastwood's *Hereafter* (2010). The Dardennes chose her for the role of Samantha because they felt her facial expression and body language alone communicated a strong yet kind and compassionate person especially toward the near uncontrollable child who crashes into her life. Given their disinclination since *You're on My Mind* to seek the services of established film stars, they accepted a challenge both to de France and to themselves in asking her to adapt to their methods and style. It may seem at first that Samantha's willingness to involve herself in Cyril's turbulent life is dramatically unconvincing, but it remains consistent with the brothers' stringent avoidance of psychological explanations or back stories. Characters in their world – for instance, Olivier in *The Son* – often act illogically or irrationally on the basis of deep emotional convictions that speak to their sense of human duty and responsibility. Gilles disgustedly walks out on Samantha; inexplicable to him is her preference for the insolent and ungrateful child. But what he perceives as her blind loyalty to the boy proves to be a crucial turning point in their relationship: Cyril is able finally to recognise someone willing to put his interest before her own.

Renier gives a suitably restrained performance as the diffident father who would rather Cyril go away for good and leave him to his own devices. The scene at the Restaurant L'Acacia where Cyril and Samantha track him down is another masterly example of the Dardennes' realist style. The setting is resolutely unglamorous – noisy street, front doorstep, side alley, back yard and kitchen – and the awkward private

Cyril (Thomas Doret) and Samantha (Cécile de France) enjoy each other's company: *The Kid with a Bike*, 2011

exchanges between father and son in the kitchen are fraught with emotional pain on both sides. Guy's cool demeanour and laconic speech barely mask an uneasiness etched in his tense facial expression. Notwithstanding the gap that has opened up between them, moments of togetherness still occur: Guy offers Cyril drinks and food, and allows his son to stir the sauces he is preparing on the stove. With no fixed address and little money, Guy is living from hand to mouth, wanting to rebuild his life but unwilling to include his son. Under pressure from Samantha, who feels it is not her task to explain on his behalf, he tells Cyril neither to come back to see him nor to phone adding that nor will he phone him. These hammer blows to Cyril's forlorn hope are all the harder for his repeated willingness to try to help his father and to forgive his neglect. 'It's okay', says Cyril, as Guy proffers a string of excuses. Of the successive shocks Cyril receives, this is one he cannot absorb: his father's outright rejection. Cyril unsurprisingly breaks down on the car ride home and tries to hurt himself. A startled Samantha cradles the distraught boy, offering him safety and serenity in her arms.

Following the theft of his bike by a local kid, Cyril gets lured into a fight by a gang of older youths led by Wes, who praises the boy's gutsy attitude and invites him to play video games in the cramped flat he shares with his invalid grandmother. As with Bruno and Steve in *The Child*, we see the influence of experienced older youths drawing youngsters into crime. Wes sees an opportunity to recruit a willing accomplice. Tired of rejection, Cyril warms to this dubious father figure and succumbs to his blandishments. Cyril subsequently breaks a promise to Samantha that he will have nothing further to do with Wes and chooses his company over that of the football-playing, film-going boys of his own age. After a fight with Samantha ends in Cyril asking to go back to the home, his resilient hostess, shaken and saddened by this turn of events,

breaks down in tears. Though pushed to the limit by Cyril, she remains willing to stand by him.

Shot in 35mm like *The Silence of Lorna*, *The Kid with a Bike* initially reminds us of *Rosetta*: the restless, handheld camera tracking Cyril's sudden bursts of physical activity accompanied by sounds of heavy breathing and the noise of the material world. Early on, when Cyril breaks free of his counsellors and makes a run for it, a long shot pays homage to *The Four Hundred Blows*, in which 12-year-old Antoine escapes from a reformatory in the penultimate scene. Doret's performance overall recalls that of Jean-Pierre Léaud as Antoine in Truffaut's film. Something of the claustrophobic atmosphere of *The Son* recurs especially in tightly framed shots of car interiors, while the home and school remind us of the training centre (and of the waffle factory in *Rosetta*). Night scenes, as in *The Son* and *The Silence of Lorna*, are shot largely in available light giving them a lurid yet accurate tinge. Much of the film displays the Dardennes' synecdochal approach to shot composition via characteristic close-ups and medium shots. Marcoen's cinematography, as in *The Child* and *The Silence of Lorna*, nonetheless pulls back occasionally to reveal more of the background. It also makes use of brighter, more saturated colours especially shades of green, befitting the fact that this is the first film the brothers had shot in summer. One example of this softer vision comes late in the film when Cyril and Samantha strengthen their hitherto fragile relationship by bicycling and picnicking along the river bank, an almost idyllic scene were it not for our awareness of a tentative situation engendered by taut plotting and strict emotional control. While the overall *mise-en-scène* is typical of how the brothers depict daily life in a working-class community, much of the action unfolds on a spaciously designed housing estate next to a forest and occasionally in the equally leafy surroundings of the children's home. In line with the brothers' principles, Marcoen's compositions carefully avoid the trap of spectacular imagery and remain strictly geared to the demands of character and plot. This film, like its predecessors, pulses with a cinematic rhythm in which there are no gratuitous images, gestures or words.

The Kid with a Bike also follows *The Silence of Lorna* in that the Dardennes guard their trademark style and subject matter while superimposing a fairytale quality that they admit grew more evident during shooting: Wes and his fellow wolves in sheep's clothing waiting in the dark forest to corrupt the lost child, and the entrance of a fairy godmother figure in the form of Samantha. Their use of nondiegetic music, expanding slightly on its introduction for the first time at the end of *The Silence of Lorna*, enhances this mythical aspect, as on each of the four occasions on which it is used it marks a moment of respite or relief for Cyril on his painful and risky route to salvation. Again using the music of Beethoven, the brothers employ a phrase from the *adagio un poco mosso* of the piano concerto number 5 in E-flat major, op. 73 ('Emperor'). We hear it first as Cyril sleeps off his failed breakout from the home in a blue-filtered shot that recalls Lorna falling asleep in a forest hut to the accompaniment of a Beethoven sonata. It recurs as Samantha comforts Cyril in the car after the first meeting with his father, then as he rides through the night back to Samantha after his father's second rejection, and again as he rides away from trouble in the final shot of the film (the piece continues to play over the end credits).

In the world of the Dardennes we experience extraordinary human stories about ordinary people and places. In writing this book I have sought to follow the trajectory of the brothers' career from their earliest video documentaries to the assured fiction of *The Silence of Lorna*. They have now added *The Kid with a Bike* to an existing series of rigorous and riveting fiction films that presents ugliness and beauty, pain and pleasure, darkness and light, misdeed and redemption, despair and hope in a manner that arguably no other living filmmakers can match. Established as major cinematic auteurs, Jean-Pierre and Luc Dardenne continue to move us with the startling freshness of their images, the responsible realism of their vision, and the demanding originality of their ongoing work.

FILMOGRAPHY

1974–77

Au commencement était la résistance

(*In the Beginning Was the Resistance*)

Videos of oral testimony by residents of various council estates in Wallonia on problems of urbanism and communal life; reports on social questions.

1978

Le Chant du rossignol. Sept voix, sept visages de résistants. Une ville: Liège et sa banlieue (*The Nightingale's Song. Seven Voices. Seven Faces of Resisters. A City: Liège and Its Suburbs*)

Documentary video, ½ inch, black and white, 62 mins

Directors: Jean-Pierre and Luc Dardenne

1979

Lorsque le bateau de Léon M. descendit la Meuse pour la première fois (*When Léon M's Boat First Sailed down the River Meuse*)

Documentary video, ½ inch, black and white, 40 mins

Directors: Jean-Pierre and Luc Dardenne

Cinematography: Jean-Pierre Dardenne

Sound: Luc Dardenne

Archives: Frans Buyens, bequest of the history of the Walloon newspaper *La Wallonie*

Production: Collectif Dérives (Drifters' Collective), with the aid of the Ministry of French Culture of Belgium

1980

Pour que la guerre s'achève, les murs devaient s'écrouler aka *Le Journal* (*For the War to End, the Walls Had to Crumble* aka *The Newspaper*)
Documentary video, U-matic, colour, 50 mins
Directors: Jean-Pierre and Luc Dardenne
Cinematography: Lucien Ronday
Archives: Frans Buyens
Sound: Robert Joris
Editing: Francis Galopin
Mixing: Lucien Lambert and G. Jodogne
Production: Collectif Dérives, RTBF, Fleur Maigre Coop

1981

R… ne répond plus (*R… No Longer Answers*)
Documentary video, U-matic, colour, 52 mins.
Directors: Jean-Pierre and Luc Dardenne
Assistant: René Begon
Cinematography: Stéphane Gatti and Jean-Pierre Dardenne
Sound: Jean-Pierre Duret and Eddy Luyckx
Editing: Jean-Pierre Dardenne
Mixing: Claude Mouriéras
Production: Collectif Dérives, Centre bruxellois de l'Audiovisuel, Mediaform

1982

Leçons d'une université volante (*Lessons from a University on the Fly*)
Documentary video, U-matic BVU, colour, 5 x 9 mins
Directors: Jean-Pierre and Luc Dardenne

1983

Regarde Jonathan. Jean Louvet, son oeuvre (*Look at Jonathan. Jean Louvet, His Work*)
Documentary video, U-matic BVU, colour, 57 mins
Directors: Jean-Pierre and Luc Dardenne
Cinematography: Claude Mouriéras
Assistant: Eddy Luyckx
Camera: Jean-Pierre Dardenne
Assistant: : Laurent Velghe
Sound: Jean-Pierre Duret, Dominique Warnier
Editing: Georges Souphy, Jean-Pierre and Luc Dardenne
Mixing: Alain Tresini
Music: Ravel, Penderecki, Constant, Stockhausen
Executive Producers: Marc Minon, Lisa Niccoli
Production: Dérives, Wallonie Image Production, No-Télé Tournai, RTBF, with the aid of the Ministry of the French Community of Belgium

1986

Falsch
Fiction, 35 mm, colour, 82 mins
Directors: Jean-Pierre and Luc Dardenne
Assistant Director: Anne Lévy-Morelle
Screenplay: : Luc and Jean-Pierre Dardenne from the play by René Kalisky
Cinematography: Walther Vanden Ende
Camera: Yves Vendermeeren
Editing: Denise Vindevogel

Sound: Dominique Warnier
Production Design: Wim Vermeylen
Music: Jean-Marie Billy, Jan Franssen
Mixing: Gilles Rousseau
Cast: Bruno Crémer (Joe), Jacqueline Bollen (Mimi), Nicole Colchat (Mina), Christian Crahay (Gustav),
 Millie Dardenne (Bela), Bérangère Dautun (Rachel), John Dobrynine (Georg), André Lenaerts
 (Ruben), Christian Maillet (Jacob), Jean Mallamaci (Benjamin), Gisèle Oudart (Natalia), Marie-Rose
 Roland (Daniella), François Sikivie (Oscar)
Production: Dérives Production (Liège), RTBF (Liège), Arcanal (Paris), Théâtre de la Place (Liège), National
 Lottery (Belgium), with the aid of the Ministry of the French Community of Belgium
Recognition: Selected for Perspectives of French Cinema (Cannes) and Forum (Berlin) 1986
SACD Prize (Belgium) and Critics' Prize, Riccione (Italy) 1987
Release: January 1987 by Cinélibre (Belgium)

1988

Il court, il court le monde (*They're Running … Everyone's Running*)
Short fiction, 35mm, colour, 10 mins
Directors: Jean-Pierre and Luc Dardenne
Screenplay: Luc and Jean-Pierre Dardenne
Cinematography: Alain Marcoen
Sound: Thierry Dehalleux
Editing: Marie-Hélène Dozo
Mixing: Gérard Rousseau
Cast: John Dobrynine, Carmela Locantore, Christian Maillet, Pascale Tison, André Laenaerts, Jean-Paul
 Dermont, François Duysinx (as himself)
Production: Dérives Productions (Liège), RTBF, with the aid of the Ministry of the French Community
 of Belgium

1992

Je pense à vous (*You're on My Mind*)
Fiction, 35 mm, colour, 85 mins
Directors: Jean-Pierre and Luc Dardenne
Assistant Directors: Antoine Beau, Bénédicte Liénard, Danillo Cati
Screenplay: Jean Gruault, Luc and Jean-Pierre Dardenne from an idea by Henri Storck
Cinematography: Yorgos Arvanitis
Sound: Jean-Pierre Duret
Music: Wim Mertens
Production Design: Yves Brover
Costume Design: Monic Parelle
Editing: Denise Vindevogel, Ludo Troch
Mixing: Bruno Tarrière
Production Director: Joey Fare
Line Producers: Dirk Impens, Jean-Luc Ormières
Cast: Robin Renucci (Fabrice), Fabienne Babe (Céline), Tolsty (Mareck), Gil Lagay (Renzo), Pietro
 Pizzuti (Laurent), Nathalie Uffner (Solange), Stéphane Pondeville (Martin), Pier Paquette (Brendon),
 Angélique Astgen (Myriam), Vincent Grass (Alain), Jean-Claude Derudder (Moustachu), Georges
 Bossair (Albert Terlinck), Robert Germay (trade unionist), Bernard Marbaix (Roger), François Torres
 (Yursen), Catherine Bady (prostitute)
Production: Films Dérives Productions (Liège), Titane (Paris), Favourite Films (Brussels), Samsa Film
 Production (Luxemburg), RTBF (Belgian television), Centre de l'Audiovisuel (CBA, Brussels) with the
 aid of the Ministry of the French Community of Belgium, the Flemish Community of Belgium, the
 Walloon Region, the Eurimages Fund of the Council of Europe, the National Lottery, the CGER Bank,
 Canal + France, and the Centre National de la Cinématographie (Paris)

Recognition: Female Performance Prize to Fabienne Babe and Audience Prize at the International Festival of Francophone Film, Namur, 1992

Audience Prize, Arcachon (formerly Biarritz) Festival, 1993

Selected for Rencontres (Cannes, 1992) and 8th Paris Film Festival, 1993

Release: October 1992 by Belgafilm (Belgium)

1996

La Promesse (*The Promise*)
Fiction, 35 mm, colour, 93 mins
Directors: Jean-Pierre and Luc Dardenne
First Assistant Director: Bernard Garant
Screenplay: Luc and Jean-Pierre Dardenne, Léon Michaux, Alphonse Badolo
Production Manager: Robert Lemaire
Cinematography: Alain Marcoen
Camera: Benoît Dervaux
Sound: Jean-Pierre Duret
Production Design: Igor Gabriel
Costume Design: Monic Parelle
Makeup: Tina Kopecka
Editing: Marie-Hélène Dozo
Music: Jean-Marie Billy, Denis M'Punga
Production Director: Véronique Marit
Line Producers: Luc Dardenne, Hassen Daldoul
Cast: Jérémie Renier (Igor), Olivier Gourmet (Roger), Assita Ouedraogo (Assita), Frédéric Bodson (Garage proprietor), Rasmané Ouedraogo (Hamidou)
Production: Les Films du Fleuve (Liège), Touza Productions (Paris), Samsa Film Production (Luxemburg), Touza Films (Tunis), Dérives, RTBF (Belgian television), ERTT (Tunisian television), with the aid of the Centre du Cinéma et de l'Audiovisuel of the French Community of Belgium, Eurimages, Centre National de la Cinématographie, Canal + France, Belgian National Lottery, Agence de Coopération Culturelle et Technique (ACCT), Fonds d'Action Sociale
Recognition: CICAE Prize, Directors' Fortnight, Cannes, 1996
Golden Bayard for best film/ best actor (Olivier Gourmet) and Audience Prize, International Festival of Francophone Film, Namur, 1996
Press Jury Prize to Jérémie Renier, Geneva Film Festival, 1996
Grand Prize (Golden Spike) and International Critics' Prize (FIPRESCI), Valladolid Festival, 1996
CGER Prize for best Belgian feature, 1997
International Critics' Prize (CIFEJ), Frankfurt Film Festival
Joseph Plateau Prize for best film, best director and best actress, Flanders International Film Festival, Ghent, 1997
Cavens Prize (UCC, Belgium), 1997
Best foreign film of the year in USA, Los Angeles Society of Film Critics, National Society of Film Critics
Best film of the year, Seattle Society of Film Critics
Crystal Simorgh Prize for best film, Teheran Festival, 1998
Release: October 1996 by Cinélibre (Belgium) and ARP Sélection (France)

1999

Rosetta
Fiction, 35 mm, colour, 91 mins
Screenplay/Directors: Luc and Jean-Pierre Dardenne
First Assistant Director: Bernard Garant
Production Managers: Philippe Groff, Philippe Toussaint
Cinematography: Alain Marcoen
Camera: Benoît Dervaux

Sound: Jean-Pierre Duret
Production Design: Igor Gabriel
Costume Design: Monic Parelle
Makeup: Tina Kopecka
Editing: Marie-Hélène Dozo
Mixing: Thomas Gauder
Production Director: Véronique Marit
Line Producers: Luc and Jean-Pierre Dardenne, Michèle and Laurent Pétin
Cast: Emilie Dequenne (Rosetta), Fabrizio Rongione (Riquet), Anne Yernaux (mother), Olivier Gourmet (boss), Frédéric Bodson (personnel manager), Bernard Marbaix (caravan site caretaker)
Production: Les Films du Fleuve (Liège), ARP Sélection (Paris), RTBF (Belgian television), with the aid of the Centre du Cinéma et de l'Audiovisuel of the French Community of Belgium and Télédistributeurs Wallons, Walloon Region, Belgian National Lottery, and with the participation of Canal + France and the Centre National de la Cinématographie
Recognition: Palme d'Or, Female Performance Prize to Emilie Dequenne, and special mention for the Ecumenical Prize, Cannes Festival, 1999
Release: September 1999 by Cinéart (Belgium) and ARP Sélection (France)

2002
Le Fils (*The Son*)
Fiction, 35 mm, colour, 91 mins
Screenplay/Directors: Jean-Pierre and Luc Dardenne
First Assistant Director: Bernard Garant
Location managers: Philippe Groff, Philippe Toussaint
Cinematography: Alain Marcoen
Camera: Benoît Dervaux
Sound: Jean-Pierre Duret
Production Design: Igor Gabriel
Costume Design: Monic Parelle
Makeup: Tina Kopecka
Editing: Marie-Hélène Dozo
Mixing: Thomas Gauder
Production Director: Véronique Marit
Executive Producer: Olivier Bronckart
Line Producers: Jean-Pierre and Luc Dardenne, Denis Freyd
Cast: Olivier Gourmet (Olivier), Morgan Marinne (Francis), Isabella Soupart (Magali)
Production: Les Films du Fleuve (Liège), Archipel 35 (Paris), RTBF (Belgian television), with the aid of the Centre du Cinéma et de l'Audiovisuel of the French Community of Belgium and Télédistributeurs Wallons, Eurimages, Belgian National Lottery, and with the participation of Canal + France, the Centre National de la Cinématographie, Wallimage
Recognition: Male Performance Prize to Olivier Gourmet, Cannes Festival, 2002
Release: October 2002 by Cinéart (Belgium) and Diaphana (France)

2005
L'Enfant (*The Child*)
Fiction, 35 mm, colour, 100 mins
Screenplay/Directors: Jean-Pierre and Luc Dardenne
First Assistant Director: Bernard Garant
Location Managers: Philippe Groff, Philip Toussaint
Cinematography: Alain Marcoen
Camera: Benoît Dervaux
Sound: Jean-Pierre Duret
Production Design: Igor Gabriel

Costume Design: Monic Parelle
Makeup: Tina Kopecka
Editing: Marie-Hélène Dozo
Mixing: Thomas Gauder
Production Director: Véronique Marit
Executive Producer: Olivier Bronckart
Cast: Jérémie Renier (Bruno), Déborah François (Sonia), Jérémie Segard (Steve), Fabrizio Rongione (young ruffian), Olivier Gourmet (plainclothes cop), Stéphane Bissot (fence)
Production: Les Films du Fleuve (Liège), Archipel 35 (Paris), RTBF (Belgian television), Scope Invest, Arte France Cinéma, with the aid of the Centre du Cinéma et de l'Audiovisuel of the French Community of Belgium and Télédistributeurs Wallons, Eurimages, Media Plus Programme of the European Community, Belgian National Lottery, and with the participation of Canal +, Centre National de la Cinématographie, Walloon Region (Wallimage), and the Tax Shelter of the Belgian Federal Government
Recognition: Palme d'Or, Cannes Festival, 2005
Release: September 2005 by Cinéart (Belgium) and October 2005 by Diaphana (France)

2008

Le Silence de Lorna (*The Silence of Lorna, Lorna's Silence*)
Fiction, 35 mm, colour, 105 mins
Screenplay/Directors: Jean-Pierre and Luc Dardenne
First Assistant Director: Caroline Tambour
Cinematography: Alain Marcoen
Camera: Benoît Dervaux
Sound: Jean-Pierre Duret
Production Design: Igor Gabriel
Costume Design: Monic Parelle
Makeup: Natali Tabareau-Vieuille
Editing: Marie-Hélène Dozo
Mixing: Thomas Gauder
Executive Producer: Olivier Bronckart
Line Producers: Jean-Pierre and Luc Dardenne, Denis Freyd
Cast: Arta Dobroshi (Lorna), Jérémie Renier (Claudy), Fabrizio Rongione (Fabio), Alban Ukaj (Sokol), Morgan Marinne (Spirou), and with the participation of Olivier Gourmet
Production: Les Films du Fleuve (Liège), Archipel 35 (Paris), Lucky Red, RTBF (Belgian television), ARTE France Cinéma, ARTE/WDR, in association with Gemini Film, Magador Film, and with the aid of the Centre du Cinéma et de l'Audiovisuel of the French Community of Belgium and Télédistributeurs Wallons, Eurimages, Walloon Region, Wallimage, Centre National de la Cinématographie, Tax Shelter of the Belgian Federal Government, Media Plus Programme of the European Community, and with the participation of Canal +, Cinécinéma
Recognition: Screenplay Prize, Cannes Festival, 2008
Release: August 2008 by Cinéart (Belgium) and Diaphana (France)

2011

Le Gamin au vélo (*The Kid with a Bike*)
Fiction, 35mm, colour, 87 mins
Screenplay/Directors: Jean-Pierre and Luc Dardenne
First Assistant Director: Caroline Tambour
Cinematography: Alain Marcoen
Camera: Benoît Dervaux
Sound: Jean-Pierre Duret
Production Design: Igor Gabriel
Costume Design: Maïra Ramedhan-Lévy

Makeup: Natali Tabareau-Vieuille

Editing: Marie-Hélène Dozo

Mixing: Thomas Gauder

Executive Producer: Delphine Tomson

Line Producers: Jean-Pierre and Luc Dardenne, Denis Freyd

Co-Producer: Andrea Occhipinti

Cast: Thomas Doret (Cyril), Cécile de France (Samantha), Jérémie Renier (Guy Catoul), Fabrizio Rongione (newsagent), Egon Di Mateo (Wes), and with the participation of Olivier Gourmet

Production: Les Films du Fleuve (Liège), Archipel 35 (Paris), Lucky Red, France 2 Cinéma, RTBF (Belgian television), Belgacom, with the aid of the Centre du Cinéma et de l'Audiovisuel of the French Community of Belgium, VOO, Centre National du Cinéma et de l'Image Animée, Walloon Region, Tax Shelter of the Belgian Federal Government, Inver Invest, Casa Kafka Pictures, Casa Kafka Pictures Movie Tax Shelter empowered by Dexia, Making Of, Media Programme of the European Community, with the participation of Eurimages, Canal +, Cinécinéma, France Télévision, and in association with Wild Bunch and Soficinéma 7

Recognition: Grand Prize, Cannes Festival, 2011

Release: May 2011 by Cinéart (Belgium) and Diaphana (France)

BIBLIOGRAPHY

Note: the parenthesis (dardenne-brothers.com) refers to an unofficial website about Jean-Pierre and Luc Dardenne that was available at *http://www.dardenne-brothers.com/articles/index.html*. However, at the time of this book's completion, the site was no longer available. References to items found on the site bear no page numbers.

Note: interviews on commercially available DVDs are included in this list.

Abani, Chris (2009) 'Ethics and Narrative: the Human and Other', *Witness*, 22, 167–73.

Abeel, Erica (2008) 'Cannes 08: The Dardennes on *The Silence of Lorna.*' Online. *IFC.com*, May.

Adorno, Theodor, Walter Benjamin, Ernst Bloch, Bertolt Brecht and Georg Lukács (2007) *Aesthetics and Politics*, trans. Ronald Taylor. London: Verso.

Andersen, Thom (2009) 'Against the Grain: Adding a Touch of Noir, the Dardenne Brothers Rethink Realism in *Lorna's Silence*', *Film Comment*, 45, 4, 25–7.

Andrew, Geoff (2006) 'Luc and Jean-Pierre Dardenne (interview)'. Online. *Guardian Unlimited*, 11 February.

Armes, Roy (1986) *Patterns of Realism*. New York: Garland.

Arthur, Paul (2006) 'Habeas Corpus: A Meditation on the Death of Mr. Lazarescu and Corporeal Cinema', *Film Comment*, 42, 3 (May-June), 44–49.

Aubenas, Jacqueline (ed.) (2008) *Jean-Pierre & Luc Dardenne*. Brussels: CGRI/CFWB.

Auerbach, Erich (1968) *Mimesis: The Representation of Reality in Western Literature*. Princeton: Princeton University Press.

Balibar, Etienne (2004) *We, the People of Europe? Reflections on Transnational Citizenship*, trans. James Swenson. Oxford: Oxford University Press.

Barnouw, Erik (1974) *Documentary: A History of the Non-Fiction Film*. Oxford: Oxford University Press.

Baronian, Marie-Aude (2008) '"La Caméra à la nuque" ou esthétique et politique dans le cinéma des frères Dardenne', in Jacqueline Aubenas (ed.) *Jean-Pierre & Luc Dardenne*. Brussels: CGRI/CFWB, 151–6.

Barthes, Roland (1982) 'The Reality Effect', in Tzvetan Todorov (ed.) *French Literary Theory Today: A Reader*. Cambridge: Cambridge University Press/Paris: Editions de la Maison des Sciences de l'Homme, 11–17.

Bartlett, Mike (n.d.) 'The Dardenne Brothers – Cinema from a New Europe.' Online. *Close-Up Film* (dardenne-brothers.com).

Bénézet, Delphine (2005) 'Contrasting Visions in Le Jeune Cinéma: Poetics, Politics and the Rural', *Studies in French Cinema*, 5, 3, 163–74.

Benjamin, Walter (1979 [1936]) 'The Work of Art in the Age of Mechanical Reproduction', in *Illuminations*, trans. Harry Zohn. Glasgow: Fontana/Collins, 219–53.

Berman, Marshall (1988) *All That is Solid Melts into Air: The Experience of Modernity*. New York: Penguin.

Bickerton, Emilie (2006) 'Reinventing Realism: The Art and Politics of the Dardenne Brothers', *Cineaste*, 31, 2, 14–18.

____ (2009) '*Lorna's Silence*', *Cineaste*, 34, 3, 49–51.

Bisztray, George (1978) *Marxist Models of Literary Realism*. New York: Columbia University Press.

Bonnaud, Frédéric (n.d.) Interview with the Dardenne brothers for Radio France Inter, *L'Enfant* (DVD).

Brecht, Bertolt (2007) 'Against Georg Lukács' [1938], in Adorno et al., *Aesthetics and Politics*, 68–85.

Bresson, Robert (1977) *Notes on the Cinematographer*, trans. J. M. G. Le Clézio. New York: Urizen.

Brooks, Xan (2006) 'We're the Same: One Person, Four Eyes.' Online. *Guardian Unlimited*. 9 February.

Bunbury, Stephanie (2008) 'Silence Not Quite Golden.' Online. *Age*, 25 July.

Burch, Noël (1973) *Theory of Film Practice*, trans. Helen Lane. New York: Praeger.

Calhoun, Dave (2008) 'Dardenne Brothers and *The Silence of Lorna*.' Online. *Time Out London*, 24 November.

Camhi, Leslie (1999) 'Soldiers' Stories: A New Kind of War Film – Work as a Matter of Life and Death.' Online. *Village Voice*, 3–9 November.

Cardullo, Bert (2002) 'Rosetta Stone: A Consideration of the Dardenne Brothers' *Rosetta*.' Online. *Journal of Religion and Film*, 1 April.

____ (ed.) (2009) *Committed Cinema: The Films of Jean-Pierre and Luc Dardenne; Essays and Interviews*. Newcastle upon Tyne: Cambridge Scholars Publishers.

Caygill, Howard (2002) *Levinas and the Political*. London: Routledge.

Chalier, Catherine (2003) *Traité des larmes. Fragilité de Dieu, fragilité de l'âme*. Paris: Albin Michel.

Collin, Françoise (2008) '*Le Fils*', in in Jacqueline Aubenas (ed.) *Jean-Pierre & Luc Dardenne*. Brussels: CGRI/CFWB, 210–13.

Concannon, Philip (2008) 'Interview – Jean-Pierre and Luc Dardenne.' Online. *philonfilm.blogspot.com*, 30 November.

Cooper, Sarah (2007) 'Mortal Ethics: Reading Levinas with the Dardenne Brothers.' Online. *Film-Philosophy*, 11, 2 (August), 66–87. Available at http://www.film-philosophy.com/index.php/f-p/article/view/88/73.

Corner, John (1996) *The Art of Record: A Critical Introduction to Documentary*. Manchester: Manchester University Press.

Crano, R. D. (2009) 'Occupy Without Counting: Furtive Urbanism in the Films of Jean-Pierre and Luc Dardenne.' Online. *Film-Philosophy*, 13, 1, 1–15. Available at http://www.film-philosophy.com/index.php/f-p/article/view/35/20.

Critchley, Simon (2007) *Infinitely Demanding: Ethics of Commitment, Politics of Resistance*. London/New York: Verso.

Cummings, Doug (2006a) 'Interview with the Dardennes.' Online. *filmjourney.org*, 23 March.

_____ (2006b) 'Dardenne Documentaries (part 1).' Online. *filmjourney.org*, 2 April; (part 2) *filmjourney.org*. 7 April (dardenne-brothers.com).

_____ (2007) *Dans l'obscurité*. Online. *filmjourney.org*, 22 July (dardenne-brothers.com).

_____ (2008) 'The Brothers Dardenne: Responding to the Face of the Other', in Kenneth R. Morefield (ed.) *Faith and Spirituality in Masters of World Cinema*. Newcastle upon Tyne: Cambridge Scholars Publishing, 91–103.

Dalrymple, Theodore (2001) *Life at the Bottom: The Worldview That Makes the Underclass*. Chicago: Ivan R. Dee.

Danvers, Louis (n.d.) Interviews with the Dardenne Brothers and Olivier Gourmet, *Le Fils* (DVD).

Dardenne, Luc (1995) 'Lutte', in Philippe Dubois and Edouard Arnoldy (eds) *Ça tourne depuis cent ans. Une histoire du cinéma francophone de Belgique*. Brussels: CGRI, 90.

_____ (2005) *Au dos de nos images, 1991–2005*. Paris: Seuil.

Dardenne, Luc and Jean-Pierre Dardenne (1986) *Falsch*. Press kit. Liège: Dérives Productions.

Dargis, Manohla (2005) 'Auteur Brothers Who Work Like Cops.' Online. *New York Times*, 18 May.

D'Autreppe, Emmanuel (2008) 'L'Impossible Désir de ce paysage que nous sommes', in Jacqueline Aubenas (ed.) *Jean-Pierre & Luc Dardenne*. Brussels: CGRI/CFWB, 117–23.

Davis, Colin (1996) *Levinas: An Introduction*. Notre Dame, Indiana: University of Notre Dame Press.

Dawson, Tom (n.d.) 'A Quick Chat with Jean-Pierre and Luc Dardenne.' Online. *kamera.co.uk*.

Deleuze, Gilles and Félix Guattari (2004) *A Thousand Plateaus*, trans. Brian Massumi. London: Continuum.

Derrida, Jacques (1978) 'Violence and Metaphysics: An Essay on the Thought of Emmanuel Levinas', in *Writing and Difference*, trans. Alan Bass. Chicago: University of Chicago Press, 79–153.

Desbarats, Carole (2008) '"Garder l'oeil sec"', in Jacqueline Aubenas (ed.) *Jean-Pierre & Luc Dardenne*. Brussels: CGRI/CFWB, 203–7.

Dubois, Jacques (1997) 'Lecture', in Jean Louvet *Conversation en Wallonie/Un Faust*. Brussels: Labor, 225–56.

_____ (2008) 'Savoir en action/savoir de fiction', in Jacqueline Aubenas (ed.) *Jean-Pierre & Luc Dardenne*. Brussels: CGRI/CFWB, 253–57.

Dubois, Philippe (1990) 'Vidéo', in Guy Jungblut et al. (eds.) *Une Encyclopédie des cinémas de Belgique*. Paris: Musée d'Art Moderne de la Ville de Paris/Editions Yellow Now, 250–61.

Dupont, Joan (2002) 'Belgian Brothers' Working-Class Heroes'. Online. *International Herald Tribune*, 29 October (dardenne-brothers.com).

Durbin, Karen (1999) 'Tough Love for a Tough Girl', *New York Times*, 7 November, 23, 33.

Eagleton, Terry (2009) *Trouble with Strangers: A Study of Ethics*. Chichester: Wiley-Blackwell.

Edelmann, Pascal (2007) 'An Opportunity to Resist: An Interview with the Dardenne Brothers', in Peter Cowie and Pascal Edelmann (eds) *Projections 15: European Cinema*. London: Faber and Faber, 218–23.

Ellis, John (1982) *Visible Fictions: Cinema: Television: Video*. London: Routledge.

Foucault, Michel (1980) *The History of Sexuality. Volume I: An Introduction*, trans. Robert Hurley. New York: Vintage.

Frampton, Daniel (2006) *Filmosophy*. London: Wallflower Press.

Gaines, Jane (1996) 'The Melos in Marxist Theory', in David E. James and Rick Berg (eds) *The Hidden Foundation: Cinema and the Question of Class*. Minneapolis: University of Minnesota Press, 56–71.

Gibson, Brian (2006) 'Bearing Witness: The Dardenne Brothers' and Michael Haneke's Implication of the Viewer.' Online. *CineAction*, 22 June.

Girish (2006) 'Dardenne Documentaries.' Online. *girishshambu.com*, 2 April (dardenne-brothers. com).

Hardt, Michael and Antonio Negri (2004) *Multitude: War and Democracy in the Age of Empire*. New York: Penguin.

Higbee, Will (2004) '"Elle est où, ta place?" The Social-Realist Melodramas of Laurent Cantet: *Ressources humaines* (2000) and *Emploi du temps* (2001)', *French Cultural Studie*s, 15, 3, 235–50.

Hill, John (2000) '"From the New Wave to Brit Grit": Continuity and Difference in Working-Class Realism', in Justine Ashby and Andrew Higson (eds) *British Cinema: Past and Present*. London: Routledge, 249–59.

Hoberman, J. (2006) 'A Child Escaped. Grace to the Finish: Dardennes Brothers' Triumphant Tale of Crime and Punishment.' *Village Voice*, 14 March, Available at http://www.villagevoice. com/2006–03-14/film/a-child-escaped/

Hobsbawm, Eric J. (1969) *Industry and Empire*. London: Penguin.

Izod, John and Richard Kilborn (1998) 'The Documentary', in John Hill and Pamela Church Gibson (eds.) *The Oxford Guide to Film Studies*. New York: Oxford University Press, 426–33.

James, David E. (1996) 'Introduction: Is There Class in This Text?', in David E. James and Rick Berg (eds) *The Hidden Foundation: Cinema and the Question of Class*. Minneapolis: University of Minnesota Press, 1–25.

Jameson, Fredric (2007) 'Reflections in Conclusion', in Theodor Adorno, Walter Benjamin, Ernst Bloch, Bertolt Brecht, Georg Lukács (2007) *Aesthetics and Politics*, trans. Ronald Taylor. London: Verso, 196–213.

Johan Van Der Keuken: Cinéaste et photographe (1981). Brussels: Ministère de la Communauté française.

Johnston, Sheila (2003) 'Film-Makers on Film: Jean-Pierre and Luc Dardenne.' Online. *Telegraph. co.uk,* 15 March.

Kaufman, Anthony (1999) '*Rosetta* Directors Jean-Pierre and Luc Dardenne's Cinema of Resistance.' Online. *indieWIRE*, 2 November.

Kellner, Douglas (n.d.) 'Ernst Bloch, Utopia and Ideology Critique (Illuminations: The Critical Theory Project).' Online. Available at http://www.gseis.ucla.edu/faculty/kellner

Kilborn, Richard and John Izod (1997) *An Introduction to Television Documentary: Confronting Reality*. Manchester: Manchester University Press.

Klawans, Stuart (2006) 'The Wild Child'. Online. *Nation*, 10 April. Available at http://www.thenation.com/article/wild-child

Klevan, Andrew (2000) *Disclosure of the Everyday: Undramatic Achievement in Narrative Film*. Trowbridge: Flicks Books.

Kupfer, Joseph H. (1999) *Visions of Virtue in Popular Film*. Boulder: Westview Press.

L'Image, la vie: le cinéma de Jean-Pierre et Luc Dardenne (2005). Brussels: CFWB.

Lay, Samantha (2002) *British Social Realism: From Documentary to Brit-Grit*. London: Wallflower Press.

Lee, David J. and Bryan S. Turner (1996) *Conflicts About Class: Debating Inequality in Late Industrialism*. New York: Longman.

Lefebvre, Henri (1991) *Critique of Everyday Life*, vol. 1, trans. John Moore. London/New York: Verso.

Legros, Robert (2008) 'La Moralité et le sublime. La philosophie morale de Jean-Pierre et Luc Dardenne', in Jacqueline Aubenas (ed.) *Jean-Pierre & Luc Dardenne*. Brussels: CGRI/CFWB, 267–71.

Leigh, Jacob (2002) *The Cinema of Ken Loach: Art in the Service of the People*. London: Wallflower Press.

Lesuisse, Anne-Françoise (1996) 'Trois étapes/un paysage', in *Revue Belge du Cinéma* 41 (Winter 1996–97), 43–49.

Levinas, Emmanuel (1998) *On Thinking of the Other: entre nous*, trans. Michael B. Smith and Barbara Horshav. New York: Columbia University Press, 1998.

Lim, Dennis (2006) 'Working Family: The Dardenne Brothers' Spiritual Tales of Economic Survival'. Online. *Village Voice*, 21 March (dardenne-brothers.com).

Loewenstein, Julius I. (1980) *Marx Against Marxism*, trans. Harry Drost. London: Routledge and Kegan Paul.

Lopate, Phillip (2003) 'The Endless Toil of Conflicted Hearts Becomes the Stuff of Moral Catharsis in the Hands of Belgian Master Craftsmen the Dardenne Brothers', *Film Comment*, 39, 2 (March-April), 22–5.

Louvet, Jean (1991) *Le Fil de l'histoire: pour un théâtre d'aujourd'hui*. Louvain-la-Neuve: Presses Universitaires de Louvain UCL.

'Luc et Jean-Pierre Dardenne: vingt ans de travail en cinéma et vidéo' (1996–97), *Revue Belge du Cinéma*, 41 (Winter), special issue.

Macnab, Geoffrey (2003) 'Timber!' Online. *Guardian Unlimited*, 27 February (dardenne-brothers.com).

Mai, Joseph (2007) 'Corps-Caméra: The Evocation of Touch in the Dardennes' *La Promesse*'. Online. *L'Esprit Créateur*, 47, 3, 133–44. Available at http://muse.jhu.edu/journals/lesprit_createur/v047/47.3mai.html

____ (2010) *Jean-Pierre and Luc Dardenne*. Urbana: University of Illinois Press.

Mandel, Ernest (1984) *Delightful Murder: A Social History of the Crime Story*. London: Pluto Press.

Margulies, Ivone (ed.) (2003) *Rites of Realism: Essays on Corporeal Cinema*. Durham, NC: Duke University Press.

Mélon, Marc-Emmanuel (1999) 'Dardenne, Luc & Jean-Pierre', in *Dic-doc: Le dictionnaire du documentaire*. Brussels: CGRI/CFWB, 147–50.

—— (2008) 'Le Regard et l'intrigue, ou comment reconstruire de l'expérience humaine', in Aubenas, *Jean-Pierre & Luc Dardenne*, 259–65.

Monk, Claire (1999) 'From Underworld to Underclass: Crime and British Cinema in the 1990s', in Steve Chibnall and Robert Murphy (eds) *British Crime Cinema*. London: Routledge, 172–88.

____ (2000) 'Underbelly UK', in Justine Ashby and Andrew Higson (eds) *British Cinema: Past and Present*. London: Routledge, 274–87.

Morandini, Morando (1997) 'Italy from Fascism to Neo-Realism', in Geoffrey Nowell-Smith (ed.) *The Oxford History of World Cinema*. New York: Oxford University Press, 353–61.

Mosley, Philip (2001) *Split Screen: Belgian Cinema and Cultural Identity*. Albany: State University of New York Press.

____ (2002) 'Anxiety, Memory, and Place in Belgian Cinema', *Yale French Studies*, 102, 160–75.

Nichols, Bill (2001) *An Introduction to Documentary*. Bloomington: Indiana University Press.

O'Shaughnessy, Martin (2007) *The New Face of Political Cinema: Commitment in French Film Since 1995*. Oxford: Berghahn Books.

____ (2008) '"Ethics in the Ruin of Politics": The Dardenne Brothers', in Kate Ince (ed.) *Five Directors: Auteurism from Assayas to Ozon*. Manchester: Manchester University Press, 59–83.

Pelletier, Frédérick (2002) 'Entretien entre Luc et Jean-Pierre Dardenne: quelque chose qui résiste au regard.' Online. *Hors Champ* (Cinéma), December. Available at www.horschamp.qc.ca/article. php3?id_article=4

Pomeranz, Margaret (2006) '*The Child* Interview'. Online. *At the Movies*, 16 August (dardenne-brothers.com).

Porton, Richard (2006) 'Tending *L'Enfant*: Dardenne Brothers Return with Another Palme d'Or Winner'. Online. *Film Journal International*, 1 March (dardenne-brothers.com).

Rancière, Jacques (2010) *Dissensus: On Politics and Aesthetics*, ed. and trans. Steve Corcoran. London: Continuum.

Renette, Eric, Ricardo Gutiérrez and Alain Boos (2000) *Liège: les sept péchés capitaux*. Liège: Editions Antoine Degive.

Renov, Michael (1993) *Theorizing Documentary*. London: Routledge.

Reynaert, Matthieu and Jean-Michel Vlaeminckx (2005) 'The Dostoevskys of Belgian Film'. Online. *Cinergie.be*, 9 September, transcript by *Cineuropa*, 14 July, 2008 (dardenne-brothers.com).

Reynaert, Philippe (2008) 'La Juste Distance: à propos du "Fils", de "L'Enfant" et de nos pères', in Jacqueline Aubenas (ed.) *Jean-Pierre & Luc Dardenne*. Brussels: CGRI/CFWB, 215–17.

Roemer, Michael (1966) 'The Surfaces of Reality', in Richard Dyer MacCann (ed.) *Film: A Montage of Theories*. New York: Dutton, 255–68.

Romney, Jonathan (2006) 'Interview.' Online. *Sight and Sound*, April.

Rosenbaum, Jonathan (2000) 'True Grit.' Online. *Chicago Reader*. Available at http://www.chicagoreader.com/chicago/true-grit/Content?oid=901208

Ryan, Michael and Douglas Kellner (1988) *Camera Politica: The Politics and Ideology of Contemporary Hollywood Film*. Bloomington: Indiana University Press.

Scott, A. O. (2009) 'In an Industrial Belgian City, an Immigrant's Brutal Dilemma.' Online. *New York Times*.com, 31 July. Available at http://movies.nytimes.com/2009/07/31/movies/31lorna.html

Sennett, Richard (1998) *The Corrosion of Character: The Personal Consequences of Work in the New Capitalism*. New York: W. W. Norton.

Shaw, Daniel (2008) *Film and Philosophy: Taking Movies Seriously*. London: Wallflower Press.

Singer, Peter (2005) 'Hegel', in Ted Honderich (ed.) *The Oxford Guide to Philosophy*. New York: Oxford University Press, 365–69.

Sklar, Robert (2006) 'The Terrible Lightness of Social Marginality: An Interview with Jean-Pierre and Luc Dardenne', *Cineaste*, 31, 2, 19–21.

Sobchack, Vivian (1992) *The Address of the Eye: A Phenomenology of Film Experience*. Princeton: Princeton University Press.

_____ (2004) *Carnal Thoughts: Embodiment and Moving Image Culture*. Berkeley: University of California Press.

Spaas, Lieve (2000) *The Francophone Film: A Struggle for Identity*. Manchester: Manchester University Press.

Stadler, Jane (2008) *Pulling Focus: Intersubjective Experience, Narrative Film and Ethics*. London: Continuum.

Thompson, E. P. (1964) *The Making of the English Working Class*. New York: Pantheon.

Thompson, Felix (2001) *Productive Observations: Naturalism and the Convergence of British Cinema and Television since the 1960s*, unpublished PhD dissertation, University of Westminster.

Thompson, Kristin and David Bordwell (1994) *Film History: An Introduction*. New York: McGraw-Hill.

Van Cauwenberge, Geneviève (1999) 'Filmer le social', in *Dic-doc: Le dictionnaire du documentaire*. Brussels: CGRI/CFWB, 47–51.

Van Den Heuvel, Chantal (1982) 'Itinéraires du cinéma de Belgique des origines à nos jours', *Revue Belge du Cinéma*, 2 (Winter). Special issue.

Walsh, David (2006) 'The Dardenne Brothers' *L'Enfant*: An Argument for a Far More Critical Appraisal.' Online. *World Socialist Web Site*, 30 June.

_____ (2008a) 'Interview with Jean-Pierre and Luc Dardenne, Directors of *Lorna's Silence*.' Online. *World Socialist Web Site*, 29 September.

_____ (2008b) 'The Dardenne Brothers: But What about the "Extenuating Circumstances"?' Online. *World Socialist Web Site*, 29 September.

West, Joan M. and Dennis West (2003) 'Taking the Measure of Human Relationships: An Interview with the Dardenne Brothers.' Online. *Cineaste*, Fall.

Williams, Raymond (1974) *Television: Technology and Cultural Form*. London: Fontana.

Winston, Brian (1995) *Claiming the Real: The Griersonian Documentary and its Legitimations*. London: British Film Institute.

Wolfreys, Jim (2008) 'Reality Bites.' Online. *Socialist Review*, December.

Young, Neil (2006) 'Standard Liege: Dardenne and Dardenne's *The Child*'. Online. *Neil Young's Film Lounge*, 17 April. Available at http://www.jigsawlounge.co.uk/film/reviews/standard-liege-dardenne-dardenne-s-the-child-6–10/

INDEX

Accatone (1961) 109
Adelin's Ark 39
Adorno, Theodor 3
Aida Vanquished 64
Aja, Alexandre 130
Akerman, Chantal 67
All or Nothing (2002) 13
Andersen, Thom 124
Anderson, Paul 11
Andrien, Jean-Jacques 28, 30
Angels of Sin, The (*Les Anges du Péché*, 1943) 124
Antenne-Centre 41
Aquinas, St. Thomas 19
Archipel 35 4, 97
Arendt, Hannah 3, 10
Argent Fou Collective 78
Aristotle 18, 19
Armes, Roy 8
Arnheim, Rudolf 10
Arte 4
Arthur, Paul 15
Arvanitis, Yorgos 73
Aubenas, Jacqueline 5, 12–13, 48, 70, 93, 103
Auerbach, Erich 8
August, Bille 1
Australia (1989) 28
auteurist cinema 32–7

Babe, Fabienne 70, 74
Badiou, Alain 16
Balibar, Etienne 19
Balthazar (1966) 112
Balzac, Honoré de 11
Barnouw, Erik 32
Baronian, Marie-Aude 91
Base of the Air is Red, The (*Le Fond de l'air est rouge*, 1977) 49
Battleship Potemkin (*Bronenosets Potyomkin*, 1927) 111
Baudelaire, Charles 15, 16
Baudry, Jean-Louis 15
Bazin, André 3, 7, 34
Beethoven, Ludwig van 121–2, 132
Begon, René 52
Belgian Resistance 43, 45
Belvaux, Lucas 1, 29, 30
Benjamin, Walter 8, 10, 15, 61
Berman, Marshall 16
Bianconi, Loredana 29
Bickerton, Emilie 125
Bicycle Thieves (*Ladri di Biciclette*, 1948) 120, 129
Black Land, Red Land (*Pays noir, pays rouge*, 1975) 29
Bloch, Ernst 3, 18, 48, 61–2
Blue (1993) 27

Bollen, Jacqueline 64
Bonmariage, Manu 29
Bonnaud, Frédéric 21, 110, 114
Borinage (*Misère au Borinage*, 1933) 28, 40
Boyle, Danny 11
Brecht, Bertolt 8, 9–10, 39, 60, 95
Bresson, Robert 6, 15, 16, 34–6, 84, 85, 95, 104, 112, 113, 116, 124
British realist cinema 28, 30
British underclass films 11
Bronckart, Olivier 4
Brothers Karamazov, The 77
Brussels 27, 28, 29, 32, 33, 39, 42, 52, 67, 83
Bucquoy, Jan 100
Bullet (2008) 15
Burch, Noël 8
Buyens, Frans 46, 48, 51

Calhoun, Dave 122
Camus, Albert 3
Canal Emploi 29, 41
Canal Plus 4
Cannes film festival 1, 77, 86, 88, 94, 97, 107, 112, 116, 124, 127

Cantet, Laurent 1
Cardullo, Bert 95
Carla's Song (1996) 13
Caron, Laurent 128
Carriers Are Waiting, The (*Les Convoyeurs attendent*, 1999) 29–30
Cassavetes, John 33, 34
Cattaneo, Peter 11
Caygill, Howard 18
Centre Bruxellois de l'Audiovisuel (CBA) 52, 55
Ceylan, Nuri Bilge 127
Chalier, Catherine 3, 113
Chaplin, Charlie 95
cinéma vérité 32, 40, 41, 60
'cine-trains' 59
class 20–1
Claus, Hugo 28
COBRA 28
Cockerill, John 26
Cockerill-Sambre 27, 46, 49, 71
Code 46 (2003) 78
Coen, Ethan and Joel 2
Colchat, Nicole 64
Collin, Françoise 103
community television network 42
Constant, Marius 57
Conversation in Wallonia 57
Cooper, Sarah 17–18
Coppola, Francis Ford 1
Coutiez, Dimitri 79
Crahay, Christian 64, 65
Crano, R. D. 15–16, 19
Cremer, Bruno 63, 65, 67
Crime and Punishment 109
Cronenberg, David 88

Damned, The (*Götterdämmerung*, 1969) 66
Dardenne, Jean-Pierre and Luc, films, main discussion of:
Child, The (*L'Enfant*, 2005) 107–15
Darkness (*Dans l'obscurité*, 2007) 112
Falsch (1986) 63–8
For the War to End, the Walls Had to Crumble (*Pour que la guerre s'achève, les murs devaient s'écrouler*, 1980) 48–52

Dardenne films *cont.*
In the Beginning Was the Resistance (*Au commencement était la résistance*, 1974–77) 40, 42–3
Kid with a Bike, The (*Le Gamin au vélo*, 2011) 127–33
Lessons from a University on the Fly (*Leçons d'une université volante*, 1982) 55–7
Look at Jonathan. Jean Louvet, His Work (*Regarde Jonathan. Jean Louvet, son oeuvre*, 1983) 57–60
Nightingale's Song, The (*Le Chant du rossignol*, 1978) 43–5
Promise, The (*La Promesse*, 1996)) 76–85
R... No Longer Answers (*R... ne répond plus*, 1981) 52–5
Rosetta (1981) 86–96
Silence of Lorna, The (*Le Silence de Lorna*, 2008) 116–26
Son, The (*Le Fils*, 2002) 97–106
They're Running ... Everyone's Running (*Il court, il court le monde*, 1988) 68–9
When Léon M.'s Boat First Sailed down the River Meuse (*Lorsque le bateau de Léon M. descendit la Meuse pour la première fois*, 1979) 45–8
You're on My Mind (*Je pense à vous*, 1992) 70–5
Dardenne, Millie 64, 66
Das Kapital 12
d'Autreppe, Emmanuel 22
Dautun, Bérangère 64, 66
de Bont, Jan 130
Decalogue, The (*Dekalog*, 1988) 36
de France, Cécile 128, 130, 131
de Heusch, Luc 28–9
Deleuze, Gilles 15, 16, 19, 124
Delvaux, André 30, 59

Delvaux, Paul 59
Dequenne, Emilie 86, 87, 88, 89, 94, 110, 112
Dérives 4, 42, 45, 48, 52, 57, 76, 86
Dervaux, Benoît 15, 76, 124
Desbarats, Carole 94, 95
De Sica, Vittorio 66, 120, 129
Diary of a Country Priest (*Le Journal d'un curé de campagne*, 1950) 35
Di Mateo, Egon 128
direct cinema 40
Dirty Pretty Things (2002) 78
Dobroshi, Arta 6, 116, 117, 120
Dobrynine, John 64, 65, 69
documentary modes 41, 60
documentary tradition in Belgian cinema 40
Dogme 95 34, 85
Doret, Thomas 11, 128, 129, 131
Dostoyevsky, Fyodor 3, 77, 92, 109, 119
Dozo, Marie-Hélène 5, 76
Dreamlife of Angels, The (*La Vie rêvée des anges*, 1998) 31
Dubois, Jacques 17, 59
Dubois, Philippe 41
Dumont, Bruno 1, 29, 31
Duquenne, Amaury 15
Duret, Jean-Pierre 76, 93
Durutti Column, The 39
Dutroux, Marc 79

Eagleton, Terry 18–19
Eastwood, Clint 130
Edelmann, Pascal 5
Edmond G. 49–51, 61, 104
Eighth Day, The (*Le Huitième Jour*, 1996) 79
Eisenstein, Sergei 12, 111
Elster, Jon 34
Enclosure, The (*L'Enclos*, 1960) 32
Ernst Bloch, or Enquiry into the Body of Prometheus 61
ethical issues 2, 16–19, 22, 60, 82, 101, 107, 118, 123
Etienne, Anne-Marie 29
Eurimages 4, 5
Europa Distribution 4
Europa 51 (1951) 123

Farrelly, Peter and Bobby 2
Faulkner, William 3, 109
Fellini, Federico 113
Fighting for Our Rights (*Vechten voor onze rechten*, 1962) 46, 51
film practice 2–7
Films du Fleuve, Les 4, 76, 86
Flaubert, Gustave 95
Fleur Maigre Cooperative 48
Foucault, Michel 51
Four Hundred Blows, The (*Les Quatre Cent Coups*, 1959) 66, 132
Frampton, Daniel 15, 104
François, Déborah 7, 107, 109, 110, 111
Frankfurt School 23, 61
Frears, Stephen 1, 78
free radio movement 52, 54
French Community of Belgium 27, 41, 57
French New Wave 33
French poetic realism 13
Freud, Sigmund 59
Freyd, Denis 4, 97, 103
From the Branches Drops the Withered Blossom (*Déjà s'envole la fleur maigre*, 1960) 28, 30
Frozen River (2008) 15
Full Monty, The (1997) 11

Gabriel, Igor 76
Gaines, Jane 12
Garden of the Finzi-Continis, The (*Il Giardino dei Finzi-Contini*, 1970) 66
Gatti, Armand 32, 39, 40, 41, 43, 48, 52, 55, 57, 60, 61
Gay, Galy 95
General Strike of 1960–61 40, 45, 47, 49, 50, 59
German Ideology, The 20
Germany Year Zero (*Germania, Anna Zero*, 1947) 33–4, 36, 95
Gibson, Brian 113
Gilles de Binche 59, 72
Godard, Jean-Luc 9, 10, 32, 42, 49
Goethe, Johann Wolfgang von 10
Gold Rush, The (1925) 95

Goodis, David 123
Good Lord's Train, The 59
Gospel According to St. Matthew, The (*Il Vangelo Secondo Matteo*, 1964) 77
Gourmet, Olivier 5, 6–7, 14, 77, 78, 79, 81, 97, 98, 100, 101, 104, 118, 129
Granik, Debra 15
Grignoux, Les 43
Grombeer, Jean-Pierre 29
Gruault, Jean 74
Guattari, Félix 15, 16, 19
Guédiguian, Robert 34
Guevara, Ché 39

Hainaut surrealist group 27, 57
Hammer, Lance 15
Hangmen Also Die (1943) 33
Hardt, Michael 12, 19, 83
Hawks, Howard 33, 95
Hegel, G. W. F. 18, 19, 20
Heidegger, Martin 17
Hereafter (2010) 130
High Hopes (1988) 113
High Tension (*Haute Tension*, 2003) 130
Hill, John 12
history and memory 2, 41, 48, 63, 74
Hoberman, J. 112
Hobsbawm, Eric 21
Hudon, Wieslaw 29
Hunt, Courtney 15
Husserl, Edmund 17

Ikuru (1952) 37, 77
Imaginary Landscape (*Paysage imaginaire*, 1983) 29
Imamura, Shohei 1
immigrants 55, 56, 57, 61, 72, 79, 83, 116, 117, 125
Industrial Revolution 21
INSAS film school 33
Institut des Arts de Diffusion (IAD) 39
In This World (2002) 78
It's a Free World (2007) 78
Ivens, Joris 28, 40
Izod, John 41

Jacob, Gilles 86
James, David 20
Jameson, Fredric 8

Joffrin, Laurent 95

Kalisky, René 57, 63, 64
Kaurismäki, Aki 30, 36
Kellner, Douglas 61, 62
Kes (1969) 30
Ketchum, John 78
Kiarostami, Abbas 88
Kierkegaard, Søren 18, 122
Kieslowski, Krzysztof 27, 36, 104
Kilborn, Richard 41
Killing of a Chinese Bookie, The (1976) 33, 34
Kotliarov, Vladimir (alias Tolsty) 72
Kubrick, Stanley 74
Kurosawa, Akira 36–7, 77
Kusturica, Emir 1

Ladies of the Bois de Boulogne, The (*Les Dames du Bois de Boulogne*, 1945) 124
Ladybird, Ladybird (1993) 13
Laenaerts, André 64
Lafosse, Joachim 29, 30
Lamorisse, Albert 30
Lancelot of the Lake (*Lancelot du lac*, 1972) 35
Lang, Fritz 33, 109
Lanners, Bouli 29, 30
Last Resort (2000) 78
Last Year at Marienbad (*L'Année dernière à Marienbad*, 1961) 67
Law of the Weakest, The (*La Raison du plus faible*, 2006) 30
Léaud, Jean-Pierre 132
Lee, David 20
Lefebvre, Henri 19, 22, 61
Leigh, Mike 1, 13, 113
Levinas, Emmanuel 3, 17–19, 22, 61–2, 77–8, 83, 91, 102, 123
Liège 26, 27, 28, 29, 30, 31, 37, 40, 41, 43, 44, 45, 46, 49, 70, 71, 76, 78, 79, 84, 92, 118, 119, 123
Liénard, Bénédicte 29
Life is Sweet (1990) 113
Life of Jesus, The (*La Vie de Jésus*, 1997) 31
Light in August 109

Lille-Roubaix conurbation 31
Loach, Ken 1, 13, 30, 78, 94
local community access stations
 (TVL/C) 41
Lopate, Phillip 80
Louvet, Jean 27, 28, 57, 58, 59,
 60, 61, 74, 81, 104
Louvière, La 57
Lukács, Georg 8, 9, 10, 19
Lumière, Auguste and Louis 2

Madame Bovary 95
Maillet, Christian 64, 69
Maison de la Culture (Huy) 40
Mallamaci, Jean 64
Mandel, Ernest 11, 26, 39
Man Escaped, A (*Un Condamné
 à mort s'est échappé*, 1956)
 35, 84
Man's a Man, A 95
Man With a Movie Camera
 (*Chelovek s Kinoapparatom*,
 1929) 47
Marcoen, Alain 76, 132
Margulies, Ivone 3
Mariage, Benoît 1, 29–30
Marinne, Morgan 6, 97, 98,
 100, 101, 112, 117, 118
Marker, Chris 32, 49
Marx, Karl 11, 12, 19, 20, 48, 59
Marxist critics 3, 8, 18–23, 61
Masy, Léon 45, 49, 50, 51,
 61, 104
*Match Factory Girl, The
 (Tulitikkutentaan tyttö,
 1990) 30, 36
Meadows, Shane 11
Médiaform 55
melodrama 12–13, 113
Mélon, Marc-Emmanuel 17,
 52, 70
Mérigeau, Pascal 99
Merleau-Ponty, Maurice 15, 16
Mertens, Wim 74
Metz, Christian 15
Meyer, Paul 28, 30
Michel, Thierry 28, 29, 45
Miéville, Anne-Marie 49
Minima Super-16 camera 103
Mizoguchi, Kenji 32, 36, 37
Money (*L'Argent*, 1983) 35, 116
Monk, Claire 11–12
Moonlighting (1982) 78
Morin, Edgar 32

Morrison, Toni 3, 77
Mouchette (1968) 35
Müller, Heiner 61
Murnau, F. W. 32, 33, 34, 109,
 113

Narodowiec 56
National Film Board of Canada
 32
Negri, Antonio 12, 19, 83
Negulesco, Jean 124
Neo-Realism 13–14, 33, 34,
 120, 124
new French realism 1
New Ice Age, The (*De Nieuwe
 Ijstijd*, 1974) 95
Nil by Mouth (1997) 16
Nobody Lives Forever (1946) 124
nordiste cinema 29–31
No-Télé (Tournai) 57
Nysenholc, Adolf 66
Nyst, Jacques-Louis 41

Oldman, Gary 16
*Once Upon a Time in Anatolia
 (Bir Zamanlar Anadolu'da,
 2011) 127
On the Ruins of Carthage 64
Ophüls, Marcel 32, 43
Optimists of Nine Elms, The
 (1973) 30
O'Shaughnessy, Martin 22
Oudart, Gisèle 64
Ouedraogo, Assita 5, 77, 81
Ouedraogo, Rasmané 77

Paquette, Pier 71
Pasolini, Pier Paolo 77, 109
Pawlikowski, Pawel 78
Pelletier, Frédérick 42
Penderecki, Krzysztof 57
philosophy and film 14–20
Pialat, Maurice 34
Pickpocket (1959) 35, 113
Piemme, Jean-Marie 66
Pizzuti, Pietro 71
Poelvoorde, Benoît 30
politics and film 20–3
Pondeville, Stéphane 72
Portrait of a Self-Portrait (*Portrait
 d'un autoportrait*, 1973) 29
post-industrial society 2, 8,
 10, 26–7, 30, 47, 79, 80,
 84, 127

Pousseur, Henri 61
Private Property (*Propriété privée*,
 2006) 30, 31
production workshops 52
Proletarian Theatre (La
 Louvière) 57
Pudovkin, V. I. 10

Quaghebeur, Marc 63
Quasimodo, Salvatore 28
Quay, Stephen and Timothy 2
Quintart, Monique 29

Rabinowicz, Maurice 29
Raining Stones (1993) 13, 94
Rashomon (1951) 37, 77
Ravel, Maurice 57
realism 8–14, 30
realist cinema 3, 12
Red Balloon, The (*Le Ballon
 rouge*, 1955) 30
Renard, André 46, 81
Renier, Jérémie 6, 7, 11, 31, 77,
 79, 81, 84, 100, 107, 108,
 109, 110, 112, 116, 118,
 120, 128, 129, 130
Renoir, Jean 7, 93
Renucci, Robin 70, 74
*Report on the Steel Seasons
 (Chronique des saisons d'acier,
 1980) 29
Resnais, Alain 67, 74
responsible realism 1–2
responsibility 2, 14, 61, 63, 77,
 107, 112, 118, 121, 130
Riga, Jean-Claude 29, 41
Riley, John 78
Ring of Night (*Ronde de nuit*,
 1984) 29
River Meuse 26, 27, 40, 42, 48,
 76, 114
Road, The (*La Strada*, 1954) 113
Roemer, Michael 2
Roland, Marie-Rose 64
Rongione, Fabrizio 79, 87, 89,
 116, 118, 128, 129
Rosenbaum, Jonathan 90
'Rosetta Law' 86
Rossellini, Roberto 32, 33, 34,
 74, 94, 123
Rouch, Jean 28, 32, 41, 43
RTBF (Belgian French-language
 public television) 4, 41, 42,
 46, 48, 55, 57

Sartre, Jean-Paul 18, 27
Scarface (1932) 95
Schumann, Robert 3
Scott, A. O. 122
Segard, Jérémie 11, 108, 112
Seraing 9, 27, 30, 31, 32, 39, 40, 48, 49, 51, 70, 71, 72, 73, 78, 79, 92, 111, 123
Sexual Life of the Belgians, The (*La Vie sexuelle des belges*, 1994) 100
Shakespeare, William 3, 119
Shopping (1994) 11
Sickness unto Death, The 122
Sikivie, François 64
Simenon, Georges 37, 67
Simmons, Anthony 30
Simon, Manu 29
Singer, Peter 20
Situationists 19, 42, 61
Six Times Two: On and Beneath Communication (*Six fois deux: sur et sous la communication*, 1976) 42
Skolimowski, Jerzy 78
Smalltime (1997) 11
Sobchack, Vivian 15, 16
social realism 1, 12, 33, 60
socio-economic margin 10, 107, 125
Solidarity 55, 56
Song of Solomon 77
Songs on Thursday as Well as on Sunday (*Jeudi on chantera comme dimanche*, 1967) 28–9
Sony Portapak 40
Sorrow and the Pity, The (*Le Chagrin et la pitié*, 1970) 43
Soupart, Isabella 97
Soviet agitprop film 51, 55
Spaas, Lieve 79
Speed (1994) 130
Springsteen, Bruce 93
Stadtler, Jane 16
Stockhausen, Karlheinz 57

Storck, Henri 28, 40, 74
Stray Dog (*Nora-inu*, 1949) 36–7
Street of Shame (*Akasen chitai*, 1956) 36, 37
Strike (*Stachka*, 1924) 12
Sula 77
Sunrise (1927) 33, 34, 109, 113

Tarantino, Quentin 36
Tati, Jacques 32
Taviani, Vittorio and Paolo 2
Télérama 33
Thousand Plateaus, A 15
Tison, Pascale 69
Toto the Hero (*Toto le héros*, 1991) 79
Trainspotting (1996) 11
Trial of Joan of Arc, The (*Le Procès de Jeanne d'Arc*, 1962) 35
Truffaut, François 66, 74, 132
Turner, Bryan 20
2001: A Space Odyssey (1968) 74

Ukaj, Alban 116
U-Matic videotape 48, 52, 55, 57
underclass 20–1, 30, 78, 82, 113, 125
unemployment 11, 12, 26, 28, 50, 79, 80, 87, 90

Van Der Keuken, Johan 33, 95
Van Dormael, Jaco 79
Vanden Ende, Walther 68
Vertov, Dziga 32, 39, 47
Vidéographie 41, 43, 45
Vidéoption 40
Vincent, Thomas 29
Virilio, Paul 68
Visconti, Luchino 66
VTR St. Jacques (1969) 32–3
Vulcan Unemployed 74

Wachowski, Andy and Larry (now Lana) 2
Walesa, Lech 56
Wallimage 29
Wallonia 1, 3, 14, 26–8, 42, 57, 71, 72
Wallonie, La 46
Wallonie Image Production (WIP) 52, 57
Walloon cinema 28–30, 40
Walloon culture 26–31
Walloon industrial region 70, 74, 79, 87
Walloon Manifesto 28, 71
Walloon working class 59, 71, 82
Walsh, David 20, 21
We Were All Names of Trees (aka *The Writing on the Wall*) (*Nous étions tous des noms d'arbres*, 1981) 52
What Means Motley? (2006) 78
Widart, Nicole 29
Wide Horizons of Alexis Droeven, The (*Le Grand Paysage d'Alexis Droeven*, 1981) 28
Window Shopping (*Golden Eighties*, 1986) 67
Winston, Brian 32
Winter 60 (*Hiver 60*, 1982) 29, 45
Winterbottom, Michael 78
Winter's Bone (2010) 15
Wittgenstein, Ludwig 18
Wolfreys, Jim 20
Workers' Film and Photo Leagues 40
Workers' Voice, The (*La Voix ouvrière*) 49

Yernaux, Anne 87
You Only Live Once (1937) 33, 109

Zola, Emile 95
Zonca, Erick 1, 29, 31